# GUSTAV STICKLEY'S CRAFTSMAN FARMS

Gustav Stickley. Craftsman furniture catalog, 1910.

# GUSTAV STICKLEY'S CRAFTSMAN FARMS

*The Quest for an*
*Arts and Crafts*
*Utopia*

Mark Alan Hewitt

Syracuse University Press

The paper used in this publication meets the minimum requirements of
American National Standard for Information Sciences—Permanence
of Paper for Printed Library Materials, ANSI Z39.48-1984.⊗™

Color photographs by Ray Stubblebine are reproduced with the permission
of the Craftsman Farms Foundation, Parsippany, New Jersey.

Library of Congress Cataloging-in-Publication Data

Hewitt, Mark Alan

Gustav Stickley's Craftsman Farms : the quest for an arts and crafts utopia /
Hewitt, Mark Alan.—1st ed.

     p.   cm.

     Includes bibliographical references and index.

     ISBN 0-8156-0689-3 (cloth : alk. paper)

     1. Craftsman Farms (Parsippany, N.J.)  2. Stickley, Gustav, 1858–1942 —Homes
and haunts—New Jersey—Parsippany. 3. Stickley, Gustav, 1858–1942 —Criticism and
interpretation. 4. Arts and crafts movement—New Jersey—Parsippany. 5. Log build-
ings—New Jersey—Parsippany. 6. Furniture, Mission—New Jersey—Parsippany. 7.
Parsippany (N.J.)—Buildings, structures, etc. I. Stickley, Gustav, 1858–1942. II. Title.

NA7238.P25 H48 2001
728'.092—dc21

00-050511

Manufactured in the United States of America

To my wife, Mia Tatiana Kissil, with gratitude and love

Far-off a young State rises, full of might:

    I paint its brave escutcheon. Near at hand

    See the log cabin in the rough clearing stand;

A woman by its door, with steadfast sight,

Trustful, looks Westward, where, uplifted bright,

    Some city's Apparition, weird and grand,

    In dazzling quiet fronts the lonely land,

With vast and marvelous structures wrought of light

Motionless on the burning cloud afar:—

    The haunting vision of a time to be,

After the heroic age is ended here,

Built on the boundless, still horizon's bar

    By the low sun, his gorgeous prophecy

Lighting the doorway of the pioneer!

    —John James Piatt (1835–1917), "Farther"

Mark Alan Hewitt is an architect, teacher, writer, and a 1996
NEH Winterthur Research Fellow. His previous books include
*The Architect and the American Country House, 1890–1940* (1990)
and *The Architecture of Mott B. Schmidt* (1991).

# Contents

# Illustrations

## Color Plates

# Figures

ILLUSTRATIONS

# Preface

DESPITE THE WIDESPREAD INTEREST in bungalows and Arts and Crafts decoration since the 1970s, I suspect that few American architects are as conversant today with Gustav Stickley's architecture as a typical furniture dealer would be with his famous line of chairs. I certainly had no idea what I might find when I first encountered Craftsman Farms almost ten years ago. I had read the *Craftsman* and admired its creator as a designer, philosopher, and cultural figure, but I knew little about his activities as a builder. Even after Robert Guter gave me an insider's tour, I suspected that there was more to discover about the house that Stickley designed for himself in 1908. This book began out of an itching curiosity to know more about Stickley as an architect and grew into a much larger project over a period of eight years.

In 1991–92 I brought a bright, enthusiastic group of architectural students from the New Jersey Institute of Technology to Craftsman Farms to study alternative strategies for preserving the site and creating a study center for the Arts and Crafts movement. Mr. Guter, one of the many heroes who helped to save the site, showed us a virtually empty group of buildings in the very early stages of preservation. Responding to an immediate need, we helped to document the site for future restoration work. By the time our one-semester analysis was complete, it was clear that we needed to learn more about how and why these buildings were constructed in this place, and what they might tell us about Stickley and his ideas about architecture.

As work progressed on the preservation of the Clubhouse, historian Constance Greiff, architect Philetus Holt, and curator Nancy Strathearn shared fascinating new discoveries about the construction of this log house. I began research for an article on Craftsman Farms, adding new material to theirs, and delving further into the complex history of the property. That essay appeared in *Winterthur Portfolio* in 1996.

Projects like this one have a way of expanding unexpectedly. I was approached by Robert Mandel, director of Syracuse University Press, about the prospect of a book on utopian communities, and the subject of Craftsman Farms seemed right for the press that had published Mary Ann Smith's pioneering book on Stickley. So the article was enlarged and expanded in scope. I was fortunate to obtain a fellowship to work on this project from the National Endowment for the Humanities in 1996, allowing me a summer's sojourn at the Winterthur Museum and Library, where Stickley's business papers are a part of the Joseph Downs Collection.

The Winterthur research was invaluable, as it not only provided time to think deeply and write, but also afforded the opportunity to pore over hundreds of pages of accounting records and other business files from the Stickley companies. I found much that had been previously overlooked and was able to chronicle in greater detail the property purchases and building campaigns that Stickley had done much to obscure prior to his bankruptcy in 1914. There is a tragic subtext to the many autobiographical articles that appeared in Stickley's magazine. In the following pages the reader will discover something of that hidden text as it relates to Craftsman Farms. The new research presented here may also help to interpret the site in a more accurate light, while not diminishing the marvelous achievements of a major American artist and thinker.

I returned to Craftsman Farms in 1997 to find the site under the direction of Tommy McPherson, with exciting new programs under way. He graciously allowed me to peruse the archives and gave me valuable criticisms on my manuscript. Additional insights about Stickley's biography from Marilyn Fish and David Cathers helped me in my final drafts of the book. What is presented here, then, collects much from these leading

Stickley scholars and synthesizes archival materials with new research. The story is not complete, but we have now a richer and more detailed look at one period in Stickley's life. With the visual and textual material presented here, I hope that readers discover things that will spur more research into this fascinating figure in American culture.

There are many others to thank for a myriad of favors, insights, and labors. I gratefully acknowledge the National Endowment for the Humanities and the Winterthur Museum and Library for my 1996 Advanced Studies Fellowship. Winterthur's Gary Kulik, Pat Elliott, Neville Thompson, Bert Denker, Richard McInstry, and Lisa Lock made my stay richly rewarding and most enjoyable. I shall never forget the late- afternoon conversations with Neville and her staff, followed by delightful walks in the Winterthur gardens. If there is a better atmosphere, or place, for scholarship and creative writing, I have not found it.

For help in getting to Winterthur, and for other favors, I thank Keith Morgan, David DeLong, George E. Thomas, and the late David Gebhard. For insights on early drafts and presentations of the work, thanks also to Lisa Lock, Robert Judson Clark, Jack Lebduska, Janet Foster, and Jeffrey Cohen. I gratefully acknowledge the staffs of the Wisconsin Historical Society, the Avery Architectural Archives at Columbia (Janet Parks, director), the Library of Congress Prints and Photographs Division (Ford Peatross, head), and the Winterthur Museum and Library Photographic Collections (Bert Denker, curator) for their assistance in obtaining the illustrations.

At Craftsman Farms, Vivian Zoe, Ray Stubblebine, the late Nancy Strathearn, Bob Guter, Muriel Berson, and Tommy McPherson were generous in their support for the project. The staff of the Free Library of Morristown and Morris Township, Local History Collection, spent many afternoons with me, helping to locate valuable material—and not merely because my mother-in-law, Claire Kissil, is a senior librarian. Thank you, Claire, Leslie Duthwaite, Christine Jochem, and your helpful staff. To Robert Mandel and his production team at Syracuse University Press, thanks for perseverance and a steady hand.

Finally, I am grateful for the loving support of my wife, Mia, and daughters, Sarah and Allison, during the long gestation period of this project. Without their gentle encouragement, the manuscript might well have remained on the shelf.

# GUSTAV STICKLEY'S
# CRAFTSMAN FARMS

1

# Prologue and Method

IN 1898 Gustav Stickley (1858–1942) was a relatively unknown furniture maker living in Syracuse, New York. He had struggled for almost three decades to find an identity amid the shifting society of Victorian America, aiming to establish a successful business in the burgeoning furniture industry. As the century neared its end, Stickley discovered the work of William Morris, transformed himself, and entered an extraordinary phase of creative innovation that placed him at the center of one of the most significant cultural movements in American history. Founding his Craftsman empire in 1901, he joined a group of American artists, reformers, writers, and architects who were seeking to remake the world. For more than a decade America's Arts and Crafts advocates created craft objects, buildings, gardens, and utopian communities that challenged prevailing views of the relationship among art, work, society, and the production of material goods. The culture they created continues to fascinate us as we begin a new millennium. Their world was simple, artful, and full of the meaning that comes of designing and making the useful things that enhance everyday life.

This book is about an ambitious and tragically unsuccessful project that occupied Gustav Stickley during his most creative and influential period, from 1908 until 1914. Craftsman Farms, as he called it, was to be the ultimate expression of the many ideals that appeared in the *Craftsman* magazine and that have subsequently been associated with the entire Arts and

Crafts movement in the United States. When placed in the context of American culture during the twentieth century's first decade, the story of its conception and realization is intensely representative of the Arts and Crafts movement as a whole. Indeed, one may see the tale of Craftsman Farms as a parable that unveils the problems and moral dilemmas faced by the courageous advocates of a new social order that was to unite art and life, work and aesthetic pleasure, during one of the century's most tumultuous and defining decades.

Gustav Stickley's utopian community was created to embody several of the central ideals of the American Arts and Crafts movement: the virtue of the "simple life," the necessity for manual childhood education in the crafts and trades, the value of "country life" on the farm and frontier, and Americans' sentimental attachment to log dwellings as a part of the myth of self-determination. Amid similar experiments in the United States and Britain, it was intended to inspire other artists and educators, and to be an organ of social and artistic reform. Scholars of the Arts and Crafts movement have frequently pointed to political, artistic, educational, and social reformers of the 1880–1920 period as catalysts for the aesthetic philosophy of the movement in the United States.[1] The years of Gustav Stickley's leadership coincided with the Progressive Era efforts of Teddy Roosevelt, Herbert Croly, Thorstein Veblen, Woodrow Wilson, and others to change the American political and economic system. The United States was entering a period of rapid political and social transformation, with a rising tide of new immigration, expansion of corporations and industries, and the consolidation of the modern two-party political system.[2] Urbanization was supplanting the nineteenth-century agricultural economy with one driven by consumer capitalism and its media-oriented world. The time was ripe for new ideas about art, society, and work, and pioneers of the Arts and Crafts movement led a vanguard of critics against the rush of industrial capitalism and consumerism.

The centers of the movement were in Boston, Chicago, San Francisco, southern California, and upstate New York, where by the late 1890s groups of artists had formed Arts and Crafts "societies." In 1895–96 the San Fran-

cisco Guild of Arts and Crafts staged the first organized exhibition (on bookmaking) in the United States, followed shortly after by Boston's show in Copley Hall in April 1897.[3] Schools for teaching new principles of art, design, and craftsmanship were founded around these societies, notably the School of Fine Arts in Pasadena by William Lees Judson and the California School of Arts and Crafts in Berkeley and Oakland.[4] Proponents of the new movement argued that society must reunite the traditional craft trades with art and design training. University faculty such as Charles Eliot Norton of Harvard and John Dewey of the University of Chicago joined with industrial leaders, artists, and craftspersons to promote experimental partnerships among industry, schools, and social service organizations. By the first decade of the new century, a remarkable confluence of social, artistic, and intellectual currents encouraged these revolutionary efforts at reform.

Paralleling the complex structure of American society during this era, Arts and Crafts reformers advanced their causes in diverse and widespread endeavors. Strong-willed individualists such as Elbert Hubbard, William Lightfoot Price, Charles Fletcher Lummis, Henry Chapman Mercer, Jane Addams, Arthur Wesley Dow, and M. Louise McLaughlin carried their torches against the tide of society with remarkable single-mindedness. Their workshops, writings, works of art, and social experiments—at the Roycroft Shops, Rose Valley Community, El Alisal, the Moravian Tileworks, Hull House, Columbia Teachers' College, and the Rookwood Pottery—were to become singular models that inspired other individuals and institutions. Although America welcomed such rugged individualism during the Progressive Era, it was hesitant to embrace widespread institutional change. The larger utopian experiments of the era were slower to develop, and generally less successful than individual forays.

Chicago's short-lived Industrial Arts League attempted to bring schools, industries, and artists together in the early years of the century to create an entirely new production system. Schools such as the Pennsylvania Museum and School of Industrial Art, Cranbrook Academy near Detroit, and the Rhode Island School of Design in Providence began their programs

with equally ambitious goals to revive crafts knowledge and elevate aesthetics.[5] Radical experiments in social reform took root in many areas of American society. In California and other parts of the country with great natural scenery, Arts and Crafts advocates promoted regional materials and rustic styles in resort architecture. Advocates for conservation and natural modes of living founded experimental resort and art enclaves that attracted many social progressives. The Woodstock art colony in New York's Catskill Mountains; Frank Miller's Mission Inn in Riverside, California; Edward MacDowell's New Hampshire music camp; Connecticut's Yelping Hill intellectual colony; and David Curry's Yosemite Valley tent colonies are but a few examples of a widespread trend of the fin de siècle: rustic life as a tonic for the ills of industrial capitalism. Amid the height of America's country-life movement, the naturist philosophy of life struck a deep chord.[6] Americans yearned to recapture a rapidly vanishing virgin landscape, a way of life slipping inexorably away with the rush of modernism.

For those people with more serious ideals of living simply, honestly, and with greater social equity, there were communities founded to promote utopian reform year-round. Philanthropist Russell Sage, architect Grosvenor Atterbury, and landscape architect Frederick Law Olmsted Jr. planned the extensive Forest Hills Garden Suburb (1909–12) on the periphery of New York City as an early American experiment in garden-city planning principles. Naturalist Charles Keeler and architect Bernard Maybeck designed an enclave of houses called the Hillside Colony in Berkeley, California, during the first years of the century that offered simple living on a smaller scale. Joaquin Miller dreamed an unsuccessful cooperative city in the nearby Oakland Hills. In 1902 Edward Gardner Lewis began his ambitious social and architectural scheme for University City in St. Louis, Missouri, eventually organizing a publishing enterprise, art school, workshops, and other socialist-influenced cooperatives around the new town.[7] Real estate developer and Anglophile George Woodward funded his quasi-utopian visions in the Philadelphia suburb of Chestnut Hill during the years around World War I. Numerous other architectural projects were constructed throughout the United States during the era

before the Great Depression that evinced the same cooperative principles of aesthetic and social utopianism.

In the arena of work, experiments were no less far-reaching. With the revival of handicrafts came a new interest in cooperative workshops that followed some of the precepts of the medieval guilds of Western Europe — ateliers, not factories, that validated the individual craftsman as a creative artist, not simply a producer of goods. "At the core of Arts and Crafts philosophy," Robert Edwards observes, "lay the concept that work should be the creative and joyful essence of daily life rather than a mere act of sustenance."[8] Progressive business owners, artists, and craftspersons began to experiment with production systems and organizations that gave each worker greater individual responsibility for the goods produced.

The most successful enterprises to employ such principles were ceramic, furniture, and metalworking companies founded by artist-entrepreneurs who could sustain both the financial and the aesthetic aspects of craft work. Louis Comfort Tiffany's New York factory, Rookwood Pottery in Cincinnati, and Boston's Grueby Faience led the way in the last decades of the nineteenth century with experiments in design, ceramic materials, and glazing techniques. By 1900 a renaissance of art pottery was in full development in the United States. Artistic products in metal were crafted in both individual workshops, such as Samuel Yellin's or Cornelius Kelley's, and larger factories, such as the Bradley and Hubbard Manufacturing Company in Meriden, Connecticut.[9] In both large enterprises and small workshops, the creative activity of artisans was dignified by a vital connection between useful objects and the craftsmanship employed in their production. For a brief instant America's industrial engines seemed to slow down and embrace an essentially aesthetic rather than purely commercial ethos.

Nowhere was this ethic more strongly represented than in the extraordinary furniture and decorative arts products of Gustav Stickley's Craftsman companies. For nearly two decades this protean designer and cultural leader marshaled the forces of fellow artisans and designers to produce objects of superb simplicity and grace. His Eastwood factory employed a dedicated force of woodworkers, metalsmiths, textile artisans,

and designers who caught the spirit of Morris's philosophy of art and work as one teleological path. Stickley was the ultimate artist-businessman of the era, attempting to show America that beautiful and useful things could be made and sold in a progressive capitalist society. Beginning with a simple line of chairs and tables, he eventually expanded his production to include wicker furniture, lamps, hardware, textiles, books, and even plans for houses designed by an architectural atelier. As his enterprises grew from a small factory near Syracuse to a network of stores; a publishing company selling magazines, catalogs, and books; and eventually a New York emporium for home products, he strove to achieve a more profound influence in American life than the place accorded a company president. He wrote about politics, education, art, work, urbanism, the rural economy, and many other social issues in his regular columns in the *Craftsman*. He became a modern media figure of significant stature.

The relationship between media and ideology is critical to an understanding of turn-of-the-century culture. The publishing media, particularly books and magazines, advanced Stickley's cause more directly than that of other Arts and Crafts leaders. He and his contemporaries were not only advocating artistic and social change through publishing but also participating in the rise of mass culture in the United States and abroad. As Richard Ohmann has shown, the turn of the last century was a critical period for the establishment of mass culture and media in the modern world. Stickley and his contemporaries sold their ideas to a willing public, creating a "habitual audience" for both ideas and products, even as they proclaimed their desire to cleanse society of commercialism and the exploitation of industrial workers.[10] Oblivious to the paradoxes and contradictions in this strategy, Stickley used advertising propaganda, magazine subscriptions, and sales brochures to sell his wares to a public hungry for new consumer products. Although the engines of commerce produced too many goods for an unsophisticated public, Stickley and other Arts and Crafts shops competed for the market against cheaper, mass-produced goods, without accounting for their higher artistic value. Eventually, most went bankrupt or sold to a small audience of connoisseurs or social progressives. Nevertheless, the linkage among publishing media, craft pro-

duction, and mass culture was established during the early 1900s by magazines such as the *Craftsman*.[11] Without these mass-media publications, the Arts and Crafts movement might simply have left a shallow imprint on American society, limited to the utopian experiments of a small group of eccentrics.

Gustav Stickley saw his chance during the first decade of the twentieth century to reach a vast, untapped reservoir of sentiment in the American populace with his messages of simplicity and honest craftsmanship. Unique among leaders in the Arts and Crafts movement, Stickley pressed for reform using his art, his life, and his words as exemplars of a new philosophy of design and work. Not content to preach a message from the bully pulpit of the *Craftsman*, this progressive designer planned and partially realized a utopian farm-school-estate that showed his followers he was willing to practice that philosophy. This story is about his quest to create Craftsman Farms—as an idea, a text, a landscape, and a group of extraordinary American artifacts.

The buildings at Craftsman Farms were built on Morris County properties acquired piecemeal by Stickley as a family estate between 1908 and 1910, eventually to comprise more than 650 acres (fig. 1). Stickley intended these buildings to become the locus of a farm-school, country estate, and workshop complex, but because of his financial problems only a handful of buildings were constructed. In 1989 efforts by preservationists saved the Clubhouse and central area of the compound from demolition and initiated the conservation of the existing buildings and landscape. Because of their efforts, Craftsman Farms is today a museum dedicated to the study of the Arts and Crafts movement in America. It is one of the few historic sites associated with the movement to retain a significant degree of physical integrity, and for this reason it is a treasure to be protected, preserved, and studied.[12]

Stickley began purchasing farm properties near Morris Plains in June 1908. In the fall of that year he announced plans in the *Craftsman* for the construction of his utopian Craftsman Farms community. His first writings

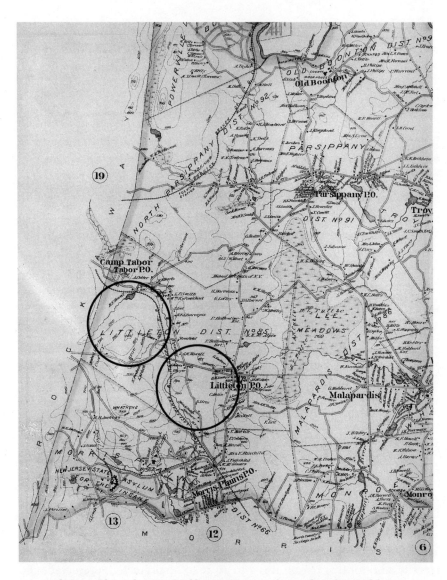

1. Area of Morris Plains showing Stickley properties to the north and east of the Newark–Mount Pleasant turnpike later to become Craftsman Farms. *1887 Atlas of Morris County*, A. H. Mueller Company. Courtesy Free Library of Morristown and Morris Township, Morristown, N.J.

suggested that he would found a farm-workshop-school that would offer summer programs for children in traditional agriculture combined with handicraft instruction. At this time he was at the height of his influence as a media figure and artist, commanding considerable public attention in the press and wealthy enough to afford his land purchases.

Immediately, he hired a small group of local farmworkers to manage his properties—initially comprising about 50 to 70 acres. He purchased farm animals, seed, building materials, and other necessary staples from local merchants and set up an account in his Syracuse company to track "Farms" expenditures. By the spring of 1909 he had tripled the property, purchasing an additional 157 acres contiguous to his first parcels. Around that time he began the construction of the first modest buildings, including farm-utility structures and worker cottages. In July 1910 he made his largest land purchase of 500 acres.

During that summer he moved his family to New Jersey from Syracuse, even though accommodations at the Farms site were modest and largely incomplete. The family was pressed into service as workers on the properties. A larger building, called the Clubhouse, was begun to provide better facilities for family and staff. By 1911 the family had moved to this building, now required to serve as the big house on the estate (fig. 2). Plans for a large manor house were not realized. Farm cultivation was poorly organized, but the small cadre of workers carried on, planting orchards, crops, and gardens and hoping for better times ahead. The *Craftsman* published an extensive portfolio of photographs showing the compound and its buildings in operation and trumpeting its success.

The story and pictures were an illusion. By early 1912 Stickley's companies—a home-building service, publishing company, furniture factory, and retail network—were faltering. No new furniture lines had been instituted since 1909, and competition from other Arts and Crafts makers was intensifying. The Farms account was removed from the books of his Syracuse company, and he began to reorganize his business interests to deal with mounting financial problems. Nonetheless, he continued to expand his Arts and Crafts empire, stepping up the house-building service and

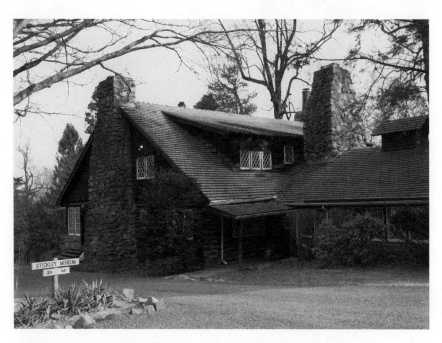

2. Clubhouse. Craftsman Farms National Historic Site, Parsippany, N.J., 1991.

readying a lavish New York emporium for its scheduled opening in 1913. His attention shifted away from the New Jersey experiment. Plans to construct more buildings languished.

Against the advice of his son-in-law Ben Wiles, Stickley continued to spend frivolously on his New York Craftsman Building, paying in excess of fifty thousand dollars for the first year's rent alone. His Boston store reported significant losses in 1912, and other aspects of his financial position indicated distress. He took out a fifty-thousand-dollar banknote against the value of his New Jersey properties in 1914, hoping to stave off bankruptcy, but his efforts came too late. In March of that year the Gustav Stickley Company, including all of its subsidiary businesses, filed bankruptcy in New York. Reports filed with the courts indicated that liabilities amounted to nearly one-quarter of a million dollars.[13]

Stickley's world crumbled quickly following his financial crisis. He and his wife, Eda, separated; she lived until only 1919. Stickley suffered a severe nervous breakdown and was briefly hospitalized, later continuing to suffer from acute depression. His brothers—Leopold, in particular—attempted to continue the Stickley furniture lines and hired Gustav as a consultant for a time. Quarrels led to a parting of the ways. His daughter Barbara and son-in-law Ben Wiles returned to live in his Syracuse house, eventually taking him in to live with them. The bank sold Craftsman Farms to Maj. George Farny for one hundred thousand dollars in 1917, just as America was entering the war in Europe. Living on until the early years of World War II, Gustav Stickley never again played a major role in the decorative arts.

The story does, however, have a happy ending. The Farny family maintained all of the buildings constructed by Stickley for more than eighty years, even preserving some of the interior furnishings and gardens. When collectors rediscovered Craftsman furniture in the 1970s and readers again

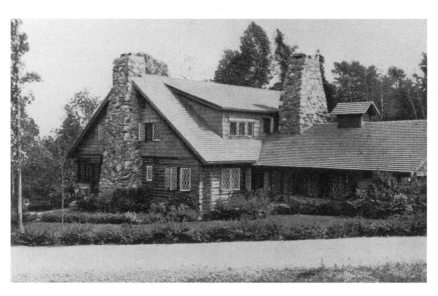

3. Clubhouse at Craftsman Farms shortly after completion. *Craftsman* (1912).

began looking at Stickley's writings, they were led to a secluded site near the modern town of Parsippany, New Jersey. There enthusiasts discovered one of the most remarkable artifacts created during the Arts and Crafts movement: an ensemble of buildings and gardens rife with the idealism of the fin de siècle. When the site was saved in 1989, the township purchased a portion of the property for use as a public park, and state funds were used to restore the Clubhouse and its immediate surroundings (fig. 3). The site was named a National Historic Landmark, the highest designation given to cultural resources in the United States. It has now become a mecca for furniture lovers and students of the decorative arts. The Clubhouse serves as a museum and study center run by the Craftsman Farms Foundation, a not-for-profit entity with a full-time director, curator, and education staff. Visitors may enjoy the buildings and site on weekends and selected weekdays, and plans exist to expand the complex and its programs. Stickley's vision proved more durable than the dreams of many Arts and Crafts proponents; his buildings, landscapes, and artifacts continue to provide lessons to those people who would remake the world as a sustainable environment, as a place where art and life may be united under the ideal of craftsmanship.

Craftsman Farms is a cultural artifact that bears examination under a number of critical lenses. As a text, the history and theoretical foundations of the crafts community envisioned by Stickley are rife with significant issues in American art and society at the century's turn. As works of architecture and design, the buildings constructed by Stickley likewise are part of larger movements and trends that have often been overlooked by historians discussing his work, including the relationship between architecture and building technology, the influence of vernacular and folk traditions on the designed environment, the development of a modern American architecture out of indigenous sources, the impact of domestic-simplification movements on the architecture of the American house at the turn of the last century, and the fate of utopian social reformers who used the Arts and Crafts movement as a vehicle for significant social change.

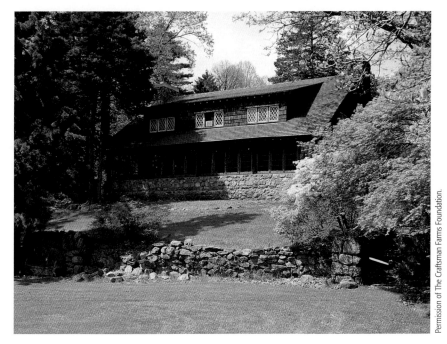

The Log House at Craftsman Farms from the southeast, now the Gustav Stickley Museum. The following color photos, by Ray Stubblebine, show the museum's ongoing restoration in progress as of summer 2000.

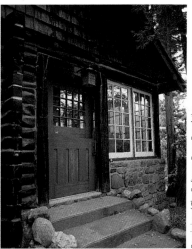

Wide Dutch door designed by Gustav Stickley leading from the porch to the outdoor eating area south of the house.

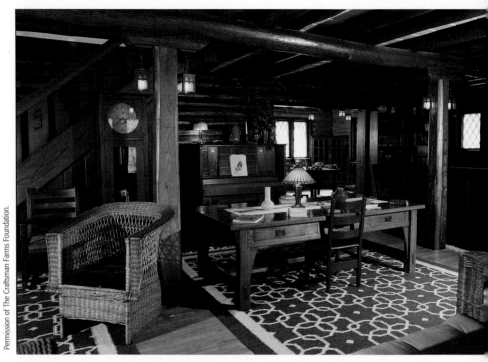

The central living room has recently been restored and furnished to resemble the 1912 decor as published in *The Craftsman*.

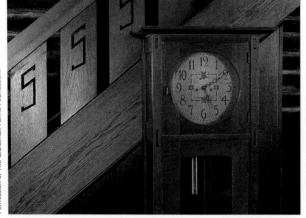

A tall clock by L. & J. G. Stickley stands in front of the distinctive main staircase. The "S" in the balustrade is Stickley's signature mark.

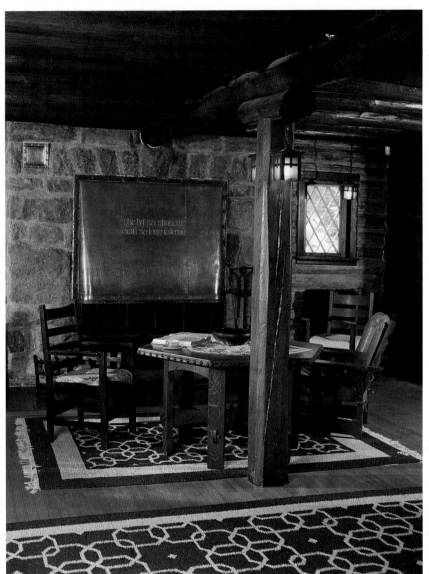

One of two massive stone fireplaces, here at the south end of the living room, features a copper Craftsman hood embossed with a motto: "The lyf so short, the craft so long to lerne."

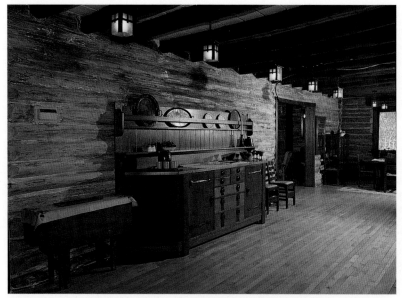

Stickley's custom-made large sideboard stands in the center of the long dining room. On it are some of the many newly acquired pieces of Arts & Crafts pottery and metalwork collected by the museum.

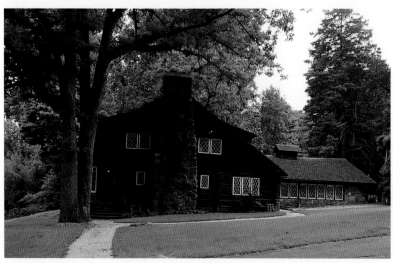

A landscape restoration program has enhanced the appeal of the rustic stone chimney and pathways leading to the north facade of the house.

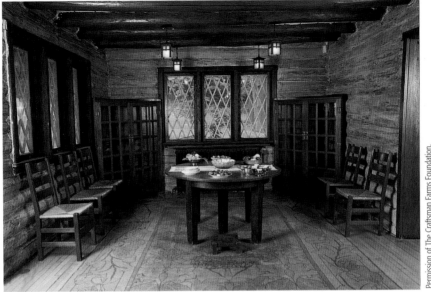

At the north end of the long dining room are two original Stickley corner cabinets. The round table and side chairs are set as shown in period photographs of the room.

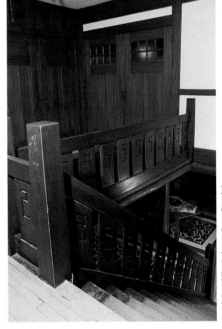

View of the second floor landing and main staircase.

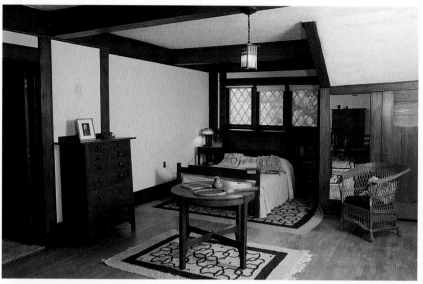

This bedroom is currently in the process of a restoration named in memory of Paul Fiore, the noted Arts & Crafts collector. Research by the curatorial staff has determined that many of the wood finishes were muted reds, grays, blues, and greens rather than the traditional brown tones of fumed oak.

The hearth of the second floor large bedroom is faced with blue Grueby tiles and features another original Craftsman copper hood.

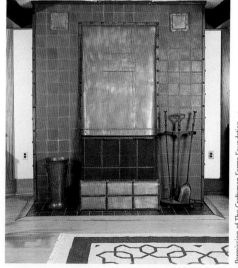

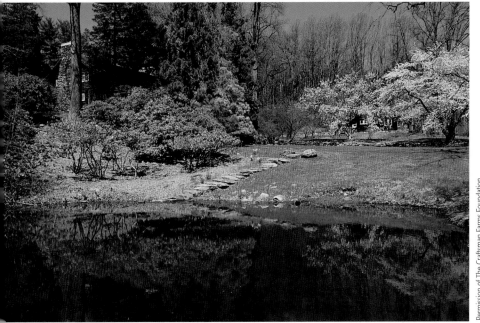

The pond at the southeast edge of the site has been cleared to reveal Stickley's original landscape design. Further restoration will restore period plant materials and other landscape features.

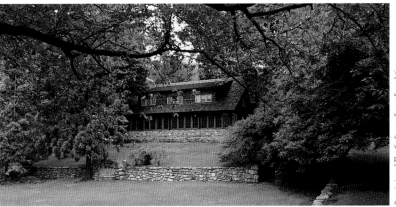

The stone walls below the east facade of the house have recently been rebuilt and pointed to restore the original configuration of terraces and enclosed gardens.

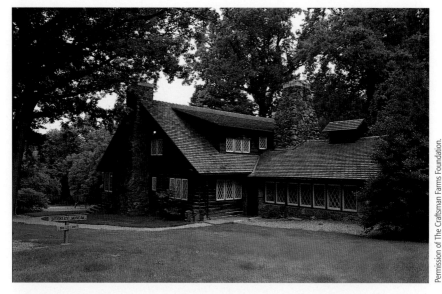

A view of the log house from the northwest shows the junction of the kitchen wing and the main building. The Ludowici tile roof was restored several years ago.

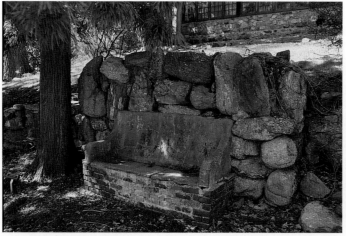

One of Stickley's rustic benches sits along the retaining wall of the lower terrace.

Because the unification of life and art was a central tenet of the Arts and Crafts movement and because Craftsman Farms was designed to promote this fusion, any study that attempts to interpret it must weave biography with art history, material culture with literary themes, social history with the analysis of technology and craft. The next four chapters are written in the form of thematic studies or narrative histories. Each theme is constructed to focus on a central problem in the interpretation of Stickley's work, but each is also designed as a kind of parable or moral dialectic. The overarching methodology employed here is borrowed from material-culture studies, literary criticism, biography, and architectural history. Using narrative analysis, each chapter attempts to unravel the meaning of the work from a different point of view, using evidence and criticism woven into a single fabric. The method follows a pattern that Jules David Prown calls "description, deduction and speculation," repeating itself in several iterations, adding significant facts, perspectives, and contexts to the story at each stage.[14] Generally, the theory underpinning this study derives from the broadening discipline of cultural studies that is increasingly followed by art, decorative-arts, and architectural historians. One of the advantages to this method is its breadth. Stickley's contribution to art, society, and culture was vast. His life, texts, and works of art are inseparable. This study uses comparative analysis to bring together the separate strands of Stickley's work and place them in the context of turn-of-the-century America.

The first subject under consideration is Stickley's complex and poorly understood character. Because he left few biographical details other than what was contained in his own writings, scholars have labored with inadequate information about how he developed his unique art. Where did this archetypal craftsman come from? How did the events of his life really inform his art, his ideas, his values? Because Craftsman Farms was the most personal of his artistic works—a house and compound built to mirror his sense of self—it is essential that biographical and psychological interpretation be applied to its study. When the psychological, textual, and material evidence are considered synchronically, we find striking parallels not

only between Stickley's life and art but also between his and leading contemporaries' complex psyches during the Progressive Era. Craftsman Farms provides a telling portrait of the man and his work, while also illuminating the predicament of the American artist at the century's turn. The following chapter takes up this inquiry.

There is additionally the theme of utopian socialism—the powerful communal impulse that guided William Morris and his many followers. Stickley conceived and executed his project during a period of immense economic, political, and social change in America. During the years between 1900 and World War I, reformers proposed utopian schemes to alleviate problems of poverty and social inequity, cultural disjunction, and artistic disaffection. Writers, politicians, social theorists, and artists addressed the need to provide meaningful work for the majority of Americans by reviving the medieval practice of handicraft production. Craftsman Farms was conceived in the spirit of these utopias, dedicated initially to causes central to the Arts and Crafts movement. Yet, because it failed to realize its goals, we are confronted with a scaffold of ideals rather than a successful social experiment. Synthesizing these ideas, chapter 3 offers a critique of both American society and the larger Arts and Crafts movement internationally.

No cultural artifact—whether a building, chair, or landscape—may be considered without regard for its physical and contextual characteristics. Craftsman Farms was located in the agrarian landscape of central New Jersey, a place settled centuries earlier by Native Americans and proximate to one of the largest concentrations of wealth in the country. When we consider its true place—its geographical, material, and social nexus—we understand more fully how its meanings intersect with those meanings of the culture at large. More important, perhaps, we can begin to comprehend the inherent qualities of place—the sensory, aesthetic, emotional aspects of the buildings and landscape—that give this work its special significance. As Clifford Geertz notes: "As interworked systems of construable signs . . . culture is not a power, something to which social events, behaviors, institutions, or processes can be causally attributed; it is a context, something

within which they can be intelligibly—that is, thickly—described."[15] There is a deep and pervasive history of the site to consider, a history that contributed to Stickley's project and that continues to inform our understanding today. The aim of chapter 4 is to provide such a "thick description" of Craftsman Farms, drawing meanings out of its social and physical space, its stratified cultural landscape. The model here also draws from what one historian has called a "biography of landscape," or an analysis of the ways in which human actors mold and interact with the natural world. Extensive description of the buildings and artifacts at Craftsman Farms leads to a deeper understanding of the ways in which designed objects are influenced by culture, place, and materials. Analysis shows that Stickley's aims were not always realized by the buildings and spaces he created in New Jersey.

Finally, Craftsman Farms poses a direct and significant problem of interpretation for the historian of art, culture, and environment: it is a work of architecture that seeks to circumvent a traditional connection to building and design in favor of a more tenuous link to handicraft and vernacular construction. Stickley strove throughout his career to create artifacts that appeared to spring from popular, unself-conscious sources, that is, out of a universal well of handicraft knowledge and structural logic. Yet, each artifact he designed and fabricated was fashioned under strict personal control—the handicraft connection between designer and maker was intentionally blurred in Stickley's works. When we consider the more complex assemblage of buildings and spaces he created at Craftsman Farms, even more questions arise about the dichotomies between design and craftsmanship, buildings made in a vernacular context versus those structures designed and drawn by architects. Chapter 5 examines these often contradictory impulses, not only in Stickley's Craftsman Farms designs but also in his furniture and extensive series of Craftsman houses.

When this complex, thick assemblage of information—including deductions and speculations—is complete, we will reconnect the pattern of narratives and themes into a final weave. The quiltlike variety of interpretive and historical information may then be assessed in terms of Stickley's

built realization at Craftsman Farms. The answers to this larger parable—
moral and aesthetic speculations about the nature of Stickley's art, life,
and society—may then be placed into the voids among his texts, his life,
and his art. What emerges is like the lessons given in a parable: not defini-
tive but provisional, an understanding born out of further questioning and
speculation.

2

# Persona

THROUGHOUT his multifaceted career Gustav Stickley fashioned a
malleable persona that supported his endeavors as artist, designer, re-
former, and public figure. Hans Sachs, the German Renaissance crafts-
man and folk hero, was an early inspiration for Stickley's idea of "the
Craftsman" (fig. 4). Poetic descriptions of the traditional trades and handi-
crafts abound in Stickley's magazine.[1] He even developed a distinctive
shop mark, the joiner's compass, and motto, "Als Ik Kan," to distinguish
his furniture and decorative art objects, but insisted on changing them
slightly from year to year. When examined in the context of his work and
his times, this multiple persona sheds considerable light on Stickley's ma-
ture period and his ideas for Craftsman Farms. Indeed, everything he en-
visioned for his utopian complex in New Jersey seems to connect directly
with one of his adopted identities. This chapter analyzes the characters
most obviously present in his personality: the German American immi-
grant, the farm boy, the businessman, the wood craftsman, and the vision-
ary intellectual.

Biographers of Stickley's contemporaries—figures such as Frank Lloyd
Wright, John Dewey, Herbert Croly, and Woodrow Wilson—have increas-
ingly noted a polarity between their subjects' idealistic utopian visions and
bitter personal contradictions. Progressive Era leaders faced an America at
once arching toward democratic fulfillment of the promise of equal op-
portunity for all, and torn asunder by the cultural and social contradictions
of capitalism. These men straddled two worlds. Their childhoods were
marked by personal struggle in a traditional, agrarian society in which

4. Woodcut showing traditional trades. "Der Schreiner," from *Standbuch* (1568), in *The Book of Trades*, by Jost Amman and Hans Sachs (New York: Dover, 1973).

family, church, and community were unified and comprehensible. In adulthood they faced a fiercely competitive, fast-paced modern world in which media, communications, transportation, and business were rushing forward, exploding the traditional social order. Resolving the psychological and personal contradictions between these two worlds was crucial to this generation, not only for the formation of the self but also for the stability of society as a whole.

Artists, intellectuals, and social and political leaders shared a common belief in the potential of individual action as an agent of social amelioration. Wright's Usonian house—a building that dug roots into the agrarian dream of individuality and self-fulfillment while reaching for a modern, technological solution to society's problems—was his ultimate attempt at

resolution. Dewey's University of Chicago Laboratory School, his wish for a unification of the material and intellectual worlds through experience, and his intense belief in liberal democracy were equally direct attempts at reconciliation. As one biographer contends, John Dewey struggled throughout his life with the problem of "how to resolve the chasm that seemed to separate the material and moral sciences."[2] Stickley addressed a similar problem in his struggle to make craft and everyday life a seamless experience.

American political thinkers and activists faced perplexing dilemmas in the reconciliation of capitalism with social equality. Pressing for reform in economics, politics, and international affairs, leaders such as Woodrow Wilson failed ultimately to control public opinion, the forces of monied interests, and the vicissitudes of international diplomacy during the uncertain years after 1900. Some have found fault with their character, others with their clan. The Brahmin class was surely fraught with internal social and psychological conflicts arising out of challenges to its oligarchy at the century's turn. Jackson Lears suggests that they were beset with a pervasive antimodernist bias amounting to an affliction. Michael Kammen argues that Americans of this generation came to terms with the tensions between modern progress and the Old World through the reinvention and transformation of traditions already present in the surrounding culture. I have maintained elsewhere that Americans embraced an eclecticism of domestic ideals largely in order to have the best of both worlds—technology and tradition, the vernacular and the modern, the comforting hearth and the labor-saving machine.[3]

Gustav Stickley did not come from the oligarchy that ruled America in 1900, but he aspired to it and sought to influence it by example and popular opinion. He was in many respects an outlander who moved gradually toward the center of his culture. An immigrant in the relatively open society of the frontier, he made his way forward by direct, pragmatic action. Much like the charismatic religious leaders of his times, he mirrored society's deepest hopes and fears. Did he invent himself, or was he made by the popular will of the movement he led? Only a closer analysis of this complex personality will tell.

## Forty-Eighters

One of the largest nineteenth-century migrations of Germans from central Europe occurred between 1820 and 1860. More than a million of these immigrants came to the United States seeking economic betterment, political and religious freedom, and a new way of life. Gustav Stickley's parents were among them. Leopold (born 1821) and Barbara Schlager (born 1838) Stoeckel were natives of Baden, in the southern area of what is modern Germany. After emigrating to Pennsylvania, Barbara Schlager met Leopold Stoeckel and married him in 1847. Census records indicate that they came to Wisconsin between 1848 and 1851.[4]

The year 1848 was fateful in the histories of both modern Germany and the state of Wisconsin. While those seeking a unification of the principalities that had ruled the German-speaking areas of Europe struggled in vain to form a stable parliament in Frankfurt, Wisconsin succeeded in shedding its frontier status as a territory. Statehood was achieved during the year that historians have identified as the center of the great antebellum wave of German immigration to the United States. Between four thousand and ten thousand political refugees fled the internal strife that followed the Paulskirche congress of Frankfurt.[5] Fearing for their lives as forces from Prussia, Saxony, and Bavaria cracked down on dissidents, Germans came by ship through New York and Philadelphia, New Orleans and Galveston, making their way to a belt of midwestern farming territory on the upper Mississippi and Missouri Rivers. They settled in St. Louis, Milwaukee, Chicago, and Buffalo. They built breweries, manufacturing dynasties, and mercantile empires. They tended farms and taught in rural schools. They voted as a bloc, generally siding with the new Republican Party against slavery and the Jacksonian Democrats. They established one of the most stable economic and social armatures in the young republic. They were known as the "Forty-Eighters."

Wisconsin attracted one of the largest and most successful German communities. The state's rich agricultural and mineral resources, its open land policies, and its hardy climate drew ambitious settlers. The state even published "official" pamphlets in German listing advantages of life in the

northland, which were distributed in Europe. The first of three waves of German immigrants came between 1845 and 1855, initially from the southwestern states: Hesse, Nassau, Rhineland, Pfalz, Baden, Württemberg, and Bavaria.[6] Settlers either came to Milwaukee (the German Athens), which in 1850 had a population of some twenty thousand, or pushed on to the central counties of the Wheat Belt to take up farming.[7] Life was difficult on the prairie land, but the German families showed both grit and organizational cleverness as they dealt with the uncertainties of the frontier (fig. 5). Like many farmers, they began with log dwellings and primitive farm structures, gradually building more permanent accommodations as their production increased. With little money, they were compelled to depend upon a cooperative barter system in order to build their houses and begin their farms. Ironically, perhaps, the dwellings they constructed were

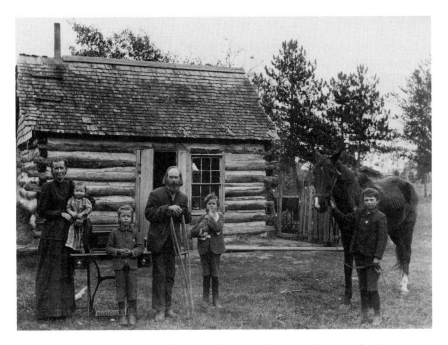

5. Wisconsin farm family at Black River Falls, circa 1895–1910. Courtesy the State Historical Society of Wisconsin, Visual Material Archives.

introduced into America by their ancestors in the early eighteenth century, but had long since been identified with the Anglo and Scotch-Irish conquest of the western territories.[8]

The Forty-Eighters came to the frontier not only with building skills but also with many other talents and traits that contributed greatly to the development of the Midwest. In Wisconsin two resources were developed and exploited that would set the stage for America's postbellum economic explosion: lumber and wheat. In the decades since the opening of the territory, the state's abundant hardwood and softwood forests were yielding significant production, accounting to nearly 25 percent of the total state economy in 1850. Wheat production in the fertile south-central region was also on the rise, tripling in the years from 1849 to 1859, and doubling during the following year alone to reach a record 27 million bushels. Wisconsin was the leading grain producer in the Northwest in 1860 (fig. 6).[9]

The region's agricultural and lumbering economies were sustained not only by direct farm and logging labor but also by local craft industries that made and maintained supporting technology. Cyrus McCormick's threshers had come to the prairies in 1847, revolutionizing wheat production; machinists were required to fabricate and maintain the new farm equipment. New labor-saving machinery for sawmills also needed maintenance. The Forty-Eighters came from an Old World society that valued craftsmanship, hand skills, and machine know-how. Their disciplined work ethic and strong social cohesion made them perfect citizens in the frontier outlands, where self-sufficiency was valued. Their organization, ingenuity, and muscle helped build Wisconsin's economy in the years around the Civil War. By 1900 more than 34 percent of the state's 2 million residents were of German ancestry; in some counties they numbered more than 60 percent.[10]

Scholars have noted other traits that are less tangible but no less important to understanding the contributions made by German Americans to the new nation. The Forty-Eighters and other Germans who followed in migrations up until 1888 were among the quickest immigrant populations to adopt American ways. They learned English and spoke it among themselves; often Anglicizing their names, these refugees turned away from

6. Cabin and valley in central Wisconsin, circa 1890. Courtesy the State Historical Society of Wisconsin, Visual Material Archives.

their old land and language to embrace a new country.[11] They were politically and socially active, forming clubs for singing and turnverein activities and voting in large numbers in local and national elections.[12] Perhaps most significant for the Stickley character, they were idealists who saw promise in their new land and were not afraid to change its institutions.

Germans made significant contributions to education, helping to form a successful American system of public and private schools during the nineteenth century. "The Forty-Eighters did not consider the public schools which they found in the United States to be generally suitable for educating the type of citizen who would think and act independently," Bettina Goldberg observes, "an essential for the functioning of a republican and democratic social system."[13] Rather, they brought the Froebel kindergarten system to the United States and employed other forward-looking methods in their teaching pedagogy. A substantial number of elementary school teachers were German born or from second-generation families in the late nineteenth century. Strong education was the cornerstone of character development and the key to success among German American families.

It is ironic that Gustavus Stoeckel could not avail himself of a traditional Old World education. His family settled on the outer edge of the Wisconsin frontier, only a stone's throw from the gorges of the St. Croix River in Polk County. There were few other settlers—farmers seeking new tracts of prairie or lumbermen cutting in the Northwest. Home tutoring and a one-room schoolhouse were his only options. So this boy made due with whatever intellectual stimulation could be gotten on the prairie, proceeding through the eighth grade in the American system. But to a German American the absence of book learning must have left a burning curiosity, a psychological void that would eventually need to be filled.

Stickley's German American heritage contributed much to his eventual success in a new society. Like many second-generation immigrants, he was fiercely patriotic and intensely committed to his adopted land. He valued honest, diligent labor, but also had great respect for learning and intellect. He was a social progressive, but could not warm to socialism. In family matters he remained a staunch traditionalist, clinging stubbornly to Old World attitudes toward women's roles and paternalism. And, like the Old World *freigesprochen*, he patiently crafted his objects and his life with an abiding belief in the redeeming power of work.

## Farmer Boy to Businessman

> The farmer boy is not given to theorizing about his work, but he soon
> learns to accept without question the fact that certain things have to be done
> and that the best way is for him to get right at it and get them done as soon
> as possible.
> —Gustav Stickley, "Craftsman Furniture"

The pervasive autobiographical columns published in Stickley's *Crafts-man* magazine between 1901 and 1914 are filled with romantic descriptions of farm life and arguments about the vital need to save U.S. agriculture as the backbone of the national economy. Stickley's first stable identity was formed on a family farm in the Midwest. Despite the privations and hardships of his frontier upbringing, he took great pride as an adult in his agrarian beginnings.

Striking outward from Pennsylvania in about 1848, Gustav Stickley's father brought his family to the far-western edge of the Wisconsin territory to find fertile land and to seek opportunities as a mason on the frontier logging routes of the St. Croix River. Osceola, the first county seat of Polk County, took its name from an Algonquian word meaning "to drink from black waters." The township was platted in 1855, using the standard six-mile square sections of the Jeffersonian grid, comprising some forty-two thousand acres.[14] Flour mills, a school, and a Methodist church formed the center of the town. Small log buildings and frame houses made up the rest of the settlement along the picturesque bluffs of the river. Following a group of pioneer settlers, Leopold Stickley purchased a tract of forty acres for approximately $1.25 per acre and laid out a farm with four acres under cultivation on the south side of town.[15]

He and his wife produced a typically large Old World family, with the children contributing to farm labor. Gustave, their first-born son, was born in March 1858.[16] Among their other children, Albert (b. 1862), Charles (b. 1860), Leopold Jr. (b. 1869), and John George (b. 1871) all became furniture makers. Of three girls born before 1870, Mary (b. 1851) was the nearest to Gustave's age.[17] Eventually, the household was to comprise eleven members, including parents.

Stickley's childhood and adolescence were spent on an isolated frontier farmstead, in circumstances that cannot have been easy for any boy. Unfortunately, there is little primary-source evidence to substantiate Gustav's recollections of his childhood. What is known has to be cobbled from recent oral histories, recollections of his brothers, and a smattering of corroborating evidence in archives. Stickley shared the experience of an agrarian childhood with a majority of his contemporaries in Victorian America. The Midwest and South were growing rapidly as a result of the influx of immigration and explosion in agricultural production from 1840 to 1860.[18] Agricultural development meant opportunity for new Americans such as the Stickley/Stoeckels, as well as for easterners seeking a better life in the fertile western plains.

The experience of childhood on a farm was the normative one for many Victorian families, uniting diverse ethnic and geographical subcultures. The myth of childhood discovery and self-determination became connected in the popular imagination with the struggle to create "little cabin homes" in the wilderness. Farm life in the Midwest was chronicled by numerous writers from the centennial years until the early twentieth century. Books such as Frank Nowlin's *Bark-Covered House; or, Back in the Woods Again* (1876) and the *Little House* series by Laura Ingalls Wilder (1930s–40s) mark a genre of children's fiction that touched a deep chord in the heart of America. Whereas Wilder painted a numenous picture of her family's first log dwelling, Nowlin saw the process of felling trees to clear the land and building the cabin as a boy's rite of passage in the wilderness. "Father brought his axe from New York state [to Michigan]; it weighed seven pounds; he gave me a smaller one. He laid the trees right and left until we could see the sun from ten o'clock in the morning till between one and two in the afternoon," he recalled. After clearing the land and stacking logs for the new house, "men came out from Dearbornville to help him raise them. He then cut black ash trees, peeled off the bark to roof his house, and after having passed two weeks under Mr. Pardee's hospitable roof, we moved into a house of our own, had a farm of our own and owed no one."[19]

Nowlin's description of the hard life of New York and Michigan farming in the 1840s echoes that of Gustav Stickley's family in Wisconsin. Despite privation there was immense freedom to be found in the making of a farmstead out of the forest and great satisfaction in seeing the first harvest. As Stickley remembered it, a frontier boyhood taught self-sufficiency.

> Unhindered and unhelped by the complex details of a more civilized society, we worked out our own plans and problems, provided for our material household requirements as well as our social needs, embodying in our pioneer group the characteristics of a miniature community. We made our clearings, built our cabins, raised our own vegetables and made our own clothes. We depended very little on outside supplies. We were cooperative and yet individualistic, for each new emergency threw us on our own resources, developed ingenuity, skill, patience. Whether I was working or playing, felling trees or making whistles from their bark, hauling logs for the fire or making untaught some simple piece of furniture for the log home—whatever it was, I was learning unconsciously the lesson of the pioneer. I was developing my power of seeing clearly, deciding promptly and acting practically, doing my own reasoning instead of following precedent, learning in short, to think for myself.[20]

That fierce sense of individuality and self-direction was to remain with Gustav Stickley for the rest of his life. The lesson of the pioneer—to depend upon oneself—guided his decisions and his art. In keeping with his father's heritage, he must have seen the outside world and its society as things to be conquered through ingenuity and hard work.

Stickley's views on nature and culture were likewise formed during his boyhood in Wisconsin. There he would have come to know Native American wisdom and folklore about the natural world, and to respect the intuitive knowledge gained by direct experience with the forces of nature. "We instinctively felt the beauty of Nature's scheme," he wrote of his childhood memories of the seasons. Winter brought "the promise of skating and coasting," spring heralded "the swelling of the buds,—and best of all, the tapping of the trees for maple sap, and outdoor sugar camp." Contrasting with his bitter memories of lime mortar and stonework, these Currier-and-Ives images connect to Stickley's innate romanticism, his attraction to

country life. "The smell of a forest today brings back to me my whole childhood," he reflected while at Craftsman Farms, "with all its delight in woodland life." But that life was to come to an end with the cruel abandonment he felt when his father separated from his mother in 1869 and he was forced to quit school a year later.[21]

The family, including eight children, sold the farm in Osceola and moved downriver to the larger town of Stillwater, Minnesota, where they lived for four years (sometimes with their father, despite his estrangement). Gustav began his apprenticeship as a cabinetmaker in Minnesota to augment the family income. Even in this larger and more prosperous frontier town, Leopold could not support his family. In 1875 or 1876 the couple separated again. Barbara Schlager, Stickley's mother, turned immediately to her own family for help. Her brother, Jacob Schlager, purchased a train ticket for her and six children that brought them to the small town of Lanesboro in northeast Pennsylvania. It was there, in the river valleys linking Scranton's coal fields with the farms of Binghamton, New York, that Stickley found a second identity as a wood craftsman and businessman. He came to depend upon his uncle's beneficence and to draw out of him-

"Plain wooden Chairs for the Kitchen"

"Cane-seated Chairs for the Rest of the House"

7. Chairs made and sold by the Brandt Chair Company during Gustav Stickley's employment in the 1880s. Stickley, *Chips from the Craftsman Workshops*, n.d., n.p.

self a saving strength. The necessity of providing for his large family—by hauling logs to market, making chairs, or managing a small store—gave Gustav his self-confidence and faith in business sense.

The story of Stickley's progress from boy entrepreneur and wood craftsman to business tycoon is only slightly better documented than his years on the farm. His mother purchased a small house in Lanesboro, where she supported her sons in their apprenticeships at the nearby Brandt furniture factory. What is known of the period from 1875 to the early 1890s suggests that, like a good German clan, "Gus" and his brothers Charles and Albert worked cooperatively to better their circumstances, with the eldest taking on the role of paterfamilias. But Stickley's strong ambitions to become more than just a chair maker were apparent from late adolescence onward. The Brandt factory expanded from a small building to a large three-story building equipped with steam-driven machinery for furniture production. By age twenty-two Gustav had become the foreman and manager of the Brandt Chair Company, an enterprise capable of producing eight thousand dozen chairs in a single year (fig. 7). In the process he learned to turn chair legs on a lathe, to prepare and finish wood, to correctly assemble and join furniture components, and other aspects of the furniture business. He and his brothers remained with the company until 1884, when they opened their own family business, a store and small factory, in Binghamton, New York.[22]

The four decades following the Civil War were among the most economically volatile years America has seen. Financial panics struck virtually every ten years, plunging the country into recessions. But there were also spikes of progress and spectacular generation of new wealth. Stickley's life mirrors these upward and downward cycles. His own recollections of the years of trial and error smooth out the bumpy path—as he tells it, he was as naturally gifted at business as at making chairs.

Stickley later saw his life as a series of decisive, adventurous, and largely successful actions that ultimately led him to national prominence. "Seeing clearly, deciding promptly and acting practically" was his creed. Unfortunately, the record indicates that his vision was not always as clear as

he remembered—his impetuosity led to a number of missteps. One of these blunders may have been his marriage. Eda Simmons, the seamstress daughter of a cart man, met Stickley in Susquehanna, Pennsylvania. Falling in love with the dashing young furniture salesman from nearby Brandt, she corresponded with Stickley, purportedly using the local milkman as an intermediary. After a short courtship Gustav and Eda were married on September 12, 1883, in the local Methodist church.[23] Six months after taking on this new responsibility, Gustav left his secure managerial position and moved his new bride to Binghamton.

In a venture financed by his uncle, Gus and his two brothers Charles and Albert opened a store selling Brandt's furniture as well as the parlor "suits" of reproduction pieces from the booming Grand Rapids factories. They also repaired furniture and sold their own mattresses. But despite an ambitious marketing campaign and novel sales ideas, Stickley Brothers Company did not fare well in the competitive environment of central New York. Gustav looked back on his first independent venture with typical Algeresque pluck—necessity became the parent of his efforts at creating handmade furniture rather than selling the inferior machine-produced products of the Victorian marketplace. Using excess capacity from lathes used to fashion broom handles, Stickley created old-fashioned chairs for sale in his own store. In a famous quote from an early Craftsman publication, he explained how the handicraft process became a revelation:

> I hired the use of this [lathe] and with it blocked out the plainer parts of some very simple chairs made after the "Shaker" model. The rest of them I made by hand, with the aid of a few simple and inexpensive machines which were placed in the loft of the store. All we had was a hand-lathe, boring machine, framing saw and chuck, and the power was transmitted by rope from a neighboring establishment. The wood in shape was dried in the sun on the tin roof of the building. The very primitiveness of this equipment, made necessary by lack of means, furnished what was really a golden opportunity to break away from the monotony of commercial forms, and I turned my attention to reproducing by hand some of the simplest and best models of the old Colonial, Windsor and other plain chairs, and to a study of this period as a foundation for original work along the same lines. . . . This was in 1886, and

it was the beginning of the "fancy chair" era. The reproduction of the Colonial designs soon became popular, as these "fancy" chairs and rockers proved a most satisfactory substitute for the heavy and commonplace "parlor-suits" of which people were beginning to tire.[24]

This telling passage underlines both the pragmatic and the idealistic sides of Stickley's character. He needed to distinguish his small company from the crowded field of merchandisers and to find a new market niche. Whether he made money from this venture is not known, but he clearly saw the step as a move toward independence and self-sufficiency. The Shaker chairs showed him the virtue of simplicity in design, while the colonial models sold well enough to sustain his business. This platform of pragmatic yet individualistic endeavor gave Stickley the confidence to press onward with his vision for a new kind of furniture.

But the time was not yet right for the realization of this dream. The labor unrest of 1887 and later panic of 1893 were signs that America's economy and society were moving in contradictory directions toward an uncertain resolution. Stickley and his brothers split up and went separate ways to find their own economic stability. In order to support his growing family, Gustav exploited his business and managerial skills in several transitional jobs. In 1888 he and brother Albert became officers in the Washington Street Asylum and Park Rail Road Company, an electric trolley car line in Binghamton. Shortly after this venture failed, he moved his family to Auburn, where he served as manager of manufacturing at the New York State Penitentiary from 1891 to 1893. Evidence suggests that these years were difficult for Eda and her two daughters, Barbara and Mildred, as Gustav made his peripatetic forays into different business schemes.[25]

Stickley finally managed to stabilize his business aspirations in 1894, when he began a partnership with Elgin Simonds in nearby Syracuse. Two years before the pair had purchased twenty-eight lots of land in nearby Eastwood that would serve as a site for their furniture factory. Over a period of several years they gradually built a manufacturing business, producing and marketing reproduction furniture in a number of eclectic

styles. Initially, Stickley commuted between Auburn and Syracuse, later taking up residence away from his family in the Yates Hotel, where he met Irene Sargent (a Syracuse University professor) and began more seriously to read the writers of the English Arts and Crafts movement.

The culmination of his odyssey from humble roots as a German American farm boy to independent business owner came in 1898. Stickley, at forty, dissolved his partnership with Simonds (though he maintained business relationships with him in subsequent years) and formed his own Gustav Stickley Company with the aim of producing original furniture that would proclaim its "structural idea" and throw off the shackles of historical ornament. In a bold announcement to the trade and world at large, the company purchased an advertisement in the December issue of the *American Cabinet Maker and Upholsterer*. It would show its first line of "medium and low priced upholstered and wood seat rockers and chairs" at the annual national exhibition in the Pythian Temple at Grand Rapids, Michigan. Within three years the business would achieve spectacular critical and commercial success, launching Stickley on a trajectory to national fame.[26]

Woodcraft

I had always been interested in wood, even before I became interested in furniture, for as a farm boy out in Wisconsin I used to make wooden ax helves, yokes for the oxen, runners for the sleigh—whatever happened to be needed for the task at hand. In fact, in the making of these rough farm implements lay the germ of what I have accomplished in later years. After farming I took up stone masonry, and it was the hard daily labor with this stubborn material that made me appreciate so keenly the responsive, sympathetic qualities of wood when I began afterward, at the age of sixteen, to learn the cabinetmakers' trade. It was like being with an old friend, to work in wood again!

—Gustav Stickley, "The Craftsman Movement: Its Origin and Growth"

Of all the identities that Stickley adopted in the course of his life, none came closer to the core of his being than the wood craftsman. As he passed his "second childhood" in old age, his daughter Barbara remembered

three Shaker chairs that he made for his grandchildren and how his experiments with stains and finishes resulted in clogged drains in their Syracuse house.[27] Like many gifted artists, this man was able to see and feel the inner properties of his medium. His ability at once to empathize and intellectualize the qualities of this material contributed much to his success in creating a new style of furniture. But his identification with the native forest, the trees of America, and the grain and surface of oak went even deeper than a craftsman's curiosity. Woodcraft became a universal metaphor for life and art.

The reasons for Stickley's acute identification with wood and its workmanship are complex, as are the meanings he himself associated with his craft. On one level, he saw woodworking as a "feminine" counterpart and foil to his father's trade, stonecutting or stonemasonry. Freudian interpretations aside, there is little reason to doubt that the boy had conflicted and ambivalent feelings toward his father even before his abandonment. Thus, his early attraction to woodworking was a way of rejecting his father, establishing an independent sense of self, while also following the German tradition of male validation through handwork.

This persona also uniquely situates Stickley in his time and place—a true wooden age in Victorian America. The rise of industrial capitalism, the Arts and Crafts movement, and the forests of Wisconsin become the axle around which wood and handicraft revolve in Stickley's narrative life.[28] If pattern design and poetry were the center of Morris's complex life activity, Stickley returned inexorably to the tree and the design of his furniture when he needed the wellspring of inspiration.

America's lumber industry was in its heyday during Stickley's lifetime. By 1856 the Great Lakes area had become the center of a monumental trade—six miles of Chicago's lakeshore were occupied with lumberyards, and twice that much a decade later. In 1890 U.S. sawmills produced lumber goods worth a value one-third greater than the output of all refined metals produced that year. In 1906 it was estimated that the country's lumber industry cut "approximately 40 million feet, board measure, of lumber, 11 billion shingles, 100 million railroad ties, 4 million poles, 20 million

fence posts, 170 million cubic feet of round mining timbers, 3 million cords of pulpwood, 1½ million cords of tanbark, and about 100 million cords of firewood."[29]

Wood joinery was Stickley's lifework, and through it he formulated his views of the relationship of labor to craft and machines to artistic production, and his attitudes toward creativity. He lived during a period of rapid industrialization in the furniture industry. In parallel with the transformation of wood production there came an explosion in consumer goods, especially products designed to enhance domestic comfort and convenience. Machines made the fabrication of household objects, especially furniture, less labor intensive and spurred the proliferation of new products, styles, and types. But the machine had its darker side, portrayed as a destroyer of honest labor and handicraft by the English theorists

8. Back-knife lathe used in nineteenth-century furniture manufacturing. Courtesy the Winterthur Library, Decorative Arts Photographic Collection.

of the movement of which Stickley became a guru in America. He knew the force and capacity of woodworking machinery and used it to his advantage but was also keenly aware of its destructive characteristics.[30]

It is crucial to a balanced assessment of Stickley's contribution to the Arts and Crafts movement to understand the context in which he created his furniture. Paralleling agricultural technology, the decades from 1840 to 1890 witnessed the invention of numerous revolutionary woodworking machines: the spindle shaper, band and scroll saws, dovetailers, back-knife lathes, molding cutters, routers, shapers, carving machines, and embossers (fig. 8).[31] These tools greatly simplified carving ornaments, cutting complex shapes, turning legs and spindles, and other time-consuming procedures. Although these innovations did much to enhance productivity and increase variety, they had a negligible effect on the cost of furniture. As Michael Ettema points out, machines were used most in the manufacture of low-priced pieces, where margin and value were low. These ubiquitous, cheaply made items became the bane of Arts and Crafts critics. "If critics observed an increase in second-rate ornament on furniture in the second half of the nineteenth century," Ettema concludes, "it undoubtedly occurred. However, it resulted not so much from the evils of technology as from the increase in the number of people who could afford to buy only second-rate goods." From his years in the furniture business, Stickley knew the insidious effects of mass-market production and manufacturing for profit, and inveighed against those manufacturers who made objects for which there was no real need or purpose.[32]

The two-edged blade of technology cut both ways in Stickley's life. His first big break in business was facilitated in great part by the Grand Rapids–based furniture industry that he later condemned. Returning to the forestlands of the Midwest that had nurtured him as a boy, he triumphed among his peers in 1900, when his company exhibited in Grand Rapids. It was this national industry that praised the first Craftsman pieces and made possible Gustav's rise to prominence.[33] Funding from the Tobey Furniture Company of Chicago helped to get Stickley's company off the ground.

Grand Rapids, Michigan—which by 1890 had thirty-four major firms, more than six thousand workers, and annual sales of more than $7 million—grew to its stature as the center of U.S. production during the years of Stickley's maturity. Serendipity and location were the keys to the city's early success. It lay near the center of Michigan and proximate to the leading logging transport routes of the Great Lakes region. With a ready supply of various lumber species and laborers from nearby Detroit, companies began to proliferate in the 1870s and '80s. Strong national marketing and a growing demand catapulted the Grand Rapids firms to the top of the industry shortly thereafter.[34] Trade journals and catalogs, along with a network of salesmen and marketers, formed the armature of merchandising from which Stickley would benefit.

The Stickley brothers learned their trade in a small but by no means unique workshop that was connected to this expanding web of manufacturing enterprises in the late nineteenth century. "In the seventies," Gustav recalled, "all the furniture in ordinary use among people of small or moderate means was of the same type as that produced in our little factory at Brandt."[35] These smaller shops—located in Newark, Philadelphia, New York City, Chicago, Grand Rapids, and Gardener, Massachusetts, among other cities—generated a large volume of machine-produced furniture for popular consumption. In only the last two decades of the century did production consolidate into the larger, assembly-line-type corporations that are common today. Nevertheless, Stickley saw in the behemoth of industrial America and its consumer society a grave danger: the dissolution of household industries, individual artisanship, and the decline of what Morris called "the lesser arts." Just as he had done in rejecting stonemasonry, Stickley turned away from the business of furniture making to embrace the craft and true art of working in wood: "With the rage for cheap ornamentation," he wrote in 1906, "and the necessity for adjusting everything to an accepted standard, there was clearly no room for art or for individuality. Furniture making was manufacturing pure and simple, and before anything could be made as good as it was in the days of the old French, Flem-

ish and English cabinetmakers, it seemed to me that it would have to return at least partially to being a handicraft."[36]

Woodcraft was thus a rediscovery for this newly successful businessman—again he turned to his "old friend." When Stickley formed his new company, began designing his "structural" furniture, and adopted his distinctive shop marks, he was fabricating yet another persona while also returning to a psychic center. That character, his most famous, was "the Craftsman." He personified it not only through his furniture but also through the magazine he founded to propound his ideas and sell his wares.

When the first Craftsman pieces were designed and produced in around 1900, Gustav Stickley was undoubtedly entering his most intense and fertile creative period. He found in American oak a material perfect for expressing his new ideas and reveled in the experimentation that accompanied the first efforts at original furniture design, untainted by precedent or copying past styles (fig. 9). But we should not think that this master craftsman was following in the footsteps of his German lime wood–carving ancestors; Stickley was in all respects a modern designer who worked in collaboration with better-skilled tradesmen in his Eastwood shops. Handicraft did not mean long hours of personal labor on individual pieces; rather, Stickley supervised his workshop of joiners, finishers, and journeyman woodworkers to produce a variety of new designs in the atmosphere of an atelier.

What we know of Stickley's design methods suggests that he was something of an artist-inventor, not unlike Thomas Edison, Louis Comfort Tiffany, or other successful entrepreneurs of his time in America. Although he supervised the design of virtually every piece in his catalog, he was adept at utilizing the talents of his shop foremen, craftsmen, and others to create the best-possible pieces. Intensely competitive, he made every effort to distinguish his own work from the furniture of his industrious brothers, four of whom soon began their own firms. Harvey Ellis, a design genius who worked briefly for Stickley, certainly contributed much to his development.

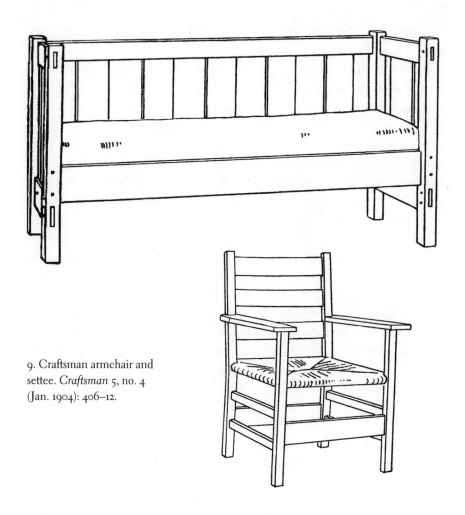

9. Craftsman armchair and settee. *Craftsman* 5, no. 4 (Jan. 1904): 406–12.

Stickley's daughter Barbara recalled that her father was a stickler for visual unity and proportion in all of his work. Shop draftsmen were employed to produce meticulous drawings of each piece to be used in manufacturing and patent applications and as magazine illustrations. The master experimented with variations on each design until it was perfected in the workshop. Stickley's early training in woodworking made it possible to direct the efforts of his staff efficiently, thereby producing an astound-

ing number and variety of designs during the peak period of Craftsman sales, from 1900 to 1910.

In his writings, Stickley focused on three aspects of furniture design that he considered crucial: joinery, structural lines, and finish. In all three areas his formal and tactile faculties were acute; woodworking training as a boy had taught him to appreciate the necessity for solid construction and fine finish. Stickley was familiar with all of the major species of American hardwood and softwood, and understood their salient properties. As Irene Sargent wrote for Stickley in the first major pamphlet on Craftsman furniture:

> We have set before ourselves the ideals of honesty of material, solidity of construction, utility, adaptability to place, and aesthetic effect. And it is by our failure, or our success in attaining these ideals that we demand to be judged. Our especial points of solicitude can be briefly summed up: *First*, the choice and treatment of the material employed; *Second*, the care used in construction, whether treated from the point of view of use, or of beauty.[37]

There has never been any doubt about the integrity of Stickley's furniture design according to these principles. This man understood wood as only a true craftsman can: as a material to be worked under a variety of conditions, absorbing flaws and idiosyncracies, to produce useful and beautiful objects. An example of this understanding is the subtle development of the Craftsman armchair: figure 9 shows a rush-seated armchair from 1904, probably designed earlier; figure 10 shows the classic No. 312½ armchair from the 1910 catalog. The basic design is quite similar, but the refinements make the later chair unmistakably Craftsman. Both stretchers and vertical members have been increased in size, thereby emphasizing structural mass and durability. The horizontal slats of the back have become vertical; the V-back and arms are subtly inflected to lessen the severity and cubic proportions of the chair, giving it just the slightest suggestion of bodily flex and muscularity. In the end, the piece achieves the strength and "structural" character that Stickley desired, while also empathizing with the human form and its utilitarian functions. In finish, the four standardized fumed-oak colors brought out what Stickley considered the innate beauty of the wood.[38]

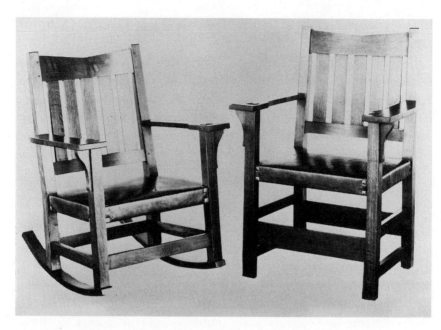

10. Craftsman armchair No. 312½ with rocker, from 1910 Stickley catalog. Courtesy the Winterthur Library, Decorative Arts Photographic Collection.

Woodworking provided Stickley with his most durable and meaningful persona. Through this craft he was able to distinguish himself from both the bourgeois makers of mass-market furniture and the captains of industry who dominated American society at the century's turn. Most important, however, it gave him access to the intellectual, social, and aesthetic ideals of a movement that had swept Great Britain during the 1870s and '80s. And through his association with the Arts and Crafts movement abroad, Gustav Stickley was cast in the last and perhaps most important of his many roles on the American cultural stage: the visionary intellectual. It was a part he was at first reluctant to play, but later came to see as his most powerful platform for effecting change in a turbulent, capitalist democracy.

## Intellectual and Designer of the World

Irene Sargent (1852–1932)—linguist, art historian, American folklorist, feminist, and teacher—first encountered Gustav Stickley in Syracuse during the late 1890s. Cleota Reed has demonstrated that Sargent was central to the development of a small Arts and Crafts cadre in Syracuse during the early years of the century. Its members included Stickley, the art potter Adelaide Robineau, Sargent, architect Harvey Ellis, and other central New York designers. Its locus was the Yates Hotel in the center of town.[39] Through this community of artists and intellectuals, Stickley came to know the literature and philosophy of the Arts and Crafts movement.

Although he suggests that he was a student of Ruskin during the mid-1880s, it is unlikely that Stickley applied himself to reading the theories of Arts and Crafts proponents until he came to Syracuse. Mary Ann Smith notes that his familiarity with English and continental work derives from a trip he took to Europe in 1898, following tutelage in French from Sargent. Both Smith and Reed stress that Stickley depended upon Sargent in the years around 1900 for much of his intellectual education and that it was she who provided the editorial direction for the first issues of the *Craftsman*. Marilyn Fish goes further to argue that Sargent, who wrote or edited the vast majority of the articles in the first issues of the magazine, was the guiding spirit who gave the magazine its substance, style, and intellectual quality and that Stickley was involved mainly as a publisher at this time.[40]

Sargent is a fascinating figure, no less complex or elusive than her more famous student. She joined the Syracuse faculty in 1895 as a professor of romance languages (she wrote and translated in no less than six), but subsequently taught art and architectural history at the school as well. A student of Charles Eliot Norton at Harvard and friend of Bernard Berenson, she was well versed in the writings of Ruskin, Carlyle, and Morris, as well as familiar with the work of many European artists in the decorative arts. Her championing of Robineau's pottery and support for Arts and Crafts societies were a reflection of her deep interest in social amelioration through

fine art. It is likely that she not only introduced Gustav Stickley to writings on the Arts and Crafts movement but also provided information and introductions to numerous figures who would later play key roles in the *Craftsman*.[41] Both a teacher and a friend, she was to push the businessman-craftsman toward a more public role in disseminating ideas through writing.

It is difficult to imagine Gustav Stickley becoming an intellectual without such a mentor. He was neither extensively educated nor particularly well read. Much of his adult life had been taken up with business. He had written little outside of business documents and advertising and would therefore have had difficulty with essay-style prose. His first publications, such as "The Structural Style in Cabinet Making" and *Chips from the Craftsman Workshops*, suggest that an editor was involved in writing the texts. Later work carries his more distinctively Germanic syntax, but was still likely ghostwritten by subsequent editorial staff such as Mary Fanton Roberts.[42] (One of Gustav's most consistent character traits was a tendency to absorb the work of others into his own sphere, without necessarily recognizing their contributions.)

The period of Sargent's involvement coincides with Gustav's intense design development of the first Craftsman pieces and with the initial (experimental) years of the *Craftsman* magazine, before it settled into a standard format around 1904 (fig. 11). The years 1901 and 1903 were signal ones: the former marks the publication of the first issue of the magazine and the lease of the Crouse Stables (Craftsman Building) in Syracuse; the latter marks a major exhibition on the Arts and Crafts movement in Syracuse and Rochester, sponsored by Stickley and Theodore Hanford Pond in which Sargent played the role of organizer.[43] The success of these public disseminations of his work led Stickley to believe that there was much to be gained by establishing a publishing organ and by writing about his work. For several years he followed Sargent's lead and learned much from her disciplined propaganda. When he absorbed what he needed, he struck out on his own as a writer, using other editors to fill her place.

VOL. XXI, No. 2      NOVEMBER, 1911      25 CENT

# THE CRAFTSMAN

"The lyf so short the craft so long to lerne."

"When ye have
gathered in the
fruit of the land
ye shall keep a
feast unto the
LORD."

F
A
H

A DEMOCRATIC VIEW OF EDUCATION:
BY WILLIAM ALLEN WHITE

THE HOUSE OF THE DEMOCRAT:
BY WILLIAM L. PRICE

LOG HOUSE AT CRAFTSMAN FARMS:
BY NATALIE CURTIS

11. Cover of the issue in which the first photographs of Stickley's buildings and activities at Craftsman Farms were published. *Craftsman* 21, no. 2 (Nov. 1911).

This pattern of behavior is familiar; Stickley had learned his woodcraft and his business skills in much the same way. He often used others to gain knowledge or power throughout his life. What is remarkable about the last persona—the visionary intellectual—is that Stickley would adopt an alter ego to help him sustain a character largely outside of his own personal experience. He found that William Morris's life and writings provided a deep well of inspiration for his own ambitions as an artist and reformer. Sargent conceived and wrote the first issue of the *Craftsman* as a tribute to Morris, but in so doing set Stickley on his path to becoming a similarly peripatetic "poet-craftsman."[44]

Peter Stansky, one of Morris's many biographers, called his subject a "designer of the world." The term is apt not only as a description of the astounding achievements of the English master but also as a broader epithet for the efforts of many Arts and Crafts reformers to mold their small societies into manifestations of a new order. Gustav Stickley began to see his empire as a complete world in itself as he read of the achievements of his English brethren. Morris's example showed him that simply making craft objects was not enough; the complete artist should also write about art and society, create opportunities for other artists, and set in motion the process of reform through political movements. As Sargent wrote:

> Morris evolved a system of household art, which has largely swept away the ugly and the commonplace from the English middle-class home. He so became an expert in what he himself was pleased to call "the lesser arts of life." He was a handicraftsman, an artisan self-taught and highly skilled in the technical processes of a half dozen trades. He disdained no apprenticeship however humble, no labor however protracted, arduous and disfiguring, in order that he might become the practical master of his work. The attainments of his genius, of his careful and intelligent study remain as lasting witnesses to the impetus and direction given by him to the arts and crafts of his time. . . . But it is not generally appreciated that his art and his Socialism were associated integrally with each other, or, rather, that they were but two aspects of the same thing. However, this fact becomes evident to any one who will follow his life which, in its intellectual aspects, although it was apparently subject to abrupt changes, was, in reality, a logical expansion of inter-dependent ideas.[45]

Stickley sensed that his own life might become such an expansion of "inter-dependent ideas" in the form of original furniture, decorative arts, architecture, philosophy, education, and social-political prescriptions. Between 1901 and 1904 he brought together for the first time all the components of a complete Arts and Crafts program, not unlike the one recently promulgated by his friend and rival Elbert Hubbard in East Aurora, New York. He launched his new furniture designs; he founded a popular publication that could disseminate intellectual ideas as well as tell the world about his new art; he joined with other artists to mount a major exhibition in Syracuse and Rochester, thereby elevating himself to a leadership role in the larger movement; and he even briefly experimented with a profit-sharing cooperative in his Eastwood workshops. In the midst of this flurry of activity, he understood that a truly national movement was under way and that it desperately needed leadership. Adopting his humble but distinctive shop mark—"Als Ik Kan"—and his "craftsman" persona, he used Morris's example to launch one of the most meteoric careers in American art. Putting himself forward as a spokesman and example through his columns in the *Craftsman*, he invited Americans of all stripes to share their "Hopes and Fears for Art" (to use a Morris phrase). And the more he spun his tales of his own life, his own dreams, and his experiences as an artisan and businessman, the more chairs and magazines he sold and the greater his popularity. Stickley captured the imagination of his readers with the media sense and homespun wit of a Will Rogers. More amazingly, he caught the attention of many of the country's progressive artists, writers, architects, musicians, poets, and intellectuals. Suddenly, he was a cultural leader.

Space will not permit consideration of the many facets of Stickley's writings or of his multifarious contributions to the political and artistic debates of his era. But there is no question of their place in his work; he became a theorist and intellectual figure of some stature and one of the most important figures in the international movement. After first publishing several autobiographical pamphlets attached to his furniture catalogs and authoring a few larger articles in the *Craftsman*, Stickley began to compose reg-

ularly for his magazine in the form of ghostwritten editorials and longer pieces in 1904.[46] For ten years he was regularly before the public as a voice for change. The more he published, the wider became his sphere of inquiry and the greater his confidence in his own ideas. Gradually, Stickley began to develop a rather comprehensive program for social, educational, and artistic reforms that he believed would transform America. Through utopian writings he became, like Morris, a designer of the world. It was a relatively short step to building that world.

Gustav Stickley's multiple personae were developed over the course of a complex, not to say tumultuous, lifetime. They represent stages of development of the self; in some ways they are distinct, yet sometimes they overlap. Rarely are they as clearly articulated as in the written works of the *Craftsman*. Yet, the traces of each role are present both in life and in art.

Erving Goffman in his classic study, *The Presentation of Self in Everyday Life*, presents a theory of social interaction based upon *performances*. This theory neatly describes the kind of activity that public figures such as Gustav Stickley "performed" in their daily lives in turn-of-the-century America. The individual, acting in a complex but definable cultural milieu, presents himself or herself to society in "characters" that can be marked and read by the culture at large. That culture may expand or contract, becoming a "region" of larger or smaller dimensions, and the role may change to address the new region. The truth of a performance lies in the relationship among the accepted codes of behavior in the world at large, the communication of acts by the performer to that social world, and the degree to which the performer has made his audience perceive an integral connection between the two—code and actor. Stickley's life is rife with "performances" that were meant to send clear messages to the society or region in which he acted at various times in his life—the family, frontier village, business community, intellectual and artistic cadre, and media culture.[47]

As a leader in late-Victorian America, Stickley faced a changing social landscape full of new challenges over the course of his lifetime. His mul-

tiple personae allowed for a range of new responses to the social conditions of the latter decades of the nineteenth century and made it possible for an immigrant to cast off his negative stereotype and embrace new, more acceptable, and more dynamic roles. Because he was not part of an established class or social group, Stickley was particularly prone to identity shifts—many immigrants chose to renounce or obscure their origins as they moved into more established social and cultural areas. By taking on a series of distinct characters, Stickley built a relatively resilient and easily presented "self" that served him for most of his life.

But the shifting and contradictory nature of society at the century's turn also presented inherent problems for the newly minted cultural leader. Stickley's writings and actions were acutely redolent of the surging dreams of a new bourgeoisie in America. As an actor on a stage that changed with the new social and cultural landscape of an emerging modern century, Stickley's character switched masks often—and unpredictably. Brendan Gill's biography of Frank Lloyd Wright posits the metaphor of a mask to describe the complex character of that great American designer, and it is not far-fetched to observe that his Wisconsin-born contemporary was nearly as malleable during the course of his life. But there is one tragic difference. Stickley's "performances," unlike Wright's, finally failed to sustain the illusion of an actor and his audience, a suspension of disbelief or code of secrets.

The parable of Craftsman Farms represents the dénouement in the arching drama of Stickley's artistic and personal development. In this story lies the ultimate and significant paradox of a craftsman's life. Each of the characters in Stickley's persona plays a vital role in the development of this idealized community. And the community itself contains a host of significant ideals present in American culture. To understand more about how Craftsman Farms relates to other utopias, we must look at the story from another perspective.

# 3

# Utopias

NORTH AMERICA has been a haven for utopian thinkers since the beginning of European colonization. As a designer of a new visionary community at Craftsman Farms, Gustav Stickley immediately connected to a deep tradition of religious, artistic, and political communitarianism in the New World.[1] Designing physical environments as model social experiments, the Pietists of Ephrata, the Shakers of New Lebanon, the Owenites of New Harmony, the Moravians of Bethlehem, and numerous other utopian communities established a heroic pattern of landscape and building that encouraged Americans to pursue their individual ideas for a better society.[2]

In her pioneering book *Seven American Utopias,* Dolores Hayden set out to chronicle the achievements of some of the earliest "social architects" who planted their visions in American soil. Focusing on the critical period between 1820 and 1850, she suggested that the Fourierists, perfectionists, Shakers, Mormons, and other communitarian groups "believed that social change could best be stimulated through the organization and construction of a single ideal community, a model which could be duplicated throughout the country." Similar model communities were envisioned by Stickley and a number of his contemporaries during the height of the Arts and Crafts movement.[3] This chapter explores several of the most pertinent communitarian experiments and educational philosophies that influenced his vision and then outlines his plans for a cooperative farm and school in Morris Plains.

Craftsman Farms was conceived and partially realized at a time when European and American artists were dedicating their lives as never before to revolutionary social change. Following the path of William Morris, dozens of decorative and fine artists sought to create oases of aesthetic life on the quasi-socialistic model of his Merton Abbey workshops. Though few succeeded in sustaining or expanding their visionary communes, numerous artist-craftspersons worked in the years surrounding 1900 to make art and life an inseparable experience, shared by forward-thinking individuals from all walks of life. It was a time when aesthetic utopias flourished in the midst of a chaotic, industrial era of surging capitalist enterprise.[4] Reform movements sought to unite art, industry, education, and society—drawing all back to the land.

Altrurian Visions

If one character came to symbolize the impulses that drove the aesthetic and political visionaries of turn-of-the-century America, it was probably the elusive "Traveler from Altruria" invented by William Dean Howells in the 1890s. In his widely read Altrurian "romances," the novelist and critic projected a future society free from the competition, social inequities, and violent upheavals characteristic of the nation in the post–Civil War decades.[5] In a plot reversal of the fantasy utopias presented in Edward Bellamy's *Looking Backward* (1888) and William Morris's *News from Nowhere* (1890), Howells's "Altrurian" voyager, Mr. Homos, comes to visit present-day New England from a far-off land of uncertain location and mysterious origin. The name derives from the word *altruism*, meaning munificent, selfless, or dedicated to socially beneficent pursuits.

It is particularly symbolic of turn-of-the-century U.S. society that Howells's visitor should light as an alien on American soil, rather than being carried through dream travel into distant realms in the future. The predicament of the American immigrant, reformer, artist, labor leader, and social critic was much the same—these individuals existed on the margins of American politics and business, far from the centers of power

and social control. Gustav Stickley and his reform-minded brethren were transplanted Altrurians who resonated with populist concerns and pursued the elusive goal of a just society.

Visions of a new society were in the air at the approach of the new century. The three popular utopian novels of Bellamy, Morris, and Howells shared several premises that were woven into many programs of the Arts and Crafts movement in America. The first was a belief in a society in which all groups were leveled into one mass community sharing common values. The second was a belief in the power and value of work as an expression of individual self-worth, creativity, and beauty. The last was a common view that capitalism, consumer culture, the unequal distribution of wealth, and predatory industrialism were the great evils of the modern world. Only through eradication of the economic and social inequalities of capitalism would society correct its ills, allowing individuals to realize their creative and social potential. At the center of reform efforts was "the labor question"—how to restore dignity and economic stability to the working classes.

Remarkably, all three authors presented utopias in which socialistic and communal values guided citizens, in which work was made "pleasurable" and social relations smoothed by lack of class struggle and status seeking. Published within ten years of the divisive 1880s labor troubles in both England and the United States, and in the wake of Marx and Engels's expostulation of communism, their common themes were endemic of a culture disillusioned with capitalism. But the American texts, unlike Morris's paean to socialism, did not fully embrace the radical destruction of the old social order. Morris's England of the future resembles a Rousseauesque, antiurban, and bucolic land directed mainly by natural law. Education, politics, property ownership, trade, sexual and family relations, and numerous other social concepts are stripped entirely of their traditional meaning as Old Hammond disabuses the narrator of his old views of the world. "The Change" comes about finally through violent revolution—albeit brief and cleansing—leaving little of the old order in its wake.[6]

In Bellamy's "nationalistic" utopia, America transforms itself into a giant, enlightened industrial monopoly, peopled by an army of satisfied workers who no longer need money, no longer reach for wealth, and work happily for the common good. A kernel of the individualistic strain of America's democracy is retained, an essence perhaps, just as the archetypal ethnic qualities of English culture persist in Morris's rather medieval view of the future.[7]

Howells's utopian vision is far more skeptical and is more poignant when compared with its reforming progeny—the art colonies of the succeeding decades. Although he can be considered a moderate socialist, Howells presented a critique of American economic and social inequities that was more pointedly critical than either Morris's or Bellamy's. Rather than bringing a citizen of the present into a new world, thereby changing (or redeeming) him, the novelist-critic imports a wise and disinterested observer to be his alter ego in the contemporary world. Mr. Homos is a Christ figure who provides a gentle but sharply ironic foil to the archetypal characters of Howells's American plutocracy. With his cool, critical eye, the Altrurian not only sees industrialism, consumerism, and labor exploitation as evils but also exposes the fallacy of the peculiarly American view that money can be a means of achieving individual liberty or collective good. "The friends of Altrurianization . . . will try to show that accumulated money, as a means of providing against want, is always more or less a failure in private hands; that it does not do its office; that it evades the hardest clutch when its need is greatest. They will teach every man, from his own experience and conscience, that it is necessarily corrupting," avers the prophetic Mr. Homos in *Letters of an Altrurian Traveller*. His words might well have been addressed to Gustav Stickley or anyone of a group of free-thinking American artists who saw utopia in capitalistic terms.[8] Their peculiar situation—of clinging to commercial values as they sought social change—is common to American Arts and Crafts theory but seldom exists in European contexts. Howells's writings represent the most incisive explications of this American dilemma.

In a critical scene at the center of the 1894 novel, *A Traveler from Al-truria*, the assembled group of plutocrats, led by the banker, presses Mr. Homos to define the ideal relationship among work, economy, and the common good. The Altrurian presents his subtle but sharp critique of the American situation by contrast to his utopia. "Nobody works for his living in Altruria; he works for others' living," he states. All citizens toil a few hours a day to free the entire society to pursue "the higher pleasures which the education of their whole youth has fitted them to enjoy." When the skeptical banker focuses on his own obsession (shared by his culture), the question of money is finally cast in high relief: "[D]oes it [money] or doesn't it degrade the work, which is the life, of those among us whose work is the highest? I understand that this is the misgiving which troubles you in view of our conditions?" he asks, and is answered with a "mixed" reply. "I should say," says the Altrurian,

> that it puts men under a double strain, and perhaps that is the reason why so many of them break down in a calling that is certainly far less exhausting than business. On one side, the artist is kept to the level of the workingman, of the animal, of the creature whose sole affair is to get something to eat and somewhere to sleep. This is through his necessity. On the other side, he is exalted to the height of beings who have no concern but with the excellence of their work, which they were born and divinely authorized to do. This is through his purpose. Between the two, I should say that he got mixed, and that his work shows it.[9]

Gustav Stickley and his Arts and Crafts colleagues were faced with precisely this dilemma—their work and lives "got mixed" in a struggle to reconcile purpose with necessity. As artists, Morris and Howells in particular were able to focus on this brutal and insidious condition—the capitalist consumption of labor, art, and aesthetic objects.

Morris and his American critics and friends directed their visionary works toward the amelioration of a host of social ills that chafed at turn-of-the-century artists no less than their working-class brethren. What is ironic about the fictionalized accounts of these new societies is that they so confidently prophesied a better world in the near future, and so res-

olutely inspired activists to found utopian communities that might galvanize others into national or even global reform. At Morris's death in 1896, efforts were under way in both England and America to bring his fantastical Nowhere to life.[10]

## News from England

Gustav Stickley made his seminal European trip in 1898, visiting both England and the Continent to view firsthand the advances being made in the decorative arts. He was already familiar with the work of major Arts and Crafts proponents through journals such as the *Studio*, the *Builder, International Studio, Deutsche Kunst und Dekoration,* and the American *House Beautiful.* Mary Ann Smith suggests that he was acquainted with the work of architects C. F. A. Voysey, Richard Norman Shaw, M. H. Baillie-Scott, and Philip Webb, and the furniture designer Ambrose Heal Jr. through publications. How much English Arts and Crafts design he saw firsthand is unclear, but his own recollections indicate that he made as thorough a survey as possible during not only the late 1890s but also several other visits to England in subsequent years. The figure who influenced him most directly was Charles Robert Ashbee (1863–1942).[11]

Ashbee's role as a catalyst for Arts and Crafts theorizing and activism alike cannot be overestimated. He was the only English designer to travel extensively throughout both the Continent and the United States, communicating directly with the most important figures on both sides of the Atlantic. His American lecture tours of 1896 and 1900 were comprehensive and influential, taking him to the East, Midwest, and West Coast.[12] A friend of Frank Lloyd Wright and direct disciple of Morris, he united the American and European ideals of the movement as no other individual was capable of doing. An architect, educator, craftsman, theorist, and founder of the Guild and School of Handicraft in 1888, this remarkable man was a fitting protégé of Morris, perhaps the only one of many who essayed to match his multifaceted genius.

Ashbee's lifework was centered on an experimental "guild" founded to expand upon the Merton Abbey and Kelmscott workshops, enlarging their social and education sphere to train and employ trade workers in cooperative handicraft production. Initially, the Guild of Handicraft was headquartered at Whitechapel, in London's East End. There, as many as 150 young men were recruited from the ranks of urban journeymen workers to be educated in traditional guild practices of silversmithing, cabinetmaking, carving, enameling, printing, gilding, and blacksmithing, among other crafts. With their guild training they would acquire a certain measure of aesthetic and intellectual education in the atmosphere of a self-contained commune. Art, labor, and daily life would be united in ways that Morris's Merton Abbey workshop had not accomplished. Distinct from the Art Worker's Guild—a loose, clublike association of master craftsmen and artists—and other mainly honorary organizations, this family of workers was a true social and artistic com-

12. Craftsman desk chair No. 308, from 1909 Stickley catalog. Courtesy the Winterthur Library, Decorative Arts Photographic Collection.

13. Two chairs designed by Charles Robert Ashbee and made by the Guild of Handicraft. *House and Garden* (1906). Courtesy the Winterthur Library, Printed Book and Periodical Collection.

munity. Stickley would have known of their accomplishments from his first London visit and from publications—they exhibited at major crafts exhibitions and at their own London establishment (figs. 12, 13).[13]

After incorporation as a profit-making business cooperative in 1898 (guided by a democratic Guild Committee but run mainly by Ashbee as honorary director), the group began to look for a country environment in which to locate its educational and production facilities. The English back-to-the-land or country-life movement was in full swing, and Ashbee was attracted immediately to the Cotwold villages of Gloucestershire and Wiltshire. As a member of the Society for the Protection of Ancient Buildings and the nascent National Trust, he was acutely concerned

with conservation of the physical and environmental heritage of rural England. He found an ideal setting in the hamlet of Chipping Campden, a country village of less than fifteen hundred inhabitants. Accommodations for the guild were found at an abandoned silk mill, and social gatherings were headquartered at a local country inn. Other houses and village buildings served as quarters, an architectural office for Ashbee, and workshops. By midsummer 1902 the school, design, and production activities of the guild were in full swing. Ashbee's experiment reached its most ambitious and far-reaching stage.[14]

Ashbee's Guild of Handicraft was the most complete embodiment to date of the principles contained in the writings of William Morris, when, following Ruskin's St. George's Guild, he proposed the renewal of medieval artisanship.[15] Its main objectives were to restore the dignity of handicraft and to unite the useful arts, education, and the workshop into a socialist labor cooperative. As the American professor Oscar Triggs wrote in his *Chapters in the History of the Arts and Crafts Movement*: "Mr. Ashbee's special plea is for a reconstructed workshop, a workshop so constituted that it may function at once as the state, the school, and the factory. Membership in it should constitute citizenship, apprenticeship in it should afford education, production in it should provide materials for use and exchange." By "reconstructed" Ashbee had in mind the recovery of ancient guild practices as well as the perpetuation of a social linkage between handicraft and daily life, as in the workshops of the Middle Ages.[16] Guild members attended special courses outside of their own trade, read poetry and literature, went on field visits to ancient buildings with tutors, ate meals together, and acted in plays and pageants—in short, they participated fully in a cooperative society that produced not merely artistic handicrafts for sale but also well-rounded, educated individuals who might function well in the larger society.

This concern with education, a lifelong passion for Ashbee, was particularly impressive to his American friends and followers. Ashbee published an extensive shelf of books and pamphlets describing in detail the philosophy, curriculum, handicraft techniques, principles, and organizational structure of the guild and school.[17] These writings were dissemi-

nated in Britain and abroad, giving Arts and Crafts disciples a clear picture of how a utopian workshop might function. Meanwhile, a substantial reform effort was under way in America to bring together education in the trades and academic subjects—the so-called manual trades movement (of which more will be said below). American Arts and Crafts proponents—including Oscar Lovell Triggs in Chicago, Ernest Batchelder in California, Charles Eliot Norton of Harvard, William L. Price of Philadelphia, and Elbert Hubbard of the Roycrofters—followed Ashbee's progress with intense interest during the early 1900s. The "news" from England was much on the minds of these forward-thinking Americans.

However, as the decade wore on, the news was not good. Implicit in the paternalistic attitudes of Ashbee and his Oxford-educated design compatriots was a class division between teachers and designers, guildsmen and laborers. The workers were not happy with this system. The business mechanisms of the organization were poorly managed; financial problems were rampant, and workmen's shares were being squandered on poor marketing and production strategies. In England as in the States, consumers wanted handcrafted products at the lowest possible cost, and commercial firms such as Liberty could offer lesser-quality goods at cheaper prices. Guild sales suffered after the initial London years. According to Batchelder, a California educator-craftsman who visited the workshop in 1905, "The workmen at Campden felt that the socialistic ideals of the Guild were well enough on paper, but that they were not practiced in fact. . . . Cooperation that does not cooperate breeds discontent among those who are cooperated upon."[18] As he noted, every English worker was a socialist by necessity, whereas the aristocratic leaders of the movement were "romantic socialists" only by choice. By the fall of 1907, staggering under a huge debt to banks and with shareholder confidence at a low ebb, the guild folded, sending most of its workers back to London and quitting its country environs.[19] Ashbee was forced to carry on as a designer and architect without his corps of "Cockneys in Arcadia."

Nevertheless, this ambitious British experiment in a craft-work cooperative inspired Americans to attempt similar efforts in the years between

1900 and World War I. A remarkable variety of art colonies, craft-work communes, cooperative workshops, and progressive companies flourished during this heady period of reform. When Stickley contemplated his own version of a guild, he was entering a crowded field of endeavors to bring art and craft, labor and education into one unified realm. The idealism of the English movement was fully alive in America, tinged with only a pragmatic bias peculiar to this democracy struggling to find its way in the modern world.

## Crafting Communities in America

Although English romantic thinkers provided much of the theoretical fuel for the movement, Arts and Crafts reformers in the United States stoked the fires with their own bold models of the future. Stickley's experiment was intentionally allied with more than a dozen similar communalistic enterprises founded around 1900.[20] These ventures joined countless art colonies, religious camp meetings, model farms, and worker cooperatives springing up throughout the nation. As Karal Ann Marling observes, "the vast majority of America's art enclaves . . . were founded in the years between 1890 and 1910," including Woodstock, Provincetown, Old Lyme, Taos, and the MacDowell colony. What she calls the "art colonial" movement sent painters, sculptors, and decorative artists to the most picturesque environs in North America to create their new visions of the land. In addition, the largest concentration of Arts and Crafts societies, schools, workshops, companies, and communal enterprises date from this time. Eileen Boris has documented and analyzed the social and educational manifestations of the craftsman ideal in America, noting that the connection between art and labor was fundamental to nearly all the utopian colonies and societies of the era.[21]

In contrast to England, America's model utopian communities were from the first intended to present pluralistic alternatives, not singular answers. Their founders were nearly always men (women often played major parts as intellectuals and crafters but were denied leadership roles)

who were generally religiously or liberally educated and were possessed with true missionary zeal. Like Emerson and the transcendentalists, Arts and Crafts reformers often came from the clergy or had religiously devout parents. (Jackson Lears contends that the movement was in large part a secularized form of religious activism.)[22] They were nonetheless pragmatic about what might be accomplished and tended to accommodate rather than rebuff the capitalist system. Membership in their communities was voluntary, usually guided by ideological, moral, or economic imperatives. Several crafts-oriented communities offered ideas that Gustav Stickley was to emulate at Morris Plains: the Roycrofters (founded 1899), the Rose Valley Association (founded 1901), New Clairvaux (founded 1901), and Byrdcliffe (founded 1902) were all known to him. Significantly, these noble experiments were as various and pluralistic as the society that spawned them: leaders ranged from ministers to architects to soap salesmen; crafts ran the gamut from ceramics and cash crops to furniture and fine books; ideals were Christian, pagan, Quaker, single tax, Ruskinian—in short, an American melting pot full of diverse notions about art, labor, and everyday life.

The community whose programs were most analogous to Ashbee's guild was Pennsylvania's Rose Valley (fig. 14). Founded by a group of Quakers in Moylan, this commune of crafters and artists sought specifically to emulate the ideals of William Morris on American soil.[23] Their leader was a talented Philadelphia architect who had come rather late to the reform movement with a fiery idealism drawn from Quaker roots. Around the same age as Gustav Stickley, William Lightfoot Price (1861–1916) had followed a similar path to business success. Designing fashionable large country houses for the elite of Philadelphia, and in partnership with a wealthy Quaker real estate speculator, M. Hawley McLanahan, he had made enough money to be free of cares about material prosperity.[24] Discussions with other free-thinking (rich) Philadelphians Edward Bok, Joseph and Samuel Fells (supporters of the Ashbees), and John Gilmore first drove Price to found a single-tax enclave at Arden, Delaware, in 1900. But the architect pressed his convic-

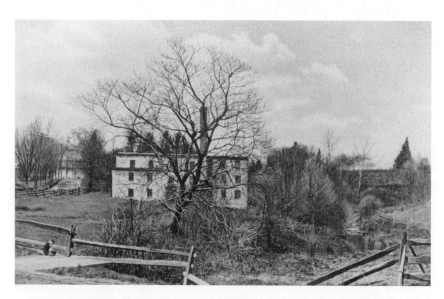

14. Old gristmill, Rose Valley, near Moylan, Pa., prior to renovation and conversion into dormitory and work spaces. *House and Garden* (1906). Courtesy the Winterthur Library, Printed Book and Periodical Collection.

tions further, arguing that "it is written that man shall not live by bread alone, and the art instinct, which is a glorified work instinct, is coexistent with the soul, and can no more be abrogated by systems of political economy than it can be destroyed by the greedy maw and itching palm of a dehumanized industrial system." Price and his partner purchased a virtually abandoned mill complex on Ridley Creek, thirteen miles from Philadelphia on the Chester turnpike, and set about renovating the buildings for craft workshops. He would extend his convictions for reform into action by building a utopian enclave where "the art that is life" could be practiced in a natural setting.[25]

At the center of the complex, Price constructed a guild hall from the ruins of an old stone mill (figs. 15, 16). There the monthly meetings of the "Folk Mote," or association, were held, with theatricals, concerts, poetry readings, and festivals. Other buildings housed a woodworking shop, a pottery studio, and various other craft work spaces. Members of the

15. Dam on Ridley Creek, Rose Valley, Pa. *House and Garden* (1906).
Courtesy the Winterthur Library, Printed Book and Periodical Collection.

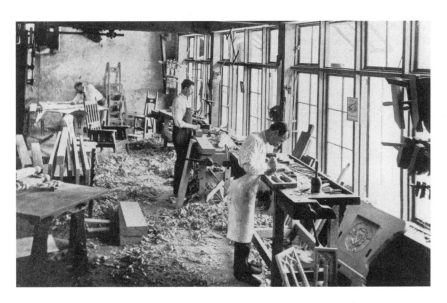

16. Furniture workshop at Rose Valley, with founder William Lightfoot Price
at drafting table in the background. *House and Garden* (1906). Courtesy
the Winterthur Library, Printed Book and Periodical Collection.

community lived in houses lining the valley of the creek, some designed by Price, others renovated from older buildings. The membership was initially made up of Price's family, friends, and colleagues, such as McLanahan, with the hope that publicity would bring like-minded artists and others to the commune. The venture was financed speculatively as well—of some twenty-five thousand dollars expended on land purchases and buildings, virtually all was either borrowed from Swarthmore College (a Quaker institution) or raised from a stock offering.[26] In 1903 the Rose Valley Press was founded under the direction of Horace Taubel to print fine books and other publications. A periodical, the *Artsman*, was launched to disseminate the ideals of the community. In it Price and his colleagues proselytized for the "simple life," goaded their fellow Americans to act for real social and political reform, and spread a Morris-inspired doctrine of art and work. As the founder wrote in the first issue of the *Artsman*:

> If Rose Valley is to become an important factor in the direction indicated it will be because it has opportunities for constructive work and thought to offer, and because here and there some craftsman will hear and accept its call. . . . Its claim for recognition is made on its program rather than on its achievements, be they much or little. By our faith we stand or fall. We believe, in the first place, that it is reasonable and possible for people who are interested in the same or similar pursuits to band themselves together to mutually secure elbow room where they may at least enjoy certain advantages of association and fellowship that are denied them in the prevalent social disorder. And it does not seem visionary to suppose that there are some people in every community prepared to welcome the advent of furniture, pottery, woven stuffs, books, made with care and skill by artsmen who are enough interested in their work to enrich it with such little marks of individuality as set it apart from even well designed machine product [*sic*].[27]

As an American experiment in cooperative industry and the "reconstructed" workshop system, Rose Valley sought not to convert the working masses from above, as Ashbee's paternalistic guild-school had done, but to offer an eminently preferable alternative to the society at large. Its hope of success lay not only in its internal workings—its crafts, social and educational programs, and moral codes—but also in a program of didac-

tic advertising made possible by publication. In a democracy with open access to information, this dependence on media proselytizing is familiar but dangerous. Rose Valley saw fit to use the *Artsman* as a mouthpiece, to spread its message initially through a subtle campaign of propaganda. Price, a Quaker to the core, stood firm in his belief that this beacon of artistic progress would draw many disaffected artisans to its center without overt recruitment efforts.

A more aggressive and evangelistic approach was taken by the Reverend Edward Pearson Pressey at New Clairvaux, a monastic farm-workshop cooperative in Montague, Massachusetts. Whereas Price's core community was liberal Quakers, Pressey was a Harvard-educated minister who drew a like-minded group of Unitarians to his utopian compound in rural New England. Publishing their own journal, *Country Time and Tide*, Pressey and his followers put forward one of the most fervent programs among Arts and Crafts communities. A grab bag of principles guided their efforts at reform: "Democracy, individualism, voluntary cooperation, sentiment, a changed method of production of wares by handicraft, altruism, the simple life, a minimum of wage earning, a maximum of dependence upon the soil for a living; distribution of menial service and emancipation of the menial class, proportion between the mental, manual, and religious education."[28] With less than two dozen members, the college community lived a monastic life inspired by the Cistercian order of Saint Bernard of Clairvaux. There were workshops for textiles, basket weaving, dying, and furniture making; a printing shop run by a master printer; subsistence farming; and regular religious meetings guided by Christian and Unitarian principles. Pressey hoped that sales of craft products at the Village Shop (completed in 1903) would sustain the community financially. He also began the short-lived Plantation and Craft School for boys based upon the manual training movement and educational philosophies of John Dewey.

Although both of the above colonies were communalistic in principle, they depended largely upon the energy and backing of key individuals. The same is true of Ralph Radcliffe Whitehead's Byrdcliffe Colony near Woodstock, New York (fig. 17). Whereas Pressey and Price studied and

emulated the ideas of Ruskin and Morris, Whitehead was born and educated in England, where he obtained firsthand knowledge of the guild ideal at Oxford during the peak years of English utopian theory, 1870–80. He was present with Ruskin on an 1876 trip to Venice and published his own treatise on industrial reform, *Grass of the Desert*, in 1892.[29] Whitehead's personal wealth allowed years of experimental wanderlust, including sojourns in Paris, Germany, and Italy, before he married a wealthy Philadelphia socialite and decamped to the Mediterranean climes of Montecito, California, in the mid-1890s. A committed socialist who mingled with the key leaders of the movement in the United States, he formulated a plan for a Ruskinian art colony and set about finding

17. Ralph Whitehead Sr., founder of Byrdcliffe Arts and Crafts colony, near Woodstock, N.Y., 1908. Courtesy the Winterthur Library, Joseph Downs Collection of Manuscripts and Printed Ephemera.

paid staff who would build and operate it. Aborted efforts to build his dream in Oregon and North Carolina fizzled before he discovered a picturesque farm and forest site in the Catskills, spending ten thousand dollars to acquire it. Hiring Stanford art professor Bolton Coit Brown as his designer and chief guildsman, he financed the construction of an elaborate colony in 1902–3.[30] The twelve hundred–acre camp and farm complex included a main house (dubbed White Pines), barn, studio and workshops, library, living quarters, and dance hall designed in appropriately rustic manner by Brown. Hervey White, a Harvard-trained sociologist and radical reformer from Chicago, was the colony's third organizer in the early years.[31]

Neither his wealth nor his true-believer credentials prevented Whitehead's colony from sputtering almost as soon as it opened its doors (fig. 18). The seeds of dissent were sown by the founder's English aristocratic hauteur and his need to control all aspects of teaching, management,

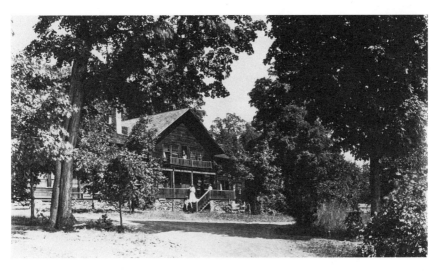

18. White Pines, the Whitehead cottage and workshop at Byrdcliffe colony, circa 1908. Courtesy the Winterthur Library, Joseph Downs Collection of Manuscripts and Printed Ephemera.

program, and artistic philosophy. Because he paid all the bills, including the ones for elaborate woodworking machinery in the furniture shops and the large costs for sustaining the dairy farming operations, the colony quickly degenerated into something between a feudal fiefdom and a paying summer resort with boardinghouses for aspiring art students. Although the colony was observed by many reform-minded artists, including no less a figure than C. R. Ashbee, it was quickly dismissed as a sham. After less than three years in operation, both Brown and White had broken with the founder and started their own competing enclaves nearby. Whitehead and his wife, Jane Byrd McCall, designed pottery and furniture that sold for high prices, and students boarded at the colony's bungalows to bring in additional revenue. Among the growing corps of Woodstock art colonists, Whitehead's compound became known as "Boredstiffe."[32]

Price, Pressey, and Whitehead founded communities based upon socialistic and utopian precepts but quickly faced economic and social forces that eroded their crafts ideals. Rose Valley's three official craft workshops—the pottery, furniture shop, and press—ceased operation after financial troubles arose in 1906; by 1908 the association faced bankruptcy and was saved only by the intercession of two rich benefactors, McLanahan and Schoen, who subsequently developed the properties and rented buildings in a traditional real estate venture.[33] Pressey's community failed to attract new members and slowly deteriorated until the founder sold the Village Shop and press in 1909. Whitehead's family continued the colony as a hobbyhorse until his wife's death in the 1950s. These noble experiments suggested that American society was sympathetic but not committed to social change through communitarian experiments. They failed in large part because they offered neither economic nor social stability for the craft workers and artists who were otherwise attracted to their ideals.

America has built its social and economic structure largely through the achievements of rugged individualists, so it is not surprising that two of the Arts and Crafts experiments that proved most durable were made

by strong-willed men who possessed personal wealth, definite ideas, and good business sense. Henry Chapman Mercer (1856–1930) and Elbert Hubbard (1859–1915) made their enterprises work as businesses, designing and fabricating Arts and Crafts products that were initially dismissed by purists in the movement but were eventually recognized as major contributions to the culture of their time.

Mercer and Hubbard were peripatetic and brilliant, possessed with boundless energy and wide-ranging interests. Each had two major careers. Hubbard made a fortune as a salesman and marketing genius for the Larkin Soap Company in Buffalo. In 1895 he left business to pursue a literary career and founded the Roycrofters as an extension of his Morris-inspired publishing empire. Mercer dabbled first in law, then became a recognized authority on early-American archaeology at the University of Pennsylvania's University Museum. When a dispute with a colleague resulted in his dismissal from the museum in 1897, he returned to his family estate in Bucks County and began to collect American tools, pottery, and material-culture artifacts, building a museum for that collection (the first of its kind in the United States). His serious interest in local ethnography and folklore led him to study the vanishing craft of Germanic redware pottery. By 1898 he had set up his own kiln and experimented with the production of decorative tiles made with similar red clay materials and glazes. It was then a short step to creating a tile-making factory with several kilns, from which Mercer could create and market his own line of decorative ceramics. Both the Roycrofters and the Moravian Pottery and Tileworks operated for more than twenty years as self-sustaining communities of artists and craftspersons, led by their dynamic founders.

Hubbard's initial efforts were directed toward writing, designing, printing, and marketing fine books and other art press publications after the model of the Kelmscott Press in England. He subsequently expanded the Roycroft Shops with pottery, furniture, metal, glass, and leather work (fig. 19). These products were sold after the proliferation of Roycroft Press media—the popular *Philistine* journal and *Little Journeys* book

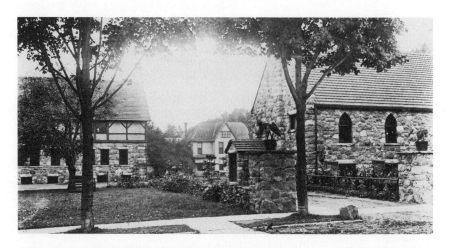

19. Chapel and print shop at Roycroft Arts and Crafts colony, founded by Elbert Hubbard at East Aurora, N.Y., circa 1900–1908. Courtesy the Winterthur Library, Joseph Downs Collection of Manuscripts and Printed Ephemera.

series—had identified a market of Arts and Crafts buyers. Hubbard's marketing genius and popularity as a public figure made possible the expansion of his small printing enterprise into a substantial colony of designers and artisans.[34] He chose as his location the town of East Aurora, New York, not far from Rochester, where he established a "campus" of buildings moved, renovated, or constructed to serve the diverse purposes of the community. By 1910 Hubbard employed more than five hundred workers in more than a dozen buildings in the center of town (figs. 20, 21).[35]

Mercer began his tile works with the intention of reviving a locally significant folk-art form but abandoned the idea when he found he could not master it himself. Turning plates and pottery was not a craft easily mastered by an intellectual dilettante. However, Mercer's talents as a scholar, folklorist, and designer came into play as he experimented with the idea of creating ceramic tiles that not only would utilize folk materials and methods but also might revive decorative motifs, symbols, and even stories of American civilization. Early frustration with the technical

20. Reception room and print shop at Roycroft colony, circa 1900–1908. Courtesy the Winterthur Library, Joseph Downs Collection of Manuscripts and Printed Ephemera.

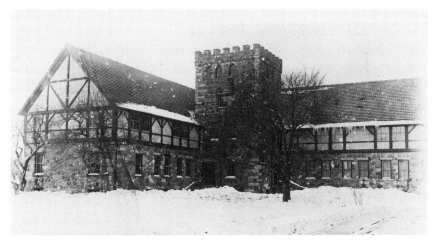

21. Print shop at Roycroft colony in winter. Courtesy the Winterthur Library, Joseph Downs Collection of Manuscripts and Printed Ephemera.

problems of glazing and firing and criticism of his first efforts by the Boston Society of Arts and Crafts did not deter him. By the end of the century's first decade he had designed and perfected a unique group of glazed, unglazed, brocade-style, and mosaic tiles that were used and ad-mired by architects and artists. He then created, between 1907 and 1910, an architectural showplace for his endeavors—the extraordinary fantasy house he called "Fonthill" in Doylestown, Pennsylvania.[36]

Mercer and Hubbard were true American eccentrics who forged vivid and inspiring craft works out of their personal interpretations of their culture and era. Although many of the Roycroft craft products were de-rivative and of uneven quality, Hubbard's enterprise proved that an artist-entrepreneur with his finger on the pulse of popular culture could succeed in elevating both taste and labor in a capitalist environment. Mercer's delightfully naïve, ethnographically varied (Native American, Meso-American, European, vernacular) tile designs suggested that the Arts and Crafts movement could respond to particular cultural condi-tions yet give expression to stories and myths in the larger civilization. Both endeavors proved that there was a market for high-quality handi-craft products and that artisans could be employed in their production under a traditional corporate labor system made fairer by liberal employ-ers.[37] By modifying the religious and socialist political ideals of Morris and his followers, these men carried on experiments that produced sig-nificant consumer goods at a reasonable cost. The true aesthetic worth of their crafts was debated in light of the artisan-designer imperative, but posterity has accorded them considerable value nonetheless.

Gustav Stickley was acutely aware of the work of Hubbard, Price, and Mercer and at least vaguely familiar with Pressey's and Whitehead's colonies. Intensely competitive and well traveled, he participated in ex-hibitions and World's Fair contests in which their crafts were shown. Hubbard was an upstate New York rival whose work taunted Stickley but who also inspired the younger man in his media and advertising campaigns. Price published extensively in the *Craftsman* and was one of Gustav's architectural mentors. Mercer exhibited tiles in the 1903

Syracuse-Rochester exhibition organized by Sargent, Stickley, and Pond (though Gustav favored Grueby tiles). He was undoubtedly also familiar with the conditions under which these men designed and produced their work and the utopian ideals that supported their endeavors. When he came to design his own experimental community at Craftsman Farms he was to emulate both the positive and the negative features of their utopias. Eventually, he would travel the same path as his predecessors, with virtually the same consequences.

The School of Life

If Craftsman Farms shared many of the characteristics of the Arts and Crafts communities of 1900, it trumpeted one ideal above all others: the belief that education, labor, and art should be allied. The workshop and school were to be combined in Stickley's experiment, teaching boys the virtues of handicraft, agriculture, and useful trades while they learned their three r's. Stickley's German background and truncated elementary education convinced him that the central problem to be solved in re-forming society's valuation of labor must be approached via education, particularly the so-called manual trades associated with the downtrodden working class.

He had powerful allies in his quest. The most formidable intellectual presence in America during Stickley's formative years was the philosopher-educator John Dewey (1859–1952). During the 1890s at the University of Chicago, Dewey founded and ran the famous "Laboratory School" for elementary pupils (including his own children) that had a profound impact on American education. From its experimental curriculum the philosopher developed a theory of education based upon a balance of social, manual, and intellectual activities that have guided liberal educators ever since. Explicitly critical of the rote learning, drills, and book-based curricula prevalent in America at the time, he stressed the interdependency between active learning and psychosocial development in the child.

22. Los Angeles schoolchildren tending gardens in 1912. *Craftsman* 22. Courtesy the Winterthur Library, Printed Book and Periodical Collection.

Dewey published his initial concepts in the influential book *The School and Society* (1899), later revising and expanding them in numerous publications.[38] Whereas his theories were complex and tied to psychology, sociology, philosophy, and science, his enormous popular influence drove politicians and reformers of many stripes to adopt aspects of his total program to further their own ends. One of the most widely emulated aspects of the Laboratory School curriculum was its early introduction of what Dewey called "fundamental social materials" in the child's life: housing (carpentry), clothing (sewing), and food (cooking) (fig. 22). Pupils learned by participating in familiar family household activities, enriched by more traditional pedagogy. He argued that through such "direct" modes of expression, the child would be led naturally to more abstract modes—speech, writing, reading, drawing, molding, modeling, and so on. In this way the dualism between external

experience in the social world and the child's internal mental development would be avoided.[39] Thus, in the Laboratory School seven year olds discovered the techniques of primitive handicrafts and materials; twelve year olds made catalog drawers and learned about cloth manufacturing (fig. 23). Popular critics of the American education system soon seized upon this experiential emphasis—some critical of its lack of mental discipline, others enthralled by its practical and occupational applications. Proponents of the Arts and Crafts movement, socialists, and industrial labor reformers saw "learning by doing" as a means of

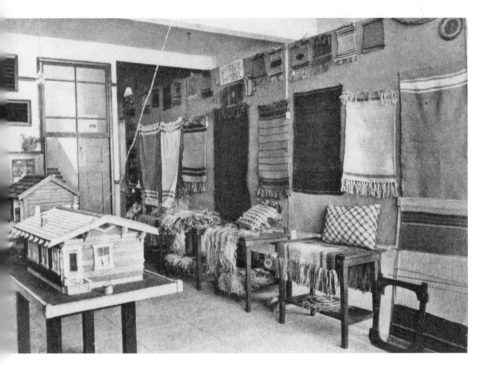

23. Model log cabins and various handicraft projects made by students at Mrs. Francis's School, Los Angeles, 1912. *Craftsman* 22. Courtesy the Winterthur Library, Printed Book and Periodical Collection.

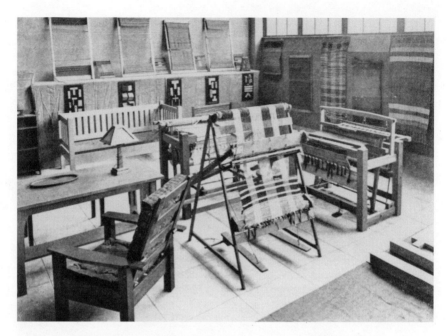

24. Elementary craft projects, Mrs. Francis's pupils, Los Angeles. *Craftsman* 22. Courtesy the Winterthur Library, Printed Book and Periodical Collection.

inculcating a sense of aesthetic worth in the work ethic at an early age. Deweyite educators and manual arts–school proponents were allied in their desire to see schools answer critical social needs (fig. 24).[40]

Dewey's reforms also connected to a larger national agenda. Under the leadership of President William Rainey Harper, the University of Chicago was concurrently developing a multidisciplinary, liberal faculty that was to provide much of the intellectual foundation for the Progressive platforms of Wilson in the next decade and that supported many goals of the Chicago Society of Arts and Crafts (founded in 1898 with six faculty as charter members). Dewey, Rainey, and their Chicago colleagues spearheaded a wide-ranging movement that called for nothing less than the redesign of America's institutions. Dewey befriended Jane

Addams, the Hull House social reformer, and took his children to see her experimental Toynbee Hall cooperative; she, in turn, supported his views on education. One of Dewey's University of Chicago colleagues was the Arts and Crafts chronicler, literary critic, and industrial arts advocate Oscar Lovell Triggs. Through Triggs and his writings the reform spirit in education came to Gustav Stickley.[41]

Triggs cast himself in the role of intellectual leader, following the examples of Morris and Ashbee. "I see the only remedy for the class system of modern society—that is, to reconstruct the institutions that embody the social spirit; to create a school which is not so far removed from the workshop as to obliterate real processes and objects," he wrote in volume 3 of the *Craftsman*, "to create a workshop which shall be so fully educative in itself that it will be a virtual school." This ideal of the unification of trade apprenticeship and conventional education was widely espoused by educators and artisans alike during the years around 1900. Part of a so-called manual trades initiative begun in England in the 1870s by Charles Godfrey Leland and followers of John Ruskin, the system was taken up by numerous American proponents in the 1880s.[42] Manufacturers saw the need for a new kind of training system to sustain their industries. Educators understood the necessity of training workers for jobs in an expanding manufacturing economy. And trade workers from the unions were concerned that their apprenticeship system was being supplanted by more formal educational programs. All agreed with Triggs and Dewey: the school should not be "so far removed" from the occupations vital to life in industrial America.[43]

The answer to this problem lay in what Triggs and his Chicago allies called "the New Industrialism." Through the Industrial Art League (founded 1899) of which he was secretary and its adjunct Bohemia Guild, he sought to create a quasi-socialistic guild system to integrate education in the arts, crafts, and industrial trades into society. "If education be expression, the child's self-activity cannot stop at the boundary of schoolyards. If education is life, then the general life must be so shaped as to be in itself educative," Triggs proclaimed. Many others agreed.

Members of the league (four hundred in all) included Frank Lloyd Wright, Louis Sullivan, William Rainey Harper, Potter Palmer, Stanley McCormick, and future Illinois governor Frank O. Lowden.[44] The league, like many utopian experiments, proved more efficacious as a propaganda organ than a true agent of change in American industry. Under its auspices, Triggs outlined his ideas for an educational utopia in both a series of articles in the *Craftsman* and his subsequent book, *Chapters in the History of the Arts and Crafts Movement*.

Triggs carefully laid out his progressive view of the evolution of Arts and Crafts reform, beginning with Ruskin and proceeding logically to the lifework of Morris and Ashbee. An American, he underlined the democratic imperative in his final chapters by presenting a plea for workshop-schools in the model of such successful enterprises as Maria Longworth Storer's Rookwood Pottery in Cincinnati (founded 1880). Suggesting that one woman's individuality, a "soul," gave spirit and energy to this "ideal workshop," Triggs called upon other Americans to build upon such efforts in reforming society as a whole. "Here are all the elements needed for the ideal workshop—a self-directing shop, an incidental school of craft, and an associative public," he wrote of this manifestation of the new industrialism in America.[45]

The final exposition of Triggs's ideas for combined reform in labor and education came in the form of a specific proposal for a model school of industrial art that would avoid the traditional "opposition between manual training and mental training" and the usual emphasis on mechanical and professional aspects. There are striking parallels not only between this school and Dewey's Laboratory School but also between Stickley's Craftsman Farms proposals and the ideas of Triggs. Published in volume 3 of the *Craftsman*, the curriculum was developed in the wake of the Chicago experiments, perhaps as a deliberate spur to Stickley's ambitious programs. The school was to be located "in the environs of a large industrial city, not so far from the city as to obscure the commercial and social bearing of industry, and not so far from nature as to lose the suggestiveness of natural forms and growths. Field, streams, and woods should be accessible." Morris Plains featured just such a location. Triggs

specified that the buildings "should be substantial but not need be conspicuous or any way extravagant. . . . Let an industrial school at least be sincere." Avoiding historical styles was preferred, although Ruskinian Gothic was acceptable. It would be better should the architecture "be native, its styles suggested by the buildings' use, its symbols indicative of the social environment. . . . [H]appy [is] the architect who can take his stand among the people of his own time, realize the significance of modern forces, and create symbols and styles for democracy." The program specified a group of classrooms, laboratories, a museum, a library, "and other features dependent upon the scope of the school." But the heart of the school would be its workshops: "from [them] all other interests radiate; back to them the results of laboratories and class-rooms return."[46]

Triggs designed a curriculum that synthesized the progressive ideas of Dewey and his followers with the already prevalent notions about the "study of design" in Beaux Arts– and South Kensington–style programs (eventually incorporated into the Werkbund and Bauhaus schools).

> These principles lead to a threefold division of the work of the school, according as design, construction, or instruction receives the emphasis. In the drawing-rooms training would be given in free-hand, mechanical and architectural drawing, representation of nature and the human figure, clay-modeling, composition, color and decoration. In the work-shops, equipped with hand and power tools, furnaces, dyevats, presses and other necessary appliances, would develop all the constructive processes in wood, leather, stone, glass, the earths, paper and textiles. Adjacent to the designing rooms and work-shops would be chemical and biological laboratories and the general experimental rooms. In the class-rooms would proceed instruction in geography, history, psychology, the English language, rhetoric and general literature.[47]

Triggs's school therefore targeted students with interests in the arts and crafts but by no means neglected book learning or traditional training in the fine arts—composition and drawing were central components. The three departments—design, workshops, and arts and sciences—correspond to the divisions of many modern design schools (Rhode Island, Cooper Union, and Pratt featured similar curricula). Dewey's progressive approach to mental development is incorporated into the

graduated academic subjects of the arts and sciences, his "learning by doing" in the other two departments. But the heart of this new trade education would be handicraft—the workshop-school experience would teach the best lessons about thinking and making, craftsmanship and intellectual growth, simultaneously.

This message was precisely what Gustav Stickley began to articulate in his own articles in the *Craftsman*, beginning in around 1904. His ideas about the combination of manual trade education, farming, and new industrialism stem directly from the theories of Dewey and Triggs.[48] As a man who received his education not from books or formal programs but from "life" and the necessity of learning a trade, he immediately connected with Dewey's experiential modalities and criticisms of the current U.S. system. Although not a socialist, he found Triggs's ideas for a unification of industry, trade education, and the schools a useful expedient to reforming the current inequitable system of labor exploitation by the robber barons and unions alike. What he added to the programs was a further synthesis of American resources—the integration of traditional agriculture into the labor, industry, and education equation. The new Craftsman workshop would be a farm-school that taught handicrafts and trades in the context of farm life, the background that had nurtured Stickley during his boyhood in Wisconsin.

Stickley used the bully pulpit of his public persona in the *Craftsman* to preach Dewey's message about education—experience and hand skills, not merely book learning and memorization, were the keys to successful mental and social development in the child. "The sole purpose of education should be to quicken the mind and rouse the spirit of investigation to study what has been done as a basis for new achievement," he wrote in 1909. To Stickley that idea meant an education spent in direct contact with the occupations and lessons of daily life. Handicraft played a crucial part in his formula for a successful new form of school. He was critical of the industrial arts courses taught in public schools, believing that craftsmanship and manual proficiency could not be taught in a setting divorced from production and mastery of a specific trade. As he ar-

gued, "No one expects a schoolboy to make elaborate pieces of furniture that would equal similar pieces made by a trained cabinetmaker. But why not try simpler pieces, and so begin at the bottom, where all work naturally begins, instead of at the top? . . . The trained worker learns things by experience and comes to have [a] sort of sixth sense with regard to their application." Connecting his own training, largely outside the sphere of organized education, to the ideas of reformers, Stickley argued persuasively for a craft-based system of smaller workshop schools after the Triggs and Rookwood models. In a related series of articles published between 1907 and 1910, he admonished readers of the *Craftsman* to get behind national reform efforts to make education more responsive to the needs of a rapidly changing industrial society, and dedicated his journal and his company to the cause.[49] He thus committed himself to becoming not only a leader in the Arts and Crafts movement but also a significant force in American education.

With this goal in mind, Stickley set in motion a series of initiatives intended to promote training in handicrafts and home-based artisanship: Ernest Batchelder (a California craftsman-educator) was commissioned to write articles on "principles of design" for the *Craftsman*; the magazine began a series of articles on home cabinetwork; another serialization was planned to address the major materials, trades, and handicrafts (including metals, textiles, glass, ceramics, wood, and so on); political and social advocacy for education reform became a theme in editorials; Craftsman competitions in the arts and crafts were planned; and the Home Builder's Service stepped up its publication of designs to stimulate interest in the total domestic environment.[50] The magazine would become a kind of manual or textbook of the new industrialism.

In the midst of these programs, all under the auspices of his Craftsman enterprises, Stickley began to consider a more ambitious scheme to put his utopian ideas into practice. If he was indeed aware of the successes and failures of his Arts and Crafts compatriots, including Triggs, Ashbee, Price, and others, he was undoubtedly frustrated by the lack of progress in advancing reform efforts on a national scale. His editorials showed this

impatience with society and politics. However, as an American who believed in the ultimate power of individual initiative, Stickley saw his chance to use his successful empire to create an experimental workshop-school using some of his own ideas, perhaps improving on the flawed conceptions of his predecessors. From the ashes and dreams of New Lebanon, Nowhere, Altruria, Rose Valley, and the School of Life, Stickley's own arts and crafts utopia emerged. We will now turn to its specific program.

A Paper Utopia

Just as he had begun his Home Builder's Service, handicraft courses, furniture sales, and other programs in print, Stickley initially "constructed" his utopian experiment at Morris Plains through a series of published texts in the *Craftsman*. Through his editorship of the magazine, which in 1908 had a circulation of more than twenty-five thousand, he hoped that he could generate interest and support for a new kind of workshop-school.[51] With a substantial income from his expanding furniture sales nationwide, he believed he could afford to establish an estate for himself within commuting distance of his offices in New York, where he had resided since 1905 in a rented apartment. In July 1908 he purchased his first parcel of fifty acres just north of the town of Morris Plains, New Jersey, for seven thousand dollars.[52] Almost immediately thereafter he began plans for the construction of his utopia.

Subsequently, ten major articles and editorials describing Craftsman Farms appeared in the *Craftsman*, running from October 1908 through October 1913.[53] In these writings Stickley presented a series of models of country living, work, and learning to be realized on his New Jersey properties: the Anglo-American ideal of the country house (estate) and garden befitting a wealthy businessman and his family; the quasi-communal, American institution of the artistic or resort enclave; the English, utopian, and Arts and Crafts concept of an artisan community, modeled after Morris's Merton Abbey and Ashbee's Guild of Handi-

craft;[54] and the "Gustav Stickley School for Citizenship," a manual trade and farm school for children of elementary age. Although none of these ideals was realized by Stickley, the buildings and landscape he created at Craftsman Farms became a hybrid of concepts borrowed from each. As he assembled his furniture out of a patchwork of paradigms from many sources, so he cobbled a somewhat vague and overly ambitious program for a new compound institution out of a host of models and philosophical ideas. Between 1908 and 1910 this project became his hobbyhorse, slowing the development of new furniture prototypes and draining cash from the coffers of his Syracuse company. In his January 1909 furniture catalog there appeared the following announcement of his new venture, building upon what Stickley considered the success of his Craftsman movement:

> I have obtained such satisfactory results from these thoroughgoing [Craftsman] methods that I am carrying them still farther, and an enterprise in which I am now deeply interested is the development of a large estate in the uplands of New Jersey, which I have called "Craftsman Farms." Here will be built Craftsman houses that in design, furnishing, relation to environment and relation to one another, carry out as completely as possible the Craftsman idea of country and village life. At Craftsman Farms we will have cottages, workshops of various kinds, club-houses and similar buildings for common use, so that individual and social life may be carried on pleasantly and profitably. We intend also to establish there an industrial and farm school where boys and girls alike may come during their summer vacations and learn how to live and work in a way that will develop in them the good old qualities of self reliance and common sense, — the qualities that enable a man or a woman to earn a living, no matter what circumstances may have to be met and conquered.[55]

Although his published aims were altruistic, Stickley began his land acquisition in New Jersey with the intention of having a country estate amid one of the large old-money enclaves near New York. Morris County had long supported a landed society (Stickley noted "many beautiful country places"), with families such as the Twomblys, the McAlpins, and the Otto Kahns in prominence as the Stickleys looked for

land.[56] Many of the estates were created from a quiltlike agglomeration of farm properties, such as the lovely 485-acre "Brooklawn Farm" of D. Hunter McAlpin just two miles from Stickley's property. Moreover, the site chosen for purchase was near the Morris Plains station of the Erie-Lackawanna Railroad, within easy commuting distance of New York, and proximate to the traditional agricultural heartland of central New Jersey (fig. 25). Land values were low, only about one hundred dollars per acre, and there were plans for increased rail service to the area.[57] When he purchased his first farm parcels, Stickley was also following a program for the retention of agricultural lands that he had advocated in numerous articles in his magazine. Many farmers surrounding Morris Plains were experiencing financial difficulty, causing them to sell land to estate owners or other developers. After acquiring the Morris Plains properties, Stickley paid farmers and caretakers to plant and maintain the land and was quick to acquire farm animals and equipment to maintain agricultural activities.

Following his first land purchases, Stickley set to work designing, instructing his draftsmen in New York to create prototypes for a number of dwellings and other structures. As was the procedure at the Craftsman Home Builder's Service, illustrations were prepared for the magazine while draftsmen simultaneously produced working drawings. In the fall of 1908 Stickley published a series of three articles in the *Craftsman* showing detailed designs for the first buildings at the new "Craftsman Farms."[58] Eventually, his properties would focus on the crossroads of the east-west Newark–Mount Pleasant turnpike (later to become New Jersey Route 10) and the north-south Morristown-Denville Road, just a mile north of Morris Plains. At this time, however, he had only about seventy acres, mainly to the south of the site later to become the Farms. There is no evidence that he ever constructed buildings on these properties.[59]

It is puzzling, therefore, to hear Stickley describing in great detail the site, procedures, and design details of "the practical experiment I am making in the building of my own house" in his extensive article of October 1908: "The Craftsman's House: A Practical Application of All the

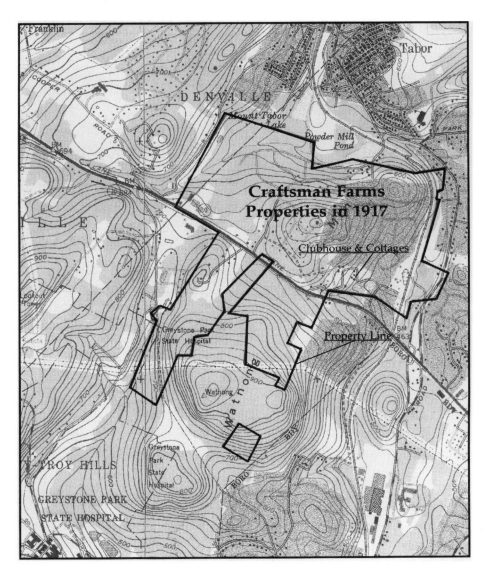

Franklin

Tabor

DENVILLE

Mount Tabor Lake

Powder Mill Pond

**Craftsman Farms Properties in 1917**

<u>Clubhouse & Cottages</u>

VILLE

Lookout Tower

Greystone Park State Hospital

<u>Property Line</u>

Wathong

Greystone Park State Hospital

TROY HILLS

GREYSTONE PARK STATE HOSPITAL

25. Site map of Craftsman Farms properties near Morris Plains, N.J., reconstructed by the author over USGS map.

Theories of Home Building Advocated in This Magazine" (fig. 26). In this essay he set out the first intentions to establish a home and school "for reviving practical and profitable handicrafts in connection with small farming by modern methods of intensive agriculture" at Craftsman Farms. His theoretical proposition was that "beauty in the home is not necessarily the result of pretentious architecture or elaborate furnishing, but . . . rather . . . of a quality that belongs to the simplest dwelling or the plainest article intended for daily use." As in his plain, "structural" furniture, Stickley set out to show how aesthetic beauty could result from simplicity and honesty in building.[60]

It is worth noting some of the unusual aspects of the design and construction of this "theoretical" building in relation to what was later constructed. In type, the building is related not only to earlier Craftsman houses of a large single-gable type but also to Swiss chalets and German traditional dwellings. The plan is highly idiosyncratic, dividing the deep ground floor into a kitchen and one large L-shaped living-dining space with an exposed stair and landing (fig. 27). Virtually every aspect of the interior wall decor and construction was considered, with much built-in furniture and many decorative features borrowed from English and Continental design.[61] Rustic and simple qualities were achieved through the use of a massive outdoor hearth and pergola dining room. "Outdoor life" was facilitated through the use of porches, both ground and sleeping, and sunrooms.

More important, however, than the spatial aspects of the design were Stickley's attempts at "actual construction, frankly revealed," a Ruskinian maxim that became an obsession in his work. The lower walls rose directly from the ground, without a cellar (Stickley hated them), and were to be built of local fieldstone to blend organically with the site. The upper walls were to be of unusual, hybrid construction; to give the appearance of half-timbering or *fachwerke*, chestnut logs were hewn on three sides and set into a wall constructed of common fireproof clay tiles, then stuccoed over. Stickley's intention was to express, unequivocally, the numerous materials used in the building. He even enumerated all of

the species of timber and finish stock used in the house — a virtual ency-clopedia of native American woods.[62]

The "Craftsman's House" was thus both a traditional manor house with Germanic overtones befitting its owner and a demonstration of the moral virtue of handicrafts and "honest construction." It was placed to take advantage of rail lines so that Stickley could ship furniture built on properties nearby, and it had the social cachet of being in a bona fide es-tate enclave. As a successful businessman, it is not surprising that this second-generation immigrant would have identified with the image of the "captains of industry" and their large country estates. What is para-doxical is that he could simultaneously embrace an elitist domestic ideal while also implicitly criticizing the kind of architecture that supported "country life" in fin-de-siècle America.

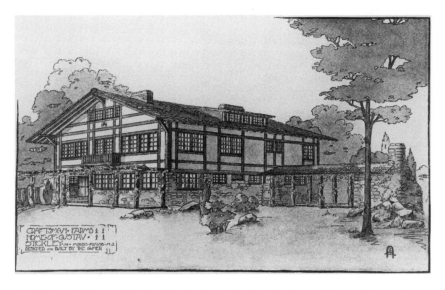

26. "Home of Gustav Stickley" (unbuilt project) at Craftsman Farms. Perspective from *Craftsman* 15, no. 1 (Dec. 1908) and *Craftsman Homes* (1909), p. 46. Courtesy the Winterthur Library, Printed Book and Periodical Collection.

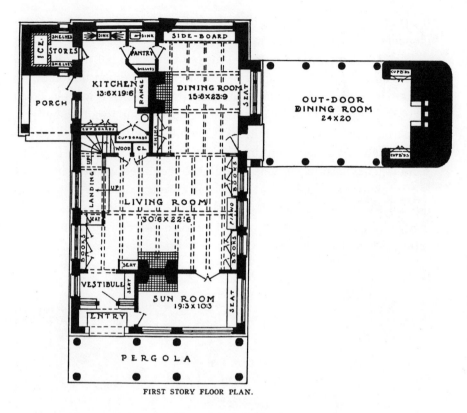

FIRST STORY FLOOR PLAN.

27. Plans of first, second, and third stories of the "Home of Gustav Stickley" (unbuilt project). *Craftsman* 15, no. 1 (Dec. 1908): 80, 88, 89.

    With his own house fictionally established as the locus for Craftsman Farms, Stickley published in short order plans for a clubhouse and three cabins, conceived along similar rustic lines. For economy's sake, these buildings were to be constructed mainly of logs, wood framing, and stone, taking maximum advantage of the native American chestnuts that stood on the land (ironically, at that very moment this genus, *Castanea dentata*, was being obliterated by a pervasive blight). The complex was at this time conceived as a kind of artisan or leisure colony, much in the

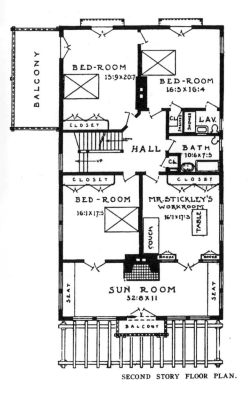

SECOND STORY FLOOR PLAN.

THIRD STORY FLOOR PLAN.

spirit of Price's Rose Valley and such enclaves as Edward MacDowell's New England retreat for musicians and literary figures. "This club-house," he wrote of the place, "will be open to all the workers, students and guests at Craftsman Farms and also to invited guests of the place. We intend to make it a sort of central gathering place where it is hoped that many a pleasant entertainment will be held." Clubhouses and casinos of this type were common in rustic Adirondack camps and seashore resorts built during this period for congregations of wealthy Americans. Stickley

was an admirer of MacDowell, a musician and composer, and seems to have taken to the idea of small studios scattered in the woods where his arts and crafts could be created by masters and students working together.[63] He may also have been thinking of the sort of art colony built by Whitehead in the nearby Catskill Mountains.

Like the master's house, the Clubhouse was designed to demonstrate principles of simple, honest construction and to celebrate the value of handicrafts (figs. 28, 29). The lower story was built entirely of logs and decorated with a masculine, rustic decor, whereas the upper story was expressed as a stucco-*fachwerke* volume and decorated with friezes "symbolizing the life and industries of the farm—as the sower, the woman with her spinning wheel, the blacksmith, the plowman and the like." There was a clear gender distinction in the program—the log-built reception room was masculine, whereas the upper "ladies sitting room"

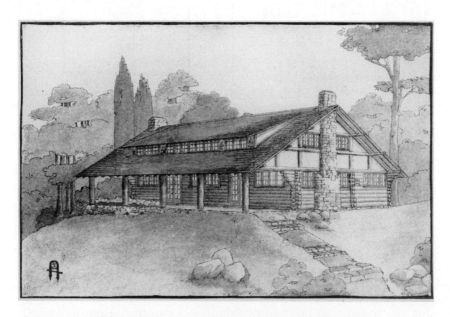

28. Perspective of the "Clubhouse at Craftsman Farms." *Craftsman* (Dec. 1908). Courtesy the Winterthur Library, Printed Book and Periodical Collection.

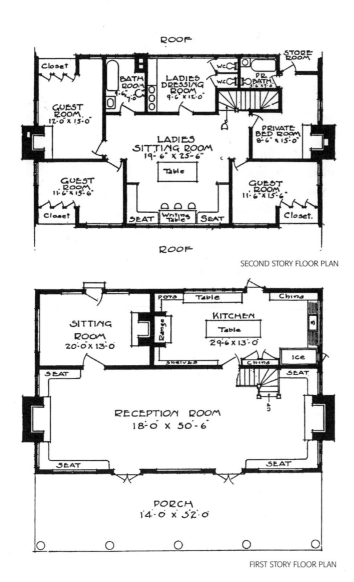

SECOND STORY FLOOR PLAN

FIRST STORY FLOOR PLAN

29. Preliminary plans of the "Clubhouse at Craftsman Farms." *Craftsman* (Dec. 1908). Courtesy the Winterthur Library, Printed Book and Periodical Collection.

was to be "lighter, daintier and more finished in construction."[64] In type, the building resembled a camp dining hall and was planned with a minimum number of rooms—kitchen, sitting room, bedrooms, and a multipurpose meeting and dining hall.

In November 1908 Stickley published the last of his designs for buildings at Craftsman Farms, a set of rustic "cabins" or bungalows intended for use as accommodations for guests and staff at the compound. One of them, called "Craftsman Bungalow No. 53," was a hipped-roof dwelling built of fieldstone and logs, whereas the other was a larger timber-framed, gabled house intended to be sheathed in wide clapboards (fig. 30). The latter served as the first prototype for the cottages built at Craftsman Farms. Stickley suggested that these dwellings would be informally grouped about his property: "scattered here and there through the woods and over the hillside, standing either singly or in groups of three or four in small clearings made in the landscape." The arrangement suggests nothing so much as the traditional groupings of Native American villages or camps, cultures Stickley is known to have admired.[65]

It was not until the spring and summer of 1909, when he had acquired another group of properties to the north and south of the Newark–Mount Pleasant turnpike, that actual construction was begun at the compound.[66] The first buildings to be built were the most modest—a set of cottages based loosely on one of the plans published in the magazine. By March 1910 two or three of these dwellings were complete (fig. 31). Although Stickley's writings indicated that he had chosen specific sites for both his own house and the Clubhouse (not necessarily on the same properties), one can only speculate upon where they were to be located.

Stickley and his family lived in two of the small cottages prior to moving into the larger Clubhouse building. Between July 1910 and midsummer 1911 the family was in one of them, having moved from Syracuse to take up residence in New Jersey and New York City.[67] This move suggests not only that Stickley was willing to practice his own tenets for the simple life, including daily farming and handicraft production, but also that he did not have the funds to build a larger house for his family.

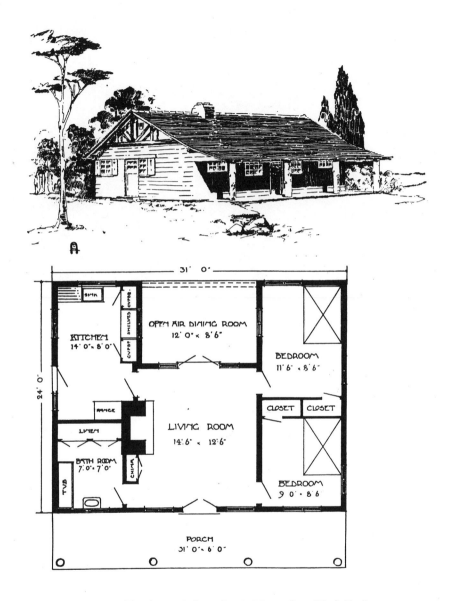

30. Perspective view of "A Rustic Cabin That Is Meant for a Week-End Cottage or a Vacation Home." *Craftsman* (Nov. 1908).

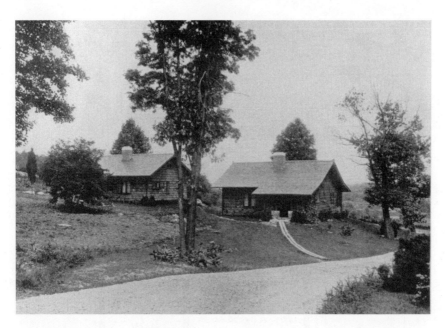

31. Two cottages at the Craftsman Farms complex based upon the prototype illustrated in figure 6. *Craftsman* (1912).

Because the cottages were originally conceived to be houses for the masters of various crafts and trades, it is consistent with the Guild of Handicraft model that the chief craftsman reside in one himself. It is unclear, however, whether Stickley made plans to bring other trade or craft masters to New Jersey from his Eastwood and New York City workshops. There is no evidence that furniture or other objects were ever produced at Morris Plains. Unlike either Ashbee's Surrey "Guild" or the contemporary pottery and Moravian tile workshop of Mercer in Doylestown, Pennsylvania, Stickley did not create a craft-work commune in Morris Plains.[68] How he intended to incorporate workshops into the plan was never explicitly stated.

We are now brought to the last of the paradigms that informed the conception of Craftsman Farms and the idea that above all others drove

Stickley to act as he did in the face of difficult financial and personal exigencies: his projected School for Citizenship. Throughout the many texts and interviews he published in his magazine dealing with Crafts-man Farms, Stickley fervently maintained his intention to bring boys to his estate-cum-school to receive a combined education in manual trades and agricultural practices. The *Jerseyman*, central New Jersey's bimonthly newspaper, announced the plan as early as June 1908. Stick-ley, it reported, had planned to purchase land upon which he "proposes to establish a Craftsman Village that will provide opportunity not only for skilled workers but for the instruction of boys whose parents desire for them a method of training that will teach them to think for them-selves."[69] Like Triggs's workshop and school and the earlier Dewey Lab-oratory School, Stickley's educational experiment was designed to combine practical, moral, vocational, and intellectual training into one unified environment.

At least two versions of the school were advertised in Stickley's writ-ings: one during 1909–10 and another in 1912–13.[70] The first was a sum-mer program, later converted to a yearlong boarding school for boys between the ages of fourteen and twenty. Half-acre family "demonstra-tion farms" would operate as laboratories and outdoor classrooms for the youths, using modern methods of intensive agriculture. Boys would live with the twenty families, learning the crafts and activities of agriculture with them in daily labor. Scheduled to open in the spring of 1911, this version of the enterprise did not materialize, perhaps simply for lack of students and facilities. However, a year later, after having finished several structures on his property, Stickley teamed with a midwestern educator, Raymond Riordan, to once again trumpet his scheme for an educational utopia. "This is my Garden of Eden," Stickley told his collaborator-disciple as they celebrated the completion of the Clubhouse. "This is the realization of the dreams that I had when I worked as a lad. It is because my own dreams have come true that I want other boys to dream out their own good future here for themselves."[71]

In its second incarnation, the School for Citizenship would run on the model of one at Interlaken, in Rolling Prairie, Indiana, then under

Riordan's leadership. Substituting manual training for traditional col-
lege-preparatory courses, the curriculum was formed around the ideal of
practical training in the environment of the home, farm, and trades. Un-
like Stickley, Riordan described the program in some detail:

> Boys will be received at the school after June fifteenth, nineteen hundred
> and thirteen. But fifty will be accommodated the first year. These boys will
> be nine years and over. They will live in Craftsman houses which they them-
> selves have helped to build, and each house will be a real home for the boys
> who have had the joy of helping to create it. Each house will conduct its own
> domestic affairs under the leadership of a woman. The entire estate will be
> maintained and developed, the entire proposition conducted by the boys,
> guided and taught, of course, by their companions, the teachers. The school
> work will not be in schoolrooms, but lessons will be taught in the fields, the
> barns, the orchard—where things are being done.[72]

Moreover, the school would produce and sell farm products and other
goods made by the boys and their teachers, making it eventually self-
supporting. Tuition and fees were graduated from one thousand dollars
in the first year to three hundred dollars in the fourth, considering the
growth in productivity of the students. The rates were relatively high by
standards of the time, but scholarships were to be offered. Despite the
greater organizational structure offered by Riordan's program, the Crafts-
man Farms School once again failed to open its doors to students. Stick-
ley's elaborate paper utopia was not actualized, for reasons that will
become clear later.

As presented in these texts, the farm-school was a highly personal re-
constitution of Stickley's own youthful dreams and missed opportunities.
Educated to only the eighth grade and schooled mainly in the hard man-
ual labor of the farm and workshop, he wished to bring his experience to
"other" boys. Believing that his childhood dream was compromised, he
would relive it in the lives of his young apprentices, thereby making it
"come true" in later life. "The grown man cannot resurrect the spirit of
his boyhood alone," he wrote of the experiment. "He needs the compan-
ionship of boys, the contact of their eager interests and quick imagina-

tions. And so I felt I must have growing boys to work and play with, to help me clear the forestland, plow the ground, dig and plant, plan and build."[73] As the father of five daughters, Gustav may also have felt a longing to work with boys as surrogate sons.

More important, the school was a concrete manifestation of Stickley's ideas about educational, labor, and agricultural reform. "The combination of school and farm and workshop," he wrote,

> affords an opportunity for learning something during every waking hour, for the manual training would come with the actual doing of necessary things under the teaching of experienced workmen, the mental development would come from the constant stimulus of a desire for information as to the physical world about and the great things that have been accomplished by men in other ages and in other lands, and a true standard as to the significance and the relation of the conditions and events that go to make up life would be the natural result of a life naturally and healthily lived and of necessary work well and conscientiously done.[74]

Thus, the child would achieve a balance of practical, moral, and intellectual training.

The other unique idea presented by Stickley in his texts and plans for Craftsman Farms was a system of small industries "allied" with agriculture that would allow farmers to augment their income with funds gained from the sale of locally produced handicrafts (not unlike the system practiced traditionally by the Pennsylvania Germans and Amish). The farm-school was intended not only to train youth to be able to accomplish this hybrid of craft and farm labor but also to show that the system could produce goods and farm products simultaneously. Stickley believed—with little economic theory to substantiate his ideas—that by freeing the laborer from high costs of living and bringing handicrafts and agriculture together he could break the vicious cycle of production and consumption that had already infected the nation. He saw subsistence farming as an answer to the low-wage plight of the working class. Like the Altrurians, denizens of Stickley's world would grow their own food and make their own clothing, needing and wanting nothing more

than they could produce locally. Unlike his socialist brethren, however, Stickley believed that his farm-workshops could coexist with corporate industries producing cheap goods by mechanized means. He did not consider the devastating effect that low-cost factory-produced goods and staples would have on locally produced food and handicrafts.[75]

If one assembles the entire corpus of texts in the *Craftsman* into a composite description of Stickley's utopian farm-workshop, the following collage emerges. As in Triggs's industrial school, Craftsman Farms was to be located near a major city but amid a natural environment where craftspersons might be inspired by nature. Its organization, however, was less centralized and formal—Stickley criticized "too much system" in any educational scheme. Workshops were to form the core of the complex, but they were designed to be scattered throughout the agrarian or forest landscape and incorporated into the farm cottages of master craftsmen and craftswomen and their families. The proposed architectural style was primitive, natural, and very American—log and stone structures resembled the vernacular of the frontier and the Adirondack camp. Social interaction in the commune was to be facilitated through assembly at "clubhouses" such as the one designed and built on the site. No provision appears to have been made for traditional classroom or laboratory instruction.

The only specialized buildings proposed or built were farm structures; a dairy barn and several other farm buildings still exist at the site. Though intended to be decentralized, the first small farm was located near the Clubhouse and two cottages. Dairy cattle, an orchard, herb gardens, and some subsistence crops were planted during the first seasons. (It is possible that some cultivation and harvesting were done using existing farm buildings on adjacent Stickley properties.) Products from the farm were served at Stickley's Craftsman restaurant in New York. If a system of small-scale farm production was intended, its accomplishments were modest. Like Pressey's New Clairvaux, Stickley's agricultural reforms were poorly managed and ill-conceived. Moreover, no plans ex-

isted for woodworking shops or other specialized handicraft facilities; all production remained in Syracuse during the years that Stickley resided in Morris Plains.

The paradigms most germane to Stickley's built realization of the farm-school are those ideas of visionary eccentrics such as Mercer and Whitehead. As an estate with a "big house" and ancillary cottages for students-disciples, Craftsman Farms was more akin to their highly ego-centric enterprises than to the more socialistic utopian communes of Price and Ashbee. The Clubhouse, like Mercer's Fonthill, became a showplace for Craftsman building products and ideals. It appears that Stickley intended to rule as a kind of headmaster, craftsman, and farmer over his utopia—the "Master's House" was the unrealized evidence of that dream. Frank Lloyd Wright constructed a similar composite residence-farm-studio at Taliesin in Spring Green, Wisconsin, during the same period (1911) and eventually built a Gurdjieff-inspired commune for his apprentices there during the 1930s. Wealthier men and women were doing the same all over America—from the Hearsts in California to Ringling in Florida. The idea of combining an estate with a school was neither original nor particularly beneficent—Stickley simply did not possess the wealth to accomplish his dream.

Here, then, was the textual program for Craftsman Farms, a paper utopia filled with far-reaching but also familiar ideas about the reform of American society. As a product of its time and place, this utopia resembled several notable examples among dozens of similar experimental communities throughout the United States and Britain. Stickley's remarkable capacity to tap the veins of sentiment, symbolism, and popular culture in America yielded a utopia with the same contradictory strivings as the ones found in society at large. His personal vision derived from an equally direct connection to the "masks" or "performances" that carried him through life. Each of his personae finds some expression in the components of his utopia: German American, farmer boy, captain of industry, visionary intellectual, teacher, woodworker. Here, simultane-

ously, was a frontier settlement, a farm, an estate, a school, a workshop, a country house, and a monastic commune.

Perhaps more remarkably, the textual narratives presented by Stickley as an exposition of the Craftsman Farms ideal, augmented by his designs for buildings, make a complex tapestry of stories and philosophies about America in 1900. There are stories of childhood striving, of gritty self-determination, of Horatio Alger's boyhood romances; stories of utopian morality and communal equality; stories of building, crafting, and making fine art out of everyday materials; stories of the individual struggling against a complex world.

It is that final story of Gustav Stickley's titanic struggle to place himself in the shifting tide of American culture, to maintain a position of influence and authority, that becomes central to the moral and aesthetic truth of Craftsman Farms. We have yet to explore how he sustained his vision, how he built his empire and his buildings, how he financed his dreams. We do not yet know why his empire failed. And we have yet to place ourselves in the context of New York City, Syracuse, and Morris Plains — the locales in which Stickley moved for fifteen years. Turning now to the aspect of place, we will consider how the environment, culture, and materials of Stickley's world contributed to his vision and how he fashioned the artifacts that were so central to the Craftsman ideal.

# 4

# Artifact and Place

## Landscape Actors

WHEREAS THE NARRATIVE of Craftsman Farms as presented in Gustav Stickley's writings arched toward universal themes, the man himself longed to find a particular locus for his ideas, to plant them, as it were, in familiar soil. *Utopia* derives from a Greek word meaning nowhere, a nonplace. But Stickley's utopian farm was *placed* in a landscape rich with history and resonant with strong agrarian chords in his psyche. Connecting the story of Craftsman Farms to the land unveils meanings that bind together men, women, buildings, and the natural world (fig. 32).

Marwyn Samuels contends that we are compelled as curious beings to demand an explanation for how our environments, the places so familiar to us, were shaped by fellow beings (animals as well as humans), yet asks why it is that "the who behind the image and facts of landscape, or the 'biography of landscape,' no longer grips our attention."[1] He points out that virtually every bounded place in the world has been formed by force of will, whether collective or individual, and that many memorable places are writ large with the biographical strokes of strong actors. When Gustav Stickley assembled his patchwork of properties in the hills of Morris County, he was re-forming a land already full of stories, actors, and events. His own "authorship" of the place we call Craftsman Farms was a palimpsest over layers of previous habitation and cultivation.

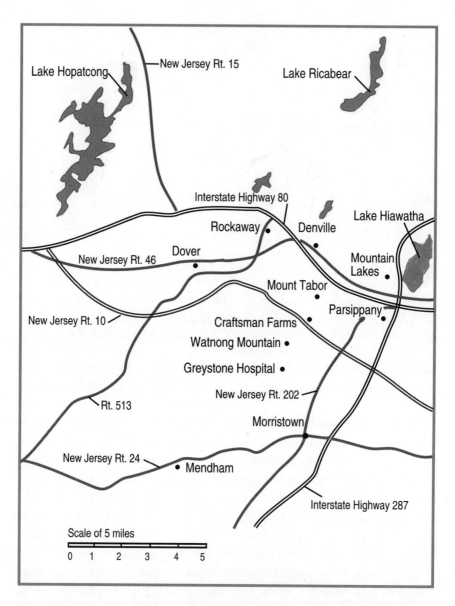

Lake Hopatcong

New Jersey Rt. 15

Lake Ricabear

Interstate Highway 80

Rockaway

Denville

Lake Hiawatha

Dover

New Jersey Rt. 46

Mountain Lakes

New Jersey Rt. 10

Mount Tabor

Parsippany

Craftsman Farms

Watnong Mountain •

Greystone Hospital •

New Jersey Rt. 202

Rt. 513

Morristown

New Jersey Rt. 24

• Mendham

Interstate Highway 287

Scale of 5 miles

0   1   2   3   4   5

32. Craftsman Farms in relation to surrounding landmarks, highways, and towns. Map of the area around Morristown, N.J.

GUSTAV STICKLEY'S CRAFTSMAN FARMS

The deepest of these layers is geology. The rocks, rolling hills, streams, and forests of Morris County lie within a zone of Azoic rock, some of the oldest on earth. A series of four diagonal striations of rock separates the relatively flat landscape of eastern New Jersey from the rising hills to the west, stretching upward in plateaus toward the Delaware Water Gap. Within seventy-five miles of the river lie a great variety of minerals, geological time periods, and rock formations—some 10 percent of all the earth's minerals can be found there. In fact, a distinct line on the U.S. Geological Survey map runs across the site of Craftsman Farms, distinguishing the "Valley and Ridge" rocks from the ones of the "Highlands." The gneiss and granite formations under this higher terrain consist of mainly Pre-Cambrian layers, the oldest geological areas in New Jersey. Although there is no clear surface distinction to the landscape lying above these igneous strata worn smooth by millions of years of glacial activity, visually the hills and valleys appear quite different from the lower terrain to the east. Before the advent of highways and homogeneous human settlements, visitors traveling from the east were confronted by a striking rise in the land marking the edge of ancient glacial erosion. This rise was literally the southern extremity of the great glaciers that had waxed and waned from the north during the last ice age.

The rich geological variety of this area was discovered and exploited by both Native American and European settlers. In the colonial and early republican periods, West Jersey sustained its economy through mining and forges, trade along canals, and agriculture. Iron and zinc deposits lying near the surface were mined from the middle of the eighteenth century to the present. Long Pond, Franklin, Andover, Oxford, Speedwell, and Ringwood were centers of early mining in the British colonies. To the south and east of Craftsman Farms, along the "terminal moraine" formed by ancient glaciers, erosion carved smooth hills and gentle river valleys—the Raritan, Passaic, and Musconetcong Rivers and their many tributaries. Water power from these streams drove the mills of the early industrial revolution, just as it had sustained Native American tribes.[2]

The Lenape Indians, or "people of the rising sun," called the tall mountain above Morris Plains "Whatnong." That prominent rise in the

moraine, three miles north of colonial Morristown, was the most compelling feature in the gentle, rolling topography that Stickley would have seen in his first trips to the area by train in the early 1900s. The native tribe, in their wisdom, could only marvel at what they called the "hill place" as they built their villages at its base, along the Parsippanong and Whatnong Creeks. Whatnong is an unusual and somewhat forbidding escarpment (though much less dramatic than the cliffs of Paterson to the east). The mountain had several smaller neighbors to the north and west, but no equals until the highlands jumped dramatically at Hackettstown, thirty miles nearer the Delaware Gap. The peaceful Lenape people settled the area between the Hudson and Delaware Valleys about three thousand years ago, and numbered as many as twenty thousand when the first Europeans came to the land in the early 1600s. By 1700 disease and war had taken its toll on the natives—they numbered only three thousand and were being pushed westward, out of their beloved Lenapehoking, eventually to be resettled in Ohio as the "Delaware" tribe. Their villages consisted of long houses, built of bark and bent branches, grouped informally along river and stream banks. They grew crops (squash, corn, and beans), hunted, and fished, drawing sustenance from the rich resources of the river valleys of the northeastern seaboard.[3] Their earth-centered way of life held new attractions for Gustav Stickley and his Craftsman readers in the twentieth century.

Whatnong Mountain presided over a region inhabited not only by native tribes but also by some of the earliest European adventurers who sought economic gain from the new land. In 1643 the white settlers fought the Tappan War to gain control of the rich mineral and agricultural lands from the first Americans, later pushing the Lenape Indians westward. In 1707 nine counties were established in East and West Jersey; Morris County was a vast area of 870,000 acres first surveyed in 1738. The largest settlements in the county, which had 17,750 inhabitants in 1800, were at Morristown, Hanover, Dover, and a handful of villages built along turnpikes and trade routes west and north to the mines of the Ramapo Mountains. On March 12, 1806, the Newark and Mount Pleas-

ant Turnpike Company opened a route between the hills above What-
nong connecting Newark, Whippany, Littleton, and Dover. This short-
lived thoroughfare (closed to business in 1833) carved a line through the
valley that was to divide Stickley's farms in 1908. More invasive excava-
tions that etched their vectors into the land were the Morris Canal
(1824–31) crossing the whole state, and the later Morris and Essex Rail-
road running east and north toward the Delaware River.[4]

Near this confluence of transportation, waterways, hills, and valleys, a
distinct group of institutions developed during the half-century before
Stickley discovered his own oasis at Morris Plains. Several miles south of
that small village, Stephen Vail constructed his Speedwell Ironworks in
1848 on a lakeside site along the Whippany River. This early industrial
complex supported a sawmill and forges beginning in the mid-eighteenth
century, using water power from the drop in elevation between Speedwell
Lake and Pocahontas Lake. On January 6, 1838, Alfred Vail and Samuel
F. B. Morse first demonstrated the electromagnetic telegraph on the
upper floor of a building on this site, beginning the explosion of com-
munication technology that was to revolutionize America during Stick-
ley's lifetime.[5]

To the west of Morris Plains, on a mountain only a few miles from
Stickley's farm, was an institution of a different sort—the Greystone Lu-
natic Asylum (fig. 33). Architect Samuel Sloan's 1,250-foot-long complex
was constructed from 1872 to 1876 as one of the first large-scale hospitals
in the United States designed to care for the mentally ill. According to a
contemporary source it had "few equals and perhaps no superiors" in
psychiatric medicine. Constructed to house eight hundred patients on a
450-acre tract, the asylum was made on a colossal scale matching such
public works as the Croton Aqueduct, Morris Canal, and Brooklyn
Bridge—a complete city, "self sufficient in every way." Gen. Fitz John
Porter, its first superintendent, went on to direct the New York City Pub-
lic Works Department in 1875.[6]

Two miles north of Craftsman Farms was the community of Mount
Tabor—perhaps the settlement most akin to Stickley's ideal colony

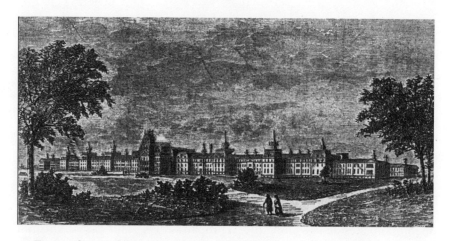

33. Engraved view of Greystone Hospital. "New Insane Asylum at Morris Plains," circa 1876. Courtesy Free Library of Morristown and Morris Township, Morristown, N.J.

(fig. 34). A Methodist church camp that began as a simple tent village in 1869 and developed into a Victorian showplace of carpenter Gothic cottages, this insular utopian compound occupied a hilltop site overlooking the northernmost Stickley properties. Like Oak Bluffs on Martha's Vineyard and Ocean Grove on the Jersey shore, the camp was organized around a central green campus, with cottages huddled in concentric rings around the Tabernacle. During summer convocations, choral singing, preaching, and education were blended in the verdant setting of a forested hilltop. Maintaining its own post office and government, the Methodist community was a "city of God" not unlike the Shaker and Moravian colonies founded in the late eighteenth century.

These institutions, though unlike Stickley's utopian compound in type and purpose, shared with Craftsman Farms a self-contained quality of isolation and social idealism. Located far from the city and on hilltop sites, each sought to create a world apart from the rushing pace of industrial America. That impulse to retreat from the world at large to a place purified by a spirit of simplicity seemed to draw Stickley and his fellow

34. Methodist family on front porch of their cottage at Mount
Tabor, N.J., circa 1880. Courtesy Morris Plains Museum,
Morris Plains, N.J.

"hill people" to this highland spot. Just as the land attracted him with its unusual topography and strangely familiar forest and field environment, the society that had discovered Morris Plains and Whatnong had something to offer as well.

Morris Plains and the Craftsman Farms Properties

Gustav Stickley visited Morris Plains for the first time between 1905 and 1907 as a guest of the famous Hearst-empire political cartoonist Homer C. Davenport (1867–1912) (fig. 35). "Red Gables," Davenport's 150-acre estate on Tabor Road north of Morris Plains, was in those years a haven for progressive political and cultural figures from New York (fig. 36). Among the guests who signed their names to the walls of his white clapboard farmhouse were Thomas Edison, William Jennings Bryan, Am-

35. Homer Davenport (1867–1912), the political cartoonist, during his years in Morris Plains, N.J. Courtesy Morris Plains Museum, Morris Plains, N.J.

36. Red Gables, Davenport's farm and country house at Morris Plains, N.J., 1905. Davenport is mounted on one of his Arabian horses in the foreground. Courtesy Morris Plains Museum, Morris Plains, N.J.

brose Bierce, Buffalo Bill, and artists A. B. Frost (of Uncle Remus fame) and Frederick Remington. As Stickley's daughter Marion Flaccus later remembered: "He [Homer Davenport] was a friend of my father's. That's how we happened to move there (to Morris Plains). And mother and father used to go down there once in a while and stay in a little bungalow that he had. And they just fell in love with Morris Plains. So that is how we happened to move down." One of the first properties purchased by the Stickleys was adjacent and to the north of the Davenport compound.

Davenport shared with Stickley a number of characteristics of the progressive cultural leaders of Theodore Roosevelt's second term. A native of Oregon, he loved the outdoors and cultivated the affectations of a gentleman farmer—his estate included the largest collection of rare pheasants in the world, a menagerie of other exotic birds and animals, and the

first substantial breeding stock of Arabian horses in the New World. Although he traveled the world on assignment for the Hearst newspapers, Davenport longed to find a country home that would sustain his agrarian passions. He found his oasis in Morris Plains, at the foot of Whatnong Mountain. In March 1902 he wrote to his father that "I am living the perfect life now. I get up at four in the morning, go to the farm at five, get there at six, leave the farm at eight-fifteen, get to the office (in New York) at nine-fifteen, quit around four, spend between that time and dark driving and walking around the place, and go to bed at eight-thirty or nine at the latest."[7] Purchasing his properties after 1901, he had by 1905 designed the perfect rural retreat for a modern intellectual, and in that year moved his wife, Daisy, and three children to the new farm.

Red Gables was unusual for a country place of its era by virtue of its rustic and informal tenor. In an area known for its large and opulent estates, the house retained its character as a farm dwelling or bungalow, with a prominent wraparound porch and simple white clapboard exterior. The gardens were also informally planted, though by a well-known firm of landscape architects, Bobbington and Notkins. Two picturesque ponds at the center of the property were formed by damming the Whatnong Brook as it meandered southward from the mountain down along the tracks of the Lackawanna Railroad. The house stood at the edge of the southernmost of these tracks, facing a small bridge designed after the fashion of Japanese gardens. Meticulously groomed plantings included forsythia, Swedish pines, hydrangea, English smoke, and a monumental lilac hedge bordering the driveway. Visitors remembered the place as being very like an English park, with benches and paths for strolling the gardens. The house at the center was small, with only fourteen rooms disposed around a massive stone hearth. From its cozy den the cartoonist could survey a landscape reminiscent of his native Oregon yet cultivated with an international flavor. In the morning he would take a carriage to the Morris Plains train station, meeting the "millionaire's special" train car that would bring him swiftly to his Manhattan office.

Davenport was one of several dozen wealthy men and women who

chose the environs of Morris Plains for their country places. Charles Surdham and William Osgoodby published a lavish photographic survey in 1910 that documented the estates of New Jersey's elite society in the area around Morristown, a pleasant county seat of only twelve thousand inhabitants in 1900. Some 122 country house properties were listed in Morristown's *Daily Record* in 1913, belonging to a group of business and professional men worth a total of more than one-half billion dollars, according to a 1902 report in the *New York Herald*. Fifteen tycoons were worth more than $10 million each and another fifteen worth more than $2 million, according to the newspaper, which cited in particular Otto H. Kahn, Sen. John F. Dryden, George McAlpin, George and Peter Frelinghuysen, and John Claflin among the Morris County plutocracy.[8] Local journalists Surdham and Osgoodby touted the "high social status" of the area, enticing nouveaux riches such as Davenport and Stickley to consider the area for their homes. In the heyday of America's country life movement, this formally rural area offered privacy, a long-standing landed society, and the amenities of urban life, all within rail commuting distance of New York City.

Morris Plains was a small village located on the rail line from Hoboken and Manhattan, two miles north of Morristown when the wealthy began to discover its rural charms in the 1890s. With only a post office, general store, train station, and two major churches, there was little in this Victorian burg to entice urbanites until society figures such as the McAlpins began purchasing farmland just prior to the turn of the century (fig. 37). Blessed with a society cachet, inexpensive land, and a quick rail connection to New York turned the rolling landscape into a verdant country-place enclave before 1900. A small business block developed along Speedwell Avenue, the road to Morristown, with Daniel M. Merchant's (1867–1947) general store at the center. Unfortunately, a tragic fire following the Independence Day festivities in 1906 leveled the mercantile buildings. They were promptly rebuilt with the aid of the surrounding landowners, and the town was again bustling when Stickley began his land purchases in 1908.

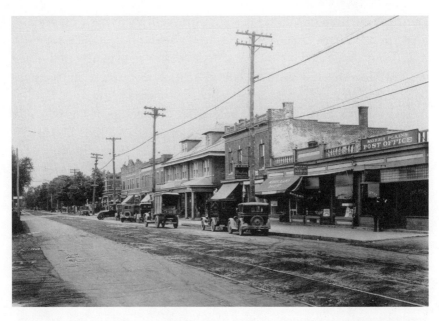

37. Speedwell Avenue business district, Morris Plains, circa 1930s. Courtesy Morris Plains Museum, Morris Plains, N.J.

Following that near calamity, Homer Davenport's life had taken an unexpectedly negative turn in 1907, when he left his wife and children and took up residence at the McAlpin hotel in New York City. Daisy Davenport was by all accounts a profligate and difficult woman who forced her husband to divorce her and then virtually fleeced him in their settlement. While she remained at Red Gables, Homer Davenport sold a piece of property adjacent to his farm to Gustav Stickley for nine hundred dollars on June 15, 1908. The Craftsman account books indicate that Gus was making regular trips to Morris Plains by rail during the spring to scout properties for his farm-school. He was looking at land to the north of the village, in the area between the railroad and the Mount Pleasant turnpike. Morristown's newspaper, the *Jerseyman*, announced in June that Stickley planned to open a "Craftsman Village for the Edu-

cation of Boys" during the summer, presumably using the existing farm buildings on his new properties. He opened an account with Daniel Merchant at the Morris Plains general store and purchased farm equipment and other supplies from local vendors in Morristown during that summer and fall. His business ledger books reveal that a separate "Farms Account" was set up as early as 1907 and that Charles C. White, one of his New York staff, was paid approximately one hundred dollars per month to direct the activities in Morris Plains beginning in 1908.

Stickley's property purchases were made with the assistance of Harvey Genung, a realtor, and Willard Cutler, a prominent Morristown attorney. Between the summer of 1908 and early 1911 Stickley purchased more than twenty-four properties, according to a record published after his bankruptcy (fig. 38).[9] It is difficult to assess whether the 650 acres eventually to make up his New Jersey holdings were contiguous, but it is highly unlikely that Craftsman Farms was ever one unified estate. The first property to be acquired was to the north of the town of Morris Plains and to the east of Mount Tabor Road. Newspaper articles recorded the second major purchase from the "Sisters of Charity of St. Elizabeth" as a 157-acre parcel in Hanover Township, probably to the south and east of the site eventually used for new buildings. It is possible that Stickley intended to construct his "Craftsman's House" on the parcel nearest to the Davenport farm as a country retreat that would emulate the estate of his friend.[10]

All of the properties that Stickley was assembling were former agricultural parcels, some probably still in cultivation, others lying fallow. His intention, if we believe his writings, was to preserve the farmland and keep it in use, protecting it from the development that would later claim so many rural lands in central New Jersey. During 1908 and early 1909, Stickley's farm account books reveal a significant number of purchases for agricultural goods, including feed, farm animals (pigs and Holstein cattle), automobiles, manure, labor, blacksmithing, and carriages.[11] Far in advance of the opening of his short-lived Craftsman Building restaurant (which used milk and other agricultural products from the New

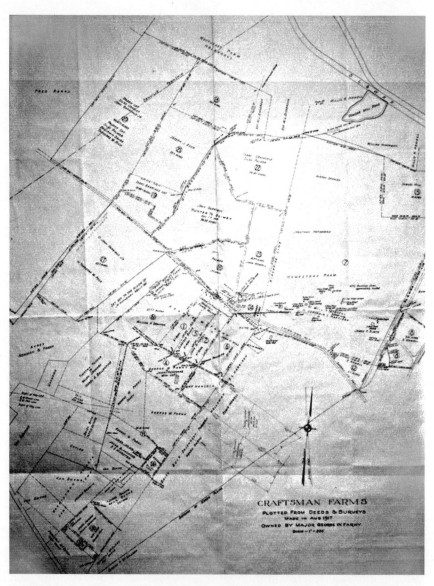

38. Property survey of Craftsman Farms, prepared by Edward Howell for George W. Farny in August 1917. Courtesy Richard E. Smith, from his collection.

GUSTAV STICKLEY'S CRAFTSMAN FARMS

Jersey farm), Stickley was expending significant funds on an agricultural enterprise. Moreover, his payments to Harvey Genung for real estate amounted to almost ten thousand dollars for land alone during this initial period of acquisition. These large cash outlays were to prove problematic as Stickley's plans advanced and his ideas grew increasingly ambitious.

Income from the various Craftsman enterprises reached its apogee during the three-year period of intense development in New Jersey. The Eastwood factory sales peaked at $387,000 (gross) in 1910, Boston and New York stores were selling furniture strongly, the magazine reached a peak subscription base of almost twenty-five thousand, and Stickley's first book sold out in three editions. Stickley's own income, though significantly less that Davenport's $25,000 yearly salary, placed him in the top echelon of Americans with earnings of $5,000 per year plus a percentage of profits on total sales. (The average American factory worker earned only $435 annually, or $8.37 per week in 1900.)[12] His factory employed 197 workers in 1907, earning good wages as stock clerks, seamstresses, cabinetmakers, joiners, finishers, and metalsmiths, ranging from $6 to $35 per week, for a total monthly payroll in excess of $2,000. Company stock was offered at a total value of more than $300,000, making it one of the most successful ventures of its kind in the United States. All business dealings were tightly controlled by Gus and his immediate family, and board actions were secret. Yet, despite incontrovertible success, Stickley's multiple ventures were sucking capital from his company faster than manufacturing and sales could keep pace. The farm project, his new *Yeoman* magazine, and his reckless plan to rent expensive midtown Manhattan space for a new Craftsman department store drained cash and created massive liabilities.[13]

During the spring of 1910 Stickley chose to begin construction of new buildings on the northernmost of his properties, lying between Mount Tabor and the center of Morris Plains along the Mount Pleasant turnpike (fig. 39). This site had the advantage of a small creek that would be dammed to make a pond, a southeast exposure for existing pastureland,

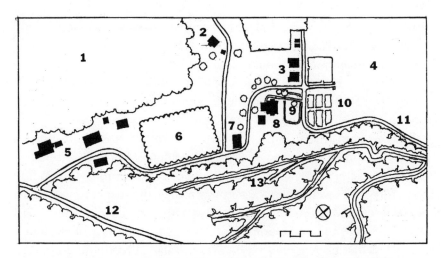

**Craftsman Farms Site During the Stickley Era: 1910-17**

1. Wooded Hillside and Spring, 2. Upper Cottage, 3. Lower Cottages, 4. Pastures, 5. Farm Group, 6. Orchard, 7. Workshop, 8. Club House and Dining Pergola, 9. Formal Garden, 10. Vegetable Gardens, 11. Entrance Drive from Mount Tabor Road, 12. Mount Pleasant Turnpike, 13. Brook and Woodland Area.

39. Clubhouse, barns, three cottages, pasture, and orchards at Craftsman Farms site plan, circa 1916. Author, after Temple University, Department of Landscape Architecture, 1994.

and a sloping aspect with fine views to the east. Native chestnut trees grew on the southwest slope, giving way to an orchard and grazing land. The property was formerly the Garrigus farm; Stickley maintained the existing Victorian house while construction proceeded on his first cottages and barn buildings. Access to Stickley's properties was from the north road to Mount Tabor, across the Lackawanna tracks (very different from the present entrance). Choosing the southwestern slope of the mountain lying just to the north of Whatnong, he planned his complex of buildings in informal groups lying along the creek at the base of the hill. He created a picturesque pond and began planning the nearby clubhouse. To the north of the main building were several cottage sites, accessed from an east-west road made by workmen of primitively graded gravel. Between the buildings were gardens planned for vegetables and

flowers, making a complex more akin to an Adirondack camp than to a conventional country estate.

The site of the complex was also determined by the location of a natural spring near the top of the hill to the north of Whatnong Mountain. Members of the Farny family remember that the water from this spring was exceedingly pure and plentiful, supplying the estate for decades: "the spring has never failed in the worst drought, we always had all the water in the world." Cyril Farny recalled in an interview, "we think it's the best water in the world."[14] Bottles of it were sold in the Craftsman Building restaurant. Because the spring was located above the site of the Farms complex, no pumps were necessary to supply water to the buildings, adding to the advantages of the site. Because there was initially no electric power on the property and no mechanical power plant, Stickley was compelled to depend on gravity-fed water systems.

On the western edge of the property Stickley constructed a farm group consisting of two barns (one for horses, the other for dairy cattle), a concrete silo, a cottage, and a dairy production building (fig. 40). His chick-

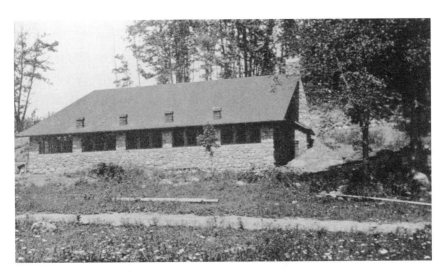

40. The cow barn at Craftsman Farms. *Craftsman* (1912).

ens, cattle, and other farm animals were given modern accommodations planned with all the scientific advances in agricultural engineering. Family members, including daughters Marion, Ruth, Barbara, and Mildred, were expected to work on the farm and in the household. The orchards and pasturelands on the existing properties were renewed and cultivated with great care to make a showcase of modern farming and land planning. Like Davenport, Stickley's aim was to make a contemporary garden and farm complex that would valorize the roots of America's self-sufficient agricultural society.

During the summer of 1909 the account books reveal an expenditure of more than $1,700 on construction, probably connected with the building of three cottages.[15] The 1908 *Craftsman* magazine designs for bungalows were modified somewhat as the two structures were built overlooking existing pasturelands on the eastern edge of the property, not far from the old Garrigus farmhouse. Each small house had a central living space and hearth, surrounded by two bedrooms, a bath, and a small kitchen. At the rear was an outdoor dining area, whereas the east front had a wide porch framed with log columns. The buildings were covered in shingles and trimmed with native chestnut (fig. 41). These buildings were to set the tone for all construction on the site—native wood, stone, and rustic details would give a vernacular feel to Stickley's ideal farm compound. Typologically, the cottages were similar to California's popular bungalow forms and had the earmarks of typical Craftsman houses published in the magazine. Stickley had seen bungalow camps and suburban examples on trips to California, one in 1904 documented in the *Craftsman*.[16] He was clearly drawn to the simplicity and directness of this house form. But there was another building type that had an even stronger hold on his imagination as he continued this personal building project. Once the Farms were operational in 1910, Stickley began the largest and most complex of the houses to be constructed at his oasis in New Jersey. It was a building that would symbolize many of his ambitions as a craftsman and reformer, but one that also contained paradoxes that continue to perplex and baffle admirers of his work.

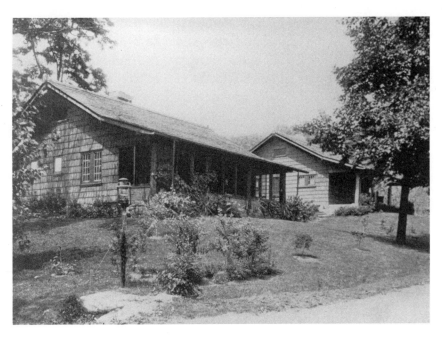

41. Two cottages at the eastern end of the site, built in 1909–10, from the west. *Craftsman* (1912).

## The Log House

The central narrative in Stickley's version of his own life was the story of a woodsman, building his family, business, and empire in the midst of a hostile frontier. The hero of that story worked with unhewn logs, creating out of the tree his uniquely designed and finished furniture. He created his useful and aesthetic artifacts out of the natural wood, connecting arms, stretchers, and legs together with pegs and tenons to demonstrate their "structural purpose." When Stickley designed the central Clubhouse at Craftsman Farms, he was creating a testament to the most enduring of his ideals—honesty of construction, the truest kind of building craftsmanship.

In his quest he turned to the building type that had sustained his family in Wisconsin: the log cabin. Despite their rarity today, log buildings were ubiquitous in nineteenth-century America. Among the earliest dwelling types introduced into North America by German, Swedish, and Finnish immigrants in the seventeenth century, and later popularized in the upland South by Scotch-Irish builders, the log or horizontal timber dwelling was an archetypal "pioneer" house type.[17] As a German American, Stickley was acquainted with rustic cabins in both Wisconsin and Pennsylvania, though by the late nineteenth century these rude buildings would have had associations with poverty and lower social status. The log dwelling had another more romantic meaning that transcended its rude origins. It was the symbol of one of the central myths of frontier self-determination in American culture, particularly vivid during the Progressive Era.[18] Gustav Stickley was an adherent of the so-called log cabin myth associated with America's rags-to-riches presidents and folk heroes. As he said in a 1907 article introducing the first three Craftsman Log Houses:

> Of all forms of building that remain to us as records of the ingenuity of man in devising places of shelter, none makes such an intimate appeal to the imagination as the house of logs. Especially is this true in this country of comparatively recent civilisation, where it is only a few generations since hardy pioneers were forced to make clearings in the virgin forests, and where the natural thing for them to do was to build shelters of the trees they had cut down. All sorts of traditions and memories of adventure and heroism and the joy that comes from wrestling strongly with the forces of Nature on her own ground are associated with the log house and there is hardly a man or woman who enjoys life in the woods or mountains who would not like to own one.[19]

Stickley's fascination with log dwellings derives from his notions of primitive, simple construction, a retelling of the myth of the primitive hut. It also connects with the vernacular legends surrounding Abraham Lincoln and the several U.S. presidents who were born or reared in frontier cabins. As Harold Shurtleff explained in his study of the log cabin myth,

the most basic tenets of American self-determination and government were encompassed in the image of the humble cabin: "In the nineteenth century Americans began to marvel at their own progress, and to make a virtue of their own struggles with the wilderness. . . . The log cabin came to be identified with 'Old Hickory,' 'Tippencanoe,' and Abraham Lincoln, with democracy and the frontier spirit, with the common man and his dream of the good life." During the Colonial Revival, the homes of America's heroes were increasingly replicated in popular culture, and the log cabin took on a special significance as a symbol of the spirit of hard work and self-determination in a democracy. Stickley's promotion of log buildings was a reflection of a deep and long-standing cultural strain as well as a personal testament. He published numerous articles illustrating log buildings and joining methods, including examples of Scandinavian wood construction. Germans and Scandinavians prided themselves at being the most sophisticated wood-building craftsmen in Europe (fig. 42).[20]

Stickley intended to make his cabin an object lesson in the potential of materials and construction techniques. The principal technical problem to be solved in horizontal log construction is the joining of the logs at the corner. Not only does much of the weight of the structure rest on the four corners, but the joints must also be fixed so as to resist twisting (torsion) and lateral movement from foundation shifting, wind loads, and so on. Moreover, the type of "cornering" utilized is often a telltale of folkways, ethnicity, and regional building traditions. The early American log building was a wooden structure that acted in crucial respects like a masonry one, using a compressive and frictional joint to transfer its loads to the ground. And the log corner was analogous to the mortise and tenon joints of Stickley's early chairs and tables (see fig. 49).[21]

Like his earlier designs for log houses, the bungalows at Craftsman Farms, and Stickley's own house, the Clubhouse was intended to represent its materials and construction "truthfully" (fig. 43). Scholars such as Edward R. Ford have explored the paradoxes underlying this romantic-modernist myth, and Gustav Stickley has often been cited as a purist

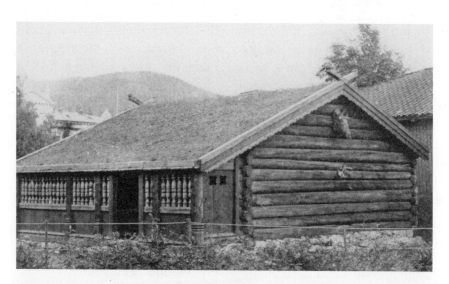

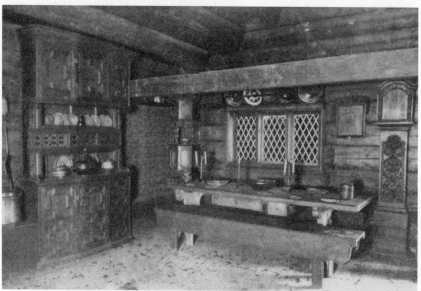

42. Norwegian cabins at Mihaugen, from the *Craftsman*. Courtesy the Winterthur Library, Printed Book and Periodical Collection.

43. Clubhouse at Craftsman Farms, from the northeast, photographed shortly after completion. *Craftsman* (1911).

with regard to its actualization. The meaning of Craftsman houses, like that of Craftsman furniture, was contingent upon direct and transparent representation of structural "facts." Indeed, Natalie Curtis, Stickley's mouthpiece in the first article published on the building, went to great pains to explain each material and technique employed in the construction, so as to underline the virtues of the modernized log cabin.[22] However, there is a riddle to be found in both Curtis's text and the Clubhouse itself: when is a log corner not a true log corner?

In order to unravel this riddle, we must look closely at the way the Clubhouse was made (fig. 44). Details of the construction history of the building have yet to be definitively established.[23] Articles in the *Craftsman* (on both the designed and the finished structure) reveal information that can be compared with physical evidence and with existing working drawings preserved in the Avery Architectural Archives.[24] From analysis of this evidence, we can ascertain that Stickley himself worked

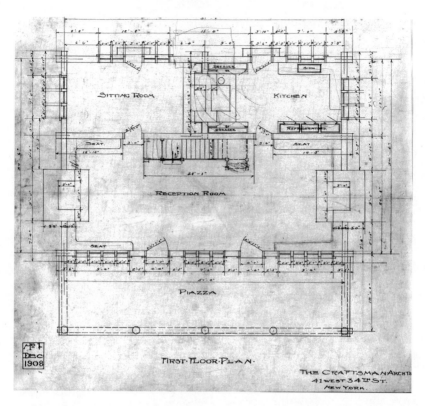

44. Main-floor plan of the Clubhouse or Log House, dated Dec. 1908, produced by the Craftsman Architects. Ink on linen, 19 3/4 x 18 1/2 inches. Note changes made in pencil to the dining room, stair, and rear fireplace. Courtesy Avery Architectural and Fine Arts Library, Columbia University in the City of New York.

on both the design and the construction of the building, in collaboration with draftsmen at the Craftsman Home Builders Club in New York and with artisans in Morris Plains. Although he had by this time designed and realized a number of houses, Stickley was not a trained architect and lacked crucial instruction in drawing, structural design, and detailing. The building was designed in late 1908, drawn and detailed by a draftsman in New York, and hastily revised prior to the start of construction in 1910, probably by Stickley himself.[25]

GUSTAV STICKLEY'S CRAFTSMAN FARMS

The didactic nature of the Clubhouse is evident from first viewing and analysis. It was originally intended to be almost square in plan, approximately 50 feet by 50 feet (fig. 45). The final building is oriented, without regard to site conditions, on a north-south grid, with the main front looking east across an orchard and farm pastures. The ground floor is divided east-west into three long bays: a 14-foot-wide porch on the east, a 13-foot service zone on the west, and a 20-foot-wide central room anchored by

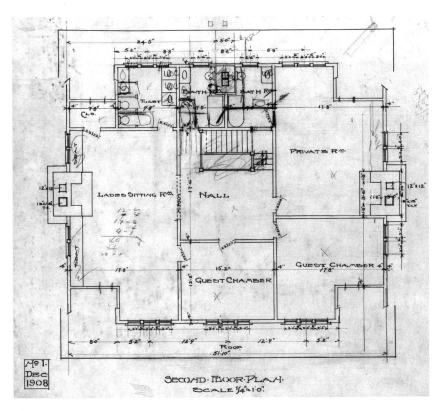

45. Second-floor plan of the Clubhouse, Dec. 1908. Ink on linen, 19¾ x 18½ inches. Changes are again shown in pencil, corresponding to the building as constructed. Courtesy Avery Architectural and Fine Arts Library, Columbia University in the City of New York.

two massive stone chimneys. A modified ground floor plan in the Avery Architectural Archives from December 1908 shows penciled changes from the original design published in the *Craftsman*. Prior to construction, to accommodate a new use as his own dwelling, Stickley converted the service zone into a long dining room and added a 20-foot-by-25-foot kitchen ell to the west side. Because the effect of this addition on the massing of the original cabin was not fully considered, the one-story kitchen is awkwardly joined to the two-story main building. The Avery working drawings indicate all of the revisions to the first and second floor in crude pencil scratches, as if builders were to follow the original design in all other areas. There are no extant drawings of the kitchen wing.

As constructed, the building's foundation is native stone, forming a cellar below the main interior rooms and a parapet wall surrounding an earthen subfloor for the porch (fig. 46). The first-floor structure consists of three penlike bays of log walls and a central spine of log columns bisecting the main room, with log joists spanning from 10 feet to 14 feet. The second floor (dormers, roof, and attic) is built as a virtually separate balloon-frame skeleton resting on the log platform below. This makes a rather discontinuous, hybrid building not unlike the one Stickley proposed as his own house. It also creates an inherent structural problem, because loads from the second floor bear eccentrically on the log structure below. It is not clear why Stickley chose to deviate from the second-floor construction proposed in the original Clubhouse design, a *fachwerke* or half-timber expression exposing the log framework all the way to the roof. The actual building is clad in rustic cedar shingles at the gable ends and between the dormer windows, suggesting, however subtly, that the log structure is limited to the first floor.

The most revealing detail in the building is the treatment of the corners and other intersections of the 17-course-high log walls (fig. 47). Analysis has revealed that these timbers are indeed American chestnut (*Castanea dentata*) from the site, peeled and hewn on two sides, measuring approximately 7.5 inches in diameter. Abundant in New Jersey, this tree made a natural and convenient choice for the builders of early

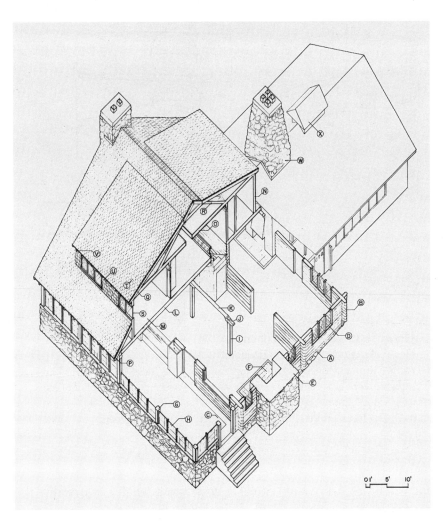

46. Cutaway axonometric, from the northeast, showing principal structural elements, construction, and materials used in the Clubhouse at Craftsman Farms. Drawing by Lori Ryder and Mark Hewitt, New Jersey Institute of Technology.

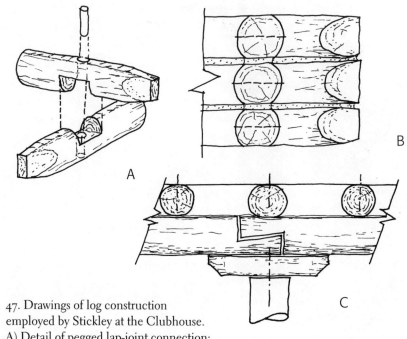

47. Drawings of log construction
employed by Stickley at the Clubhouse.
A) Detail of pegged lap-joint connection;
B) section through corner of typical log wall, showing "false- cornering" wherein
logs align precisely at each course as in masonry construction; C) detail of log col-
umn, bolster, "summer beam" scarf joint, and log joists supporting the second floor
in the living room. Author, after Holt, Morgan, Russell, Architects.

log dwellings. Curtis and Stickley go to great lengths to describe the
method of connecting the logs:

> The fitting of the logs at the corners when they are to be used in the old-time
> horizontal way must be carefully done when each log is ready to be laid in
> position. The irregularity of the logs demands very careful measuring for the
> halving of the corners. The logs are pinned together at the corners with
> wooden pins about an inch in diameter. If the logs are very long, if the house
> is to be a large one, wooden pins are used occasionally between the corners
> to hold the logs together.[26]

The connection described here is essentially a lap joint familiar to carpenters and joiners, but rarely (if ever) used in traditional log buildings. Unlike the simple saddle joint in which each log is notched on top and bottom in a concave depression, the lap joint requires precise mortiselike fitting of each half-log, virtually concealing the joining technique and requiring more precise alignment of the log courses (fig. 48). Pegging the logs, a technique associated more with timber-frame construction, added

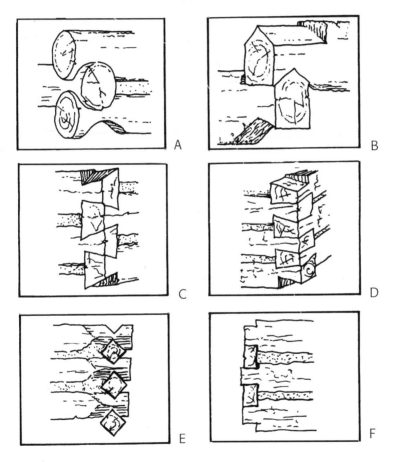

48. Typical log cornering employed in vernacular cabin construction in North America. Author, after Glassie and Kniffen.

stability but also increased labor (and log cabins were significantly less labor intensive than framed buildings). Pegging was necessary structurally to prevent each course from sliding out from the one below, because courses did not alternate as in traditional cabin construction. Thus, the joints were unstable and not "self-binding" as in true log construction. Moreover, at Craftsman Farms the logs are extended beyond their corners approximately 12 to 13 inches to accentuate the rustic associations with "old-time" cabins and represent the spatial subdivisions within the plan. Another unusual innovation is the finishing method used for both the inner and the outer surfaces: Stickley recommends an oil-stain mixture similar to the ones employed in his furniture and advocates staining the cement mortar chinking to impart a uniform color to the walls.

Anyone who has ever constructed a toy "cabin" using Lincoln Logs understands something of the problem with lateral stability in log construction. Lacking either mortar chinking or self-binding corner connections, the toy logs rattle loosely and deform when pressed from the sides (fig. 49). The lap joints used at Craftsman Farms are remarkably similar

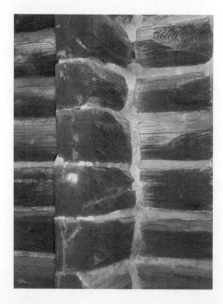

49. Detail of log corner at the Clubhouse, Craftsman Farms. Photo by the author.

visually to the joints of the toy logs, and there is a similar rationale in their design: to "idealize" the log cabin (a word used by Curtis) so that even a child recognizes the archetype.[27] Stickley's cabin is one that a boy would find romantic but that a vernacular builder would find incomprehensible. Hence, the answer to the riddle: Stickley has made a corner that does not express the *structural idea* of a log cabin.

Why, then, did Stickley rebuff vernacular building practices in constructing his cabin? His 1907 series of three Craftsman log cabins, designed by the staff in New York, uses conventional saddle-notched corners, despite other superficial similarities to the Clubhouse.[28] Though we can never know with certainty, the most provocative interpretation of the corner joint is that it symbolizes Stickley's hard-won persona as a wood craftsman or joiner. Writings on his furniture designs (both his own and others' interpretations) point consistently to his understanding of the properties of wood, his feeling for grain and finish, and his celebration of the connections between horizontal and vertical members in chairs, tables, and other furniture. Indeed, in virtually all of his post-1900 furniture designs he hyperarticulates the mortise-tenon-peg or key connections and enlarges the sizes of legs, stretchers, and slats to express their "structural" purpose.[29]

What was the "structural idea" in this log building? By lapping and pegging the logs, Stickley employed a method familiar to furniture craftsmen but impractical in heavy, compressive log construction. He underlined the inherent difference between small-scale, moveable structures such as chairs, which relate directly to the body, and buildings, which are large-scale, earthbound, and subject to larger forces. Because the log building is a hybrid construction type—a kind of compressive, masonry structure built of wood—it represents the contradictory sides in Stickley's personality, the mason-joiner conflict. And his misunderstanding of the structural design issues in log buildings, typical of a nonarchitect, suggests that he was intent upon idealization rather than straightforward structural expression. This tendency toward idealization is one explanation for the curious fact that Stickley and his builders eschewed proved traditional methods of joining the corners, instead choosing less stable

but more didactic ones. Another is the clear desire, expressed in Curtis's article, for a modernization or improvement in the technology of log building: a new finishing method is advocated; cement mortar rather than mud is used for chinking; foundation support is improved. "To the strength, the courage and the honest effort typified by the primitive log cabin," Curtis zealously declared, "art has here added the grace of beauty and science the requisites of comfort." With these improvements, it is suggested that log buildings will "last from generation to generation" rather than being reclaimed by the elements within a single lifetime.[30] Of course, part of the organic quality of the log building is its relationship to the life cycle of its wooded environment: harvested from the forest, it eventually decays and is recycled. The cabin, in short, was an illustration of craftsmanship rather than structure, an idea informed by artifice rather than a building made with vernacular methods.

Indeed, the craft of the mason, the joiner, and the carpenter is aptly illustrated in each component of the Clubhouse. The foundation and chimneys are laid in massive, rubble fieldstone, a coursing style that idealizes the primitive origins of stone construction. On the upper floor, the stud framing of the interior and exterior walls is sheathed in wood on both sides, an unusual practice that makes it possible for carpenters to manage the entire process (rather than employing a plasterer). To give the impression of plastering, interior surfaces that were not wallpapered were covered in canvas or cardboard before painting. To provide stability, the interior walls were sheathed in tongue-and-groove boards, a labor-intensive practice that would likely have been avoided in standard house construction but probably appealed to Stickley's cabinetmaker's aesthetic. The upstairs rooms have less built-in cabinetwork than either the 1908 Clubhouse design or the "Craftsman's House," probably a concession to the cost of materials and labor. These rooms were fitted out by cabinetmakers brought from Syracuse to do the work.[31] Their color schemes—yellow ocher and blue-gray—were designed to harmonize and complement the dark gumwood trim and oak furniture.

Stickley's tendency toward didactic, idealized construction at the expense of practicality and expediency is complemented by a kind of spatial and social idealization of the house itself. From his writings we know that the *Craftsman* saw the traditional Old World values of home, family, and agrarian life being eroded by materialism and capitalism. And we know that he associated many negative values of commercial capitalism with architects and builders who did not adhere to Arts and Crafts principles. So it is consistent with these beliefs that the Clubhouse be a critique of the complex and overwrought houses that wealthy capitalists of Stickley's generation were building in the country. His own house would epitomize "the simple life."

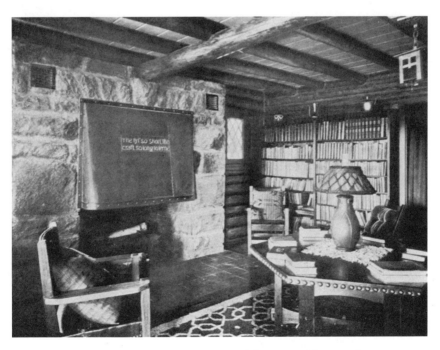

50. Living room, south fireplace, photographed during Stickley's residence. *Craftsman* (1911).

One of the primary ways in which simplicity is demonstrated is in the large multipurpose rooms of the Clubhouse. As in many Craftsman house plans, all of the ground-floor rooms are rectangular, and each was to serve several purposes. The middle room took on the greatest significance, as a gathering place for family and group entertaining (a piano stood under the staircase), while also serving as the master's library (figs. 50, 51). Bookshelves, which could not be built-in because of the monolithic log walls, were placed against them. The porch, initially designed to be an open veranda with log columns, was enclosed and screened for outdoor dining and living. Connection to the living room was facilitated by two screen doors and three banks of casement windows—breezes flowing through the veranda blew into the otherwise sparsely ventilated middle of the house. The dining room (see fig. 55), though too long for convenient family eating, was subdivided by the large hearth, a specially

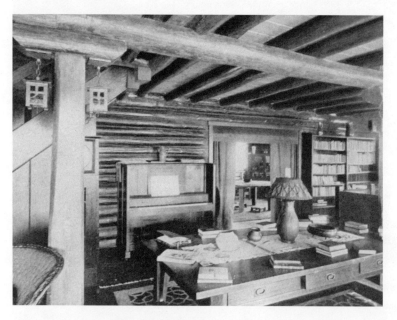

51. Living room looking northwest, stairway on left. *Craftsman* (1911).

GUSTAV STICKLEY'S CRAFTSMAN FARMS

designed sideboard, and two smaller tables. Yet, all of the furniture and other decor was conceived to give the impression of a "show house" that would impress others as evincing the Craftsman ideal—a pure and didactic simplicity. There is a self-consciousness to each space, each detail, which belies an interest in the cultivation of domestic comfort. (Ironically, the special ventilating Craftsman fireplaces utilized to heat the main room did not work.) So here was a "picture" of the simple life that necessitated some rather complicated functional and pragmatic compromises.

Upstairs, four bedrooms and three baths, converted from the guest rooms in the original plan, must have made difficult sleeping accommodations for the large family (fig. 52). The plan provides little privacy among the sleeping and bathing rooms. And, strangely, there was no work space provided for Stickley's writing, as in his original design for

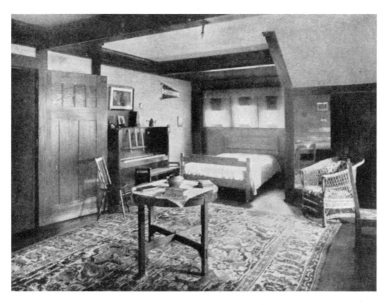

52. Large bedroom or chamber on second floor, looking east. This room served as a bedroom for Stickley's teenage daughters. *Craftsman* (1911).

the "Craftsman's House." Thus, there is a kind of paradox in the apparent informality and lack of specificity in many of the spaces. Was the building a family home or a communal hostelry? Where were the conventional gender- and age-specific zones of public and private space? Why did even so large a family need a giant, almost commercial kitchen? Were there servants, and where would they work and sleep? Any examination of the building in comparison with even progressive houses of the time begs such fundamental questions. Stickley's cabin not only contradicted its structural idea, but also deviated from its type, the "little cabin home on the hill" so prominent in folklore. Intended first as a communal clubhouse or guest hostel, then as a temporary home, it never served its original purpose. Even after the Stickleys sold the building in 1917, it was refitted as a single family home and served that purpose until 1989. Only recently has it been put to something approximating its original function, as a museum for the display of Arts and Crafts furniture.

Although the Clubhouse communicates great charm and warmth, both as a building in a rural environment and as a set of homelike spaces, it does not compare favorably with works of other Arts and Crafts–influenced architects—the Greene brothers, Wilson Eyre, or Irving Gill (all designers published and admired by Stickley).[32] The exterior proportions are clumsy, the fenestration is haphazard, and the massing offers little to distinguish the building from the most utilitarian architecture found in many rural areas. The rooms, without Stickley's distinctive furniture, lack focus and spatial variety. The ceilings of the first floor appear low in proportion to the size of the rooms, a design consideration generally resolved in studies of the building section. As architecture—as space—the building does not promote the kind of aesthetic interest that its creator fervently sought in the objects he designed.

This lack is in part because Stickley adhered quite literally to the principles in his Arts and Crafts texts: a building that expressed its function, construction, and materials in the simplest and most honest manner would, ipso facto, achieve aesthetic value or beauty. And, unlike visually

trained architects, Stickley was not adept at conceptualizing and designing spaces, masses, and forms in three dimensions, forms too large to be constructed in a workshop. The Clubhouse was conceived somewhat in the vernacular manner of the frontier—to be made from materials near at hand, using methods passed by word of mouth from builder to builder. Yet, it was also a large and complex piece of architecture, built of hybrid systems and containing many different kinds of spaces, drawn first by a draftsman in New York City. The clash between the vernacular craft tradition and the more modern design method of the professional architect is evident not only in the Clubhouse but also in many other Arts and Crafts–influenced buildings. Various architects, such as Wright, Greene and Greene, and Philip Webb, concealed or managed the contradictions between theory and practice and resolved spatial and constructional problems through drawing and consultations on the site.[33] Stickley conceived his building as furniture, drew it hastily, constructed it in a workshop atmosphere, and was thereby compelled to leave these contradictions exposed.

Life as Art at the Farms

The complex of twelve buildings at Craftsman Farms was essentially complete by the fall of 1911, when the first photographs of the Clubhouse were published in the *Craftsman*. The Stickley family staged a party for the daughters as a kind of coming out, attended by local Morristown residents and friends from New York during the summer of that year. As the local paper reported: "There were sixty young people of Morristown and Morris Plains in attendance at the dance given by the Misses Margaret Hazel [sic], Marion and Ruth Stickley at their home at Craftsman Village. This is the first entertainment to be given in the new home just constructed by their father, Gustav Stickley."[34] Guests would have seen the Clubhouse at its best, with new Craftsman pieces installed from Syracuse, fabrics, books, metalwork, and other interior fittings filling out the picture of the perfect Arts and Crafts home. The grounds were taking

shape, groomed with the help of an unidentified gardener hired by Stickley to create a natural oasis in the Jersey hills. Finally, Gustav had his family about him in the home he had promised to create. For six years the estate served as a compound for the daughters, their father and mother, and a retinue of servants and farmworkers. Son Gustav Jr. was conspicuously absent, sent to boarding school and kept aloof from the family nucleus.

There is little in the historical record that indicates how the Stickley family used the farm, or how they carried on their daily lives. Oral histories from interviews with the daughters give a partial account of the years spent in New Jersey, but memories of the time are vague and often contradictory. Photographs published in two major articles on the complex show an idyllic and carefully staged setting, with family members engaged in bucolic agricultural work in concert with their father. There is a

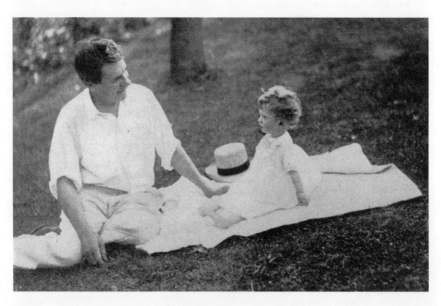

53. Gustav Stickley with his grandchild at Craftsman Farms, circa 1912. *Craftsman* (1912).

famous photograph of Stickley and his granddaughter sitting on a grassy knoll, indicating a relaxed and tranquil life that varied considerably from the storm that was soon to beset him (fig. 53). A daughter feeding chickens, wide pastures filled with Holsteins, gardens tended with great care, and a neat, tidy complex of buildings were portrayed in the 1911 and 1913 articles in the magazine.

Published interior views of the house show a variety of archetypal Craftsman pieces and decorative arts. In the main room were several leather-seated armchairs, a Morris chair, a classic settle, and a leather-covered hexagonal library table. In the center of the space was a wide desk and a wicker chair; on the staircase wall Stickley placed a specially designed piano and a tall clock. Arts and crafts books lined the walls and were placed on tables (fig. 54; see fig. 51). Craftsman electroliers were suspended from the column bolsters, while pottery table lamps and

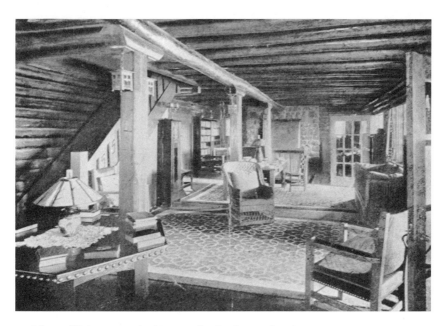

54. View of living room, looking north. *Craftsman* (1912).

Rookwood pieces adorned the tops of furniture. Between the main rooms Stickley hung "Wild Rose"–design portiers, similar to the ones advertised in his 1910 catalog.[35] The blue and green of the fabrics were complemented by rich leather and green and white Stickley-designed carpets. In the dining room, a long Craftsman sideboard was designed as a centerpiece on the log wall, flanked by smaller drop-leaf tables and straight-backed dining chairs (fig. 55). Two glass-fronted, gridded china cabinets were placed in the corners of the room, framing a large, round dining table. No photographs show the kitchen, and only one view of the large girls' bedroom was published.

The ultimate impression given is one of a showroom packed with the most impressive examples of Craftsman decorative art. Indeed, the photographs and interior arrangements are reminiscent of Stickley's self-

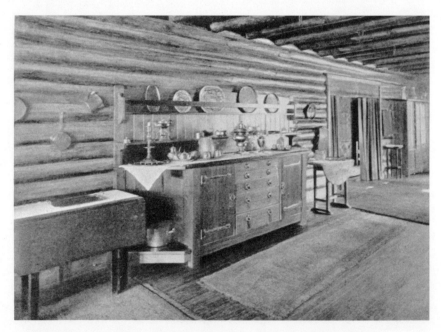

55. Dining room showing special sideboard and tables. *Craftsman* (1912).

consciously artistic interiors for his first architectural project, the Colum-
bus Avenue house in Syracuse, designed in 1901 (fig. 56). These interiors
were made for didactic purposes, to be published, with deliberate picto-
rial and decorative qualities that could be recognized by *Craftsman*
readers.

The pictures, published as propaganda, do not always square with the
memories of family members who lived for several pleasant years in the
Morris Plains area. Marion Stickley Flaccus, the fourth of five daughters,
remembers a period of relative prosperity and serenity after the girls
moved with their mother from Syracuse. Barbara, the oldest, was already
married to Ben Wiles; both were active in the family business in New

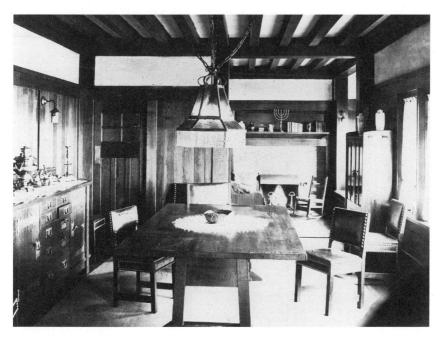

56. Columbus Avenue house, Syracuse, interior of dining room furnished with
early Craftsman pieces. Courtesy the Winterthur Library, Decorative Arts
Photographic Collection.

York. They lived in a cottage near the Clubhouse with their young child. Marion (Mrs. G. W.) Flaccus, born in 1895, was sixteen when the family came to the Farms and had attended a private school in Syracuse before coming to Morristown High School to finish her education. Her stories, told while in her eighties, provide some of the few glimpses of the family as a whole, with father and mother together in New Jersey.

Gustav, it appears, was actively involved in the running of the farm, taking an interest in livestock (horses, Holstein cattle, and chickens) and spending the early mornings on the property before taking the train to New York (fig. 57). As his daughter put it: "[H]e got up at 6:00 AM every morning and went over to the farm. He loved our farm. That would keep every body busy. . . . I mean getting the men started in the morning. . . . He liked to be active. I don't know how he ever did so much. . . . He was some man" (fig. 58).[36] Running the estate like his business, he had Japanese workers as garden and service staff and a group of local men hired to do farmwork. Strangely, there were no furniture makers or other

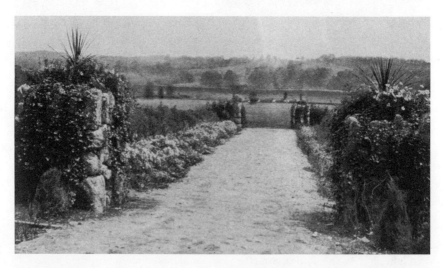

57. Pastureland at Craftsman Farms, circa 1911, looking eastward from gates near Clubhouse. *Craftsman* (1912).

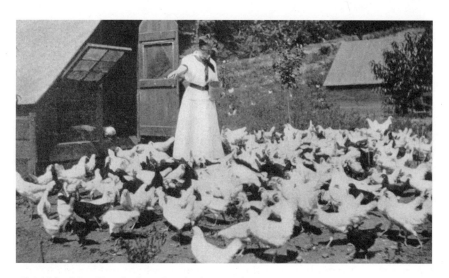

58. Mildred Stickley feeding the chickens at the Farms, circa 1912. *Craftsman* (1912).

craftsmen on the site during the six years of family residence. Business was conducted strictly at the company offices in New York City, where Gustav would spend his workdays, much as Davenport did. Family friends included Daniel Merchant, the Morris Plains general store owner; photographer Daniel Parker, for whom Gustav designed a home; Davenport; and members of the Morristown business community. Editorial staff from the *Craftsman*, including Mary Fanton Roberts and other "women from New York," were often present as guests at the house.

The girls were encouraged to have parties and to socialize with the best of Morris County society but also brought friends from upstate New York to stay at their new home. Eventually, two of the daughters, Marion and Mildred, were married at Craftsman Farms. The couples were then invited to live in cottages specially built for them. When Barbara and Ben Wiles outgrew their small bungalow, Gustav designed a larger brick Craftsman house for them and published the plans in his magazine. The family was treated to the best a rich man's income could provide—new

automobiles and trucks, consumer goods, and a lifestyle quite different from their years in Auburn and Syracuse. Eda Stickley must have been particularly pleased, as she had grown up in a relatively prosperous family. "My father," Mrs. Flaccus recalled, "when he fell in love with my mother, and her family were very high society and when she wanted to marry my father they disowned her."[37] Stickley's embarrassment may help to explain why he so zealously pursued the lifestyle of a wealthy businessman and set his family up in Morris Plains among some of the social elite.

Mrs. Flaccus remembers a close-knit family and an atmosphere of happy socializing among residents of the Morris Plains community. Her father liked to gather his girls around him at the piano in the living room or sit quietly by the fire in the evening with his wife. "I know every Sunday night, no matter who was there, we would get around the piano and sing hymns, all evening. . . . He was going to be a minister. He was very religious." Her recollections indicate a typical Victorian deference to domestic life, especially toward his daughters. His son did not fare well: "[M]y father was hard on my brother. . . . I think just because he was a boy. He probably thought he should be." Gustav Jr. was sent to military school and is seldom mentioned in literature on the Stickley family. There may well have been a reenactment of father-son animosities between Gustav and his only boy as an echo of childhood traumas at the hand of his own father. These facts, like many other unpleasant secrets, were never spoken about among the girls or with their mother. Stickley maintained a tight-lipped posture toward even his own family about his business, his past, and his relationships with his brothers. Between 1911 and 1914 the girls—Ruth was in a Morristown public school and her sisters of marriageable age—saw only a busy, typically aloof Victorian patriarch who gave them the attention they expected from a man of his time.[38]

After three years in residence at Morris Plains, Stickley's business troubles overtook him. The bucolic picture of an artful family life in the country came to an abrupt and tragic end. Apparently without informing

his family of his business difficulties, Stickley secured a fifty-thousand-dollar note as a second mortgage on his New Jersey properties to stave off creditors. Unfortunately, his defensive strategy came too late—he had built up debts far greater than the net worth of all his companies and enterprises. As Mary Ann Smith pointed out in her study of Stickley's life, the 1913 opening of the Craftsman Building in New York and the introduction of the ill-fated Chromewald furniture line were designed to increase falling revenues, but instead they hastened the demise of his empire. Even his income was drastically reduced after 1912, making the illusion of wealth in Morris Plains more difficult to sustain. On March 23, 1915, Stickley filed a bankruptcy petition in New York. The *New York Times* carried two items on the collapse of the Craftsman companies, eventually reporting that total liabilities amounted to $229,705.64.[39]

After a period of depression and hospitalization, Stickley left his family in Morris Plains to find work in Kenosha, Wisconsin, where he worked as a consultant for the Simmons Furniture Company. He was briefly employed by his brothers Leopold and J. G., who eventually took over the Eastwood factory and continued to produce Craftsman pieces. Mary Fanton Roberts continued the *Craftsman* until 1916, when it was incorporated into *Art World*. But there was to be no respite from mounting personal troubles—Eda Stickley died in 1919, and the family continued to drift.

One year before Eda's death, an extraordinary family visited the Craftsman Farms site in Morris Plains. Maj. George Weinberg (later Farny) made an offer on the property before going to France to serve in the Army Corps of Engineers. Weinberg (1871–1941) was a Russian Jew who had already distinguished himself as an engineer before emigrating and becoming a naturalized U.S. citizen in 1901. He married Sylvia Wurlitzer, the wealthy heiress of the Cincinnati organ and jukebox company fortune, in around 1895. The family name was changed to Farny, her mother's maiden name. Both husband and wife were to leave a large mark on Morris Plains and New Jersey during their long residence in Morris County.[40]

On September 1, 1917, Mrs. Weinberg (Farny) and her two children moved into the Clubhouse, supplanting the remaining Stickleys. Marion stayed on in New Jersey, while the other sisters returned to Syracuse. The *Jerseyman* reported that Major Weinberg had paid just one hundred thousand dollars for 650 acres of land and all of the buildings, "less than half" of what Stickley had expended to create the compound.[41] Cyril, the youngest son, remembered a house that seemed to have been left abruptly, with contents intact, and a site full of history:

> [W]hen we moved in, everything was there. All the books were on the shelves—... but the cows were in their stalls and the horses were in the barn and so forth. And there was a farmer who lived in the little farmhouse down there whose grandfather [Garrigus] ... was really a native of the place. And there was a herdsman who lived in the house that Stickley built up there near the barn, which has burned down since then. So these people came with the place, you might say.[42]

So the actors who had fashioned the historic landscape lived on with the addition of the Craftsman's stories. As Gustav Stickley's interventions faded, others were added to the site, and the artifacts lived on in other uses. The Farny family found much to admire about Stickley's Arts and Crafts ethos and continued to develop the property with new gardens, a swimming pool, and an annex to the house. In 1946 Cyril Farny and his wife moved into the Clubhouse and redecorated, living at Morris Plains until the late 1980s (see fig. 84). Many of Stickley's original decorative features were retained, and much of his furniture remained in the house until 1989, when pieces were auctioned off prior to the preservation of the site.

Stickley's buildings, gardens, farming activities, and landscape interventions form a web of interconnected artifacts that together define the meaning of Craftsman Farms as a place. Visitors today see a landscape that looks primordial, historical, and largely outside the experience of ordinary late-twentieth-century Americans. Yet, the meaning of this unique

Arts and Crafts environment is buried deeper in the intentions of the makers and the historical record of their acts than a surface reading may unveil.

When he created his utopian farm, estate, workshop, and school, Gustav Stickley brought together aspects of his own character and personal history, laying them upon the New Jersey site as artful interventions. Economic, personal, and psychological factors prevented him from molding the land as radically as he might have liked, yet the gentle and incomplete gestures he made speak firmly of his convictions as an artist and social reformer. When we add the sum total of his actions to the already rich geography of this place, a picture emerges that helps to explain the meaning of Craftsman Farms both as a utopian compound and as a personal testament.

The first term in this equation is the location that drew this Wisconsin native to the hills of New Jersey. Whatnong Mountain and Morris Plains lie at the edge of a clear boundary—in fact, just outside a familiar realm for inhabitants of the New York megalopolis. The Craftsman Farms site is on the cusp of a major geological and social divide—glacial time divides the memory of one boundary from the other by millions of years, yet the dividing line is very real nonetheless. What was once the edge of a glacier became for Stickley the brink of a societal threshold—between those people who would change society and the ones who would cling to traditions, between the daring and religiously zealous and the commonplace, between the insane and the normal, between a rugged individualist and the increasingly conservative oligarchy that would rule twentieth-century America. Stickley's choice of a site was an unconscious decision to stand very slightly apart from his milieu, yet also to embrace something common and safe in the country his parents had chosen, fleeing European oppression.

By working in New York and then coming to Morris Plains, this progressive businessman and artist could stand both as a rebel and as a quotidian, populist representative of the workingman. Near Mount Tabor and the Greystone Asylum, amid the farmers of Morris County, he was

an American Babbit, a fiercely tragic hero among other outsiders. Among the elite of Morris County, however, including Homer Davenport, he chose to stand with the powerful capitalists who would come to dominate society as the century progressed. The messages that his buildings and gardens provide show just how this ambivalence toward wealth, family life, society connections, and domestic symbols grated against his professed Arts and Crafts ideals.

The 650 acres of picturesque New Jersey land that Stickley assembled were largely rural farms that he intended to save for agricultural cultivation; the fact that he maintained residences for some of the former farmworkers indicates the seriousness of his wish to see his childhood landscape preserved. When he cut his chestnut trees to make an elaborate cabin, Stickley was likewise grasping for a romantic, lost symbol of American self-sufficiency even as he sold mass-market suburban houses to those people who would eventually drive farm families from their land. His sense of loss, like the romantic wish to preserve "country life" that resulted in a popular mass movement at the century's turn, compelled him to make an individual statement about the durable, pioneer values that had propelled Americans toward their destiny throughout the nineteenth century—to conquer and eventually subdue the land that had once overpowered them.

We now come to the second term in the equation—Stickley's individual artifacts. His furniture lay at the heart of all creative endeavors at Craftsman Farms. To make a chair, a cabin, a garden, a tapestry, a piece of tableware as one's own art was Stickley's highest ideal. At his own creative compound, he sought to teach others how to bring everyday crafts into their lives. Yet, when he faced the harsh economic reality of making his own home in a place near America's metropolis, distractions of business life prevented him from devoting himself to the artful design and craftsmanship that he admonished his readers to pursue. The sheer cost of his ambitious endeavor was another obstacle that could not be overcome. Like other reform-minded builders, he realized only a small fraction of his goals at Craftsman Farms. And when one analyzes the

resulting buildings, landscape spaces, and interiors, the end products do not match the best decorative art and architecture of the period—even the finest efforts of Stickley's own commercial workshops. The strange construction of the Clubhouse provides the clearest exposition of Stickley's dilemma—how to make a building that speaks of its construction as honestly as a well-built chair or bookcase. How also, he seemed to ask, might men and women reclaim the right to create their own home places, not simply with consumer choices but also with the purer acts of work and craft?

The answer he provided in physical form (as he did in his splendid furniture) is blunt and honest, if also rather muddled. The buildings, farms, and gardens at Craftsman Farms add up to a truncated and rather tragic exposition of just those dichotomies that forced other Arts and Crafts reformers to abandon their high ideals and look for smaller and ultimately more elite forms of personal expression. The dissociation in modern society between work and everyday life, between high art and everyday craft, between costly material goods and cheap mass-produced ones, between architecture and utilitarian building could not ultimately be bridged by one man and his quixotic woodsman's utopia. When we look with wonder at the modest buildings and bucolic landscapes of Craftsman Farms, their ultimate message may be that physical artifacts such as architecture can catch only the messy spirit of an age such as the Progressive Era, conveying meanings that project beyond the intentions of their makers, and expose their fallacies as well as romantic ideals. It remains, finally, to explore how the relationship between buildings and other designed artifacts defined Gustav Stickley's flawed ideals as a businessman, artist, and social architect. Why, ultimately, did this chair maker turn to buildings?

# 5

# Architecture and Craft

## The Craftsman House

ALTHOUGH HE WAS NOT trained as an architect, Gustav Stickley clearly saw himself as a designer of innovative American homes. He published three popular books of home designs, produced more than two hundred mail-order house prototypes, and saw many houses constructed throughout the United States.[1] As he said, "I sometimes feel that the greatest good that can be done for any nation is to build for the people a house in harmony with the ideal of that country." His ultimate project at Craftsman Farms was to construct a complete architectural laboratory that would demonstrate the qualities of simplicity, honesty, sincerity, and structural directness that he saw as the core principles of Craftsman architecture. Craftsman Farms was a physical adjunct of the Craftsman magazine and home plan service, where one would expect to find the purest and most succinct expressions of Stickley's architectural ideas.[2]

These core ideas were as pluralistic as Stickley's social prescriptions. Like all products of the Craftsman movement, the new architecture was fundamentally democratic, progressive, and utopian. The owners of Craftsman homes were members of an extended family attached to Stickley's utopian compound by virtue of their subscriptions and their idealism. They collectively believed in an architecture that was fresh, inventive, and newly minted, while also traditional, individual, and American—an indigenous architecture created by one of America's reform-minded designers, inspired by the archetypal buildings of the

American vernacular landscape. Stickley hoped that his populist style would sweep away all other forms of building, as Americans saw the logic and practicality of simple, well-built homes. He believed that this new form of building would emerge from the people's will—not from architects or factories but from a collective desire for beauty and practicality in the home environment. "We have not yet quite begun to realize that the great mass of American people have moderate incomes with an unusual degree of mental cultivation," Stickley wrote in 1908. "And so I have striven to build the Craftsman house with as much comfort and beauty as the most intelligent would require, yet so to plan and develop it that it should be within the means of the moderate salaries which prevail throughout the country."[3] Stickley and his followers saw the same kind of popular appeal in Craftsman buildings as in chairs, textiles, lamps, and hardware. The total "home grounds" would be unified through Arts and Crafts aesthetics; social reform would evolve via the transformation of that domestic environment. Publishing his first house designs as experiments in 1902 and 1903, Stickley formed the Craftsman Home Builders' Club (CHBC) in 1904 to offer designs by mail to subscribers to his magazine.[4]

The vast majority of these Craftsman houses were designed by a small group of draftsmen employed in his New York offices under what must have been cursory supervision from the busy company president. After initial collaborations with architects Harvey Ellis, Ernest W. Dietrich, and Samuel Howe, Stickley worked mainly with anonymous draftsmen.[5] Most homes were constructed by their owners from rudimentary working drawings purchased from the CHBC; with Stickley's encouragement, they changed details and materials freely as conditions and budgets dictated. This practice led to an inevitable mixing of architectural results that often makes the "authentic" Craftsman house virtually indistinguishable from many contemporary mail-order builder- or architect-designed homes.[6] Add the fact that Stickley's sources were themselves eclectic, and it is difficult to assemble a clear-cut description of the typical Craftsman house. Nevertheless, there are principles, stylistic attributes, and typological characteristics that may be analyzed to

reveal the core characteristics of Craftsman architecture. This chapter examines the critical question of how this architecture was conceived to address the disjunction between designer, builder, and user; how it dealt with problems of technology, handicraft, and new building materials; how it related to vernacular design and the simple life; and ultimately how it connects with other American domestic architecture of the early 1900s.

The first premise to be understood is that Stickley designed his houses during a period of significant change in American society and concomitant innovation in the design of middle- and upper-class house types. Although he and others have maintained that his designs were unique, most features of the Craftsman house can be found in earlier prototypes designed by architects, plan-book sources, or in the vernacular types that he admired such as the midwestern farm dwelling or log cabin.[7] Stickley had his aims clearly in mind when he began to design houses in 1903, and he wrote about them succinctly. But when it came to making architecture he often borrowed what he needed and reassembled features to make a new whole—a synthesis much in keeping with the prevalent eclecticism of the period. He intended to offer middle-income Americans a complete range of domestic solutions tailored to the prevailing needs of the time: economy of construction, durability, family size, functional efficiency, and constructional variety (using the full range of available materials and technology). He was hardly the first designer to attempt to do so (pattern books from H. H. Holly and A. J. Downing to Sears and Roebuck reflected the same goals), but he tapped a strong sentiment in American culture by making his case so vividly in his books, pamphlets, and magazine articles.[8]

The cottages and Clubhouse at Craftsman Farms are archetypal examples of the kind of house Stickley espoused as ideal for middle-class families. Proclaiming their virtue through practical organization of space, simple "do-it-yourself" construction, and honest representation of materials, they underlined the ideology behind Craftsman designs. As he did with the Farms project, Stickley conceived the Craftsman house as a

didactic program, then set about creating designs to match his concepts. In his major writings on the subject, he outlined the characteristics that form the core of all genuine Craftsman houses:[9]

1. Simplicity of form, plan, construction, and function;
2. Regularity of outline and plan;
3. A low-profile roof pitch, giving a more "homelike" feel (bungalow-like);
4. Constructed of materials indigenous to site, that is, "natural," and durable;
5. Honesty in construction and use of materials (no "useless" ornament);
6. Economy of construction and use of space (no "wasted" space);
7. Maximum potential for indoor-outdoor living, garden spaces, and site views;
8. Open and flexible interiors—multiple-use spaces, minimal partitioning; and
9. Democratic in spirit.[10]

Although there is considerable variety among the two hundred–odd designs produced by the Craftsman service, a remarkable consistency is maintained in the adherence to these core principles. We may initially observe that they are closely analogous to the principles set down by Frank Lloyd Wright some years later in his writings on "the natural house" and that they reflect the myriad prescriptions for reform in the domestic environment published by writers and designers in the Progressive Era.[11] In other words, Stickley set down the political and social menu for what Americans seemed to want in their post-Victorian dwellings and then sought to serve them à la carte. Moreover, he echoed the major prescriptions for honesty and sincerity in construction, the modern spirit of functionalism, and the emphasis on craftsmanship that were recorded earlier by English Arts and Crafts proponents and subsequently appeared in architectural manifestos of the modern movement.

As a modern reformer, Stickley outlined a memorable platform for a new form of American domestic architecture—his architect colleagues, from William L. Price and Wilson Eyre to Frank Lloyd Wright and George Washington Maher, were voicing the same rhetoric in 1900.[12]

But unlike an architect, Stickley approached the design problem as a manufacturer, businessman, and craftsman: to wit, begin with a small number of basic prototypes (as in his line of armchairs), perfect them, and then expand the line, adding features to suit the market. His model homes were designed in a variety of material and constructional forms and revised to fit different climatic and social conditions. In keeping with his shop methods, Stickley began his program by drawing upon a range of houses from the American vernacular landscape: the farmhouse, suburban house, pioneer cabin, and bungalow, all popular "democratic" house types appealing to middle-class *Craftsman* readers.

The cottages he constructed at Craftsman Farms are examples of the simplest and most direct of these forms: the bungalow. Riding the craze for this populist house form after 1900, Stickley's designs were intimately connected with designs of other bungalow proponents such as the Greene brothers, Myron Hunt, Elmer Grey, and Henry Wilson in California.[13] As many as one hundred Craftsman designs were either named or based upon the classic bungalow form—a low-slung, one-story gabled house with overhanging eaves and a prominent porch. Two variants similar to the Craftsman Farms cottage, one in concrete and the other in shingles, appeared in the 1913 *Craftsman Houses* pamphlet (nos. 81 and 116) (figs. 59, 60). All three houses use the same plan type and overall form—a low gable roof and porch covering an oblong, rectangle-shaped (almost a square) plan. Although one has three bedrooms and the others two, the basic plan disposes the rooms in a similar manner around a central hearth. Typically, rooms are divided in a rather strict grid of wall partitions, each drawn as a simple rectangle. There are virtually no hallways ("no wasted space"), and the building footprint (square footage) is frugal. The multiuse living room occupies the center of the plan, sporting its familiar hearth and inglenook; the roomy kitchen is at the back.

59. "Two Story Cement Bungalow." *Craftsman Houses* and *Craftsman* (Dec. 1909).

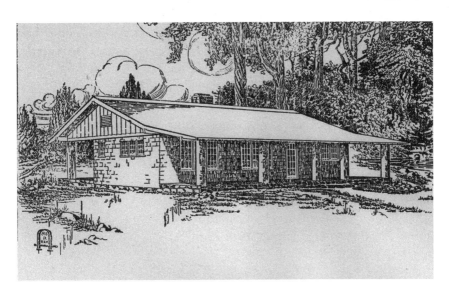

60. "Craftsman Shingled Bungalow," No. 116, in *Craftsman Houses* (1916).

Descriptions of the houses are terse and functional—materials, advantages of the plan arrangement, construction, and economy are emphasized. This design is the essential recipe for a Craftsman house—to some memorable and boldly simple; to others, such as Frank Lloyd Wright, "as plain as a barn door."[14]

Indeed, Stickley's agrarian sensibility favored barnlike characteristics: another preferred type was the midwest farm dwelling. His first attempt at updating this form was published in 1906 (fig. 61), another more sophisticated variant several years later, leading to many similar models. "Plain and wholesome" was the epithet pinned on the latter in the *Craftsman* of March 1909. Stickley underscored the flexibility and openness of the plan: "There is hardly anything to mark the divisions between the reception hall, living room and dining room, so that these names rather serve to indicate the uses to which the different parts of this one large room may be put than to imply that they are separate rooms."[15] Another salient characteristic was the "broad and low" profile of the roof and overall massing. Stickley, like Wright, favored horizontal rather than vertical lines to emphasize connections among the house, the horizon, and the landscape—even two-story Craftsman houses often hide their second floor under dormers or wide, overhanging roof volumes. This particular solution, using a transverse dormer, is one of the two most often employed by Stickley. The other, a long eyebrow dormer, appears in the Clubhouse and numerous other Craftsman models. A rustic variant appeared in the same issue of the *Craftsman* (December 1908). This long-gabled type with an integral porch along one side became the most popular of all Craftsman models, even appearing in full two-story variations. If there is one picture that captures the essence of Stickley's ideal home, it is this cottage-farmhouse settling firmly on the earth under its generous roof.

The third "vernacular" form preferred by Stickley is already familiar to us—the log house or cabin. Introducing his first series of log houses in 1907, he continued to develop rustic houses for vacation and year-round living throughout his most productive years as a designer (figs. 62, 63).

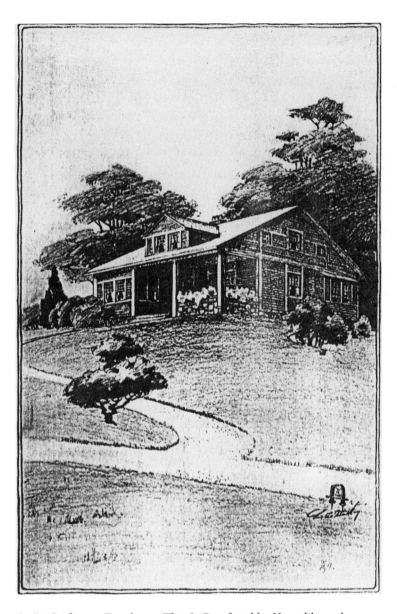

61. "A Craftsman Farmhouse That Is Comfortable, Homelike and Beautiful," *Craftsman* (June 1906).

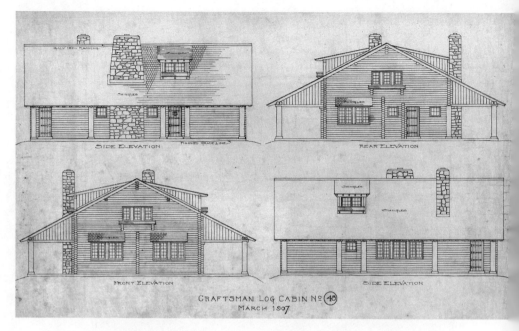

62. Elevations of Craftsman Log Cabin No. 48, Mar. 1907. Courtesy Avery Architectural and Fine Arts Library, Columbia University in the City of New York.

When one adds the more rustic bungalow and "camp" designs to this list, several dozen designs are available for study, particularly in *More Craftsman Homes* (which published photographs of Craftsman Farms to open its log house series). These designs are notable not for their plans or general arrangement but for their direct expression of wood structure. The most illustrative is "Craftsman Log Cabin No. 48," for which complete working drawings exist in the Avery Architectural Archives. The plan utilizes an unusual (and nonvernacular) grid pattern suggesting columnar construction. In fact, a hybrid of log columns and alternating saddle-notched "pens" are employed to allow for both porch space and walled rooms. The result is a crude and not terribly functional arrangement of structural partitions, yielding a dark and low-ceilinged interior

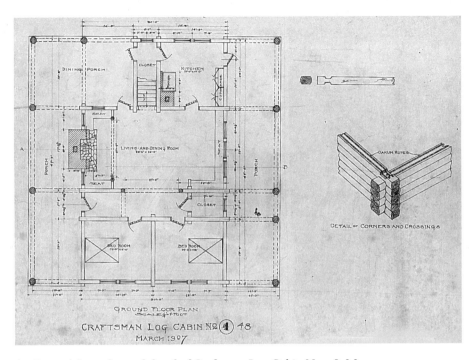

GROUND FLOOR PLAN

CRAFTSMAN LOG CABIN N⁰ ④ 48
MARCH 1907

63. Ground-floor plan and detail of Craftsman Log Cabin No. 48, Mar. 1907.
Courtesy Avery Architectural and Fine Arts Library, Columbia University in
the City of New York.

living room and small bedrooms ringed by porches. Compared to the
simpler and more archetypal "Summer Bungalow of Logs" (No. 122), in
which the single living space more nearly replicates pioneer types, Stick-
ley's experiment with log structure is rather unpersuasive (fig. 64).
Single- and double-pen pioneer cabins no less than dog-trot types were
cellular and structurally primitive—very different from the modern
three-bedroom suburban dwelling. Nevertheless, Stickley romanticized
the pioneer dwelling as a suitable form for "rustic" and vacation houses,
presaging a continuing fascination with primitive log construction to this
day. By 1928 Chilson Aldrich would jump on the bandwagon with his

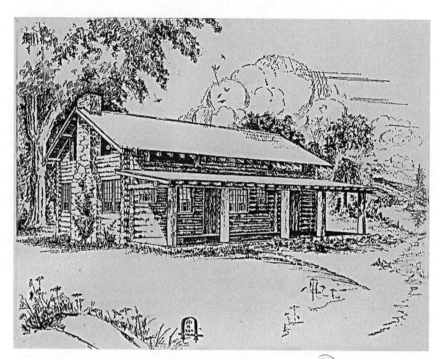

64. "Log Bungalow for Summer Use," *Craftsman* (Aug. 1911).

*Real Log Cabin,* suggesting how do-it-yourselfers could build pioneer homes in the wilderness.[16]

How do these three types relate to Stickley's program for the ideal house? And what do they suggest about his methodology? First, by employing familiar house types, he immediately connected with the aspirations of his readers. There was no need, as in the typical Aladdin or Sears brochure, to invent picturesque names for each model—identification with a "bungalow" lifestyle was immediate, populist, and generic.[17] Second, each type addressed specific points in his program: the farmhouse was open, functional, and land centered; the bungalow was artistic, bohemian, and honest; the log cabin was democratic, structurally pure, and primitive. Each avoided the question of style by embracing the con-

cept of type. However, a closer examination reveals that Stickley's own understanding of type forms was simplistic—what he really wanted was a single, basic formal model (like a side chair), from which all design variations might be derived. When we review the several examples above, we find that they are all the same formal type made to suggest three different genres, rather than a distinct investigation of three rural-American house types. Third, the homes of the rural- and working-class vernacular were far removed from the rhetoric and design ethos of architects (who in this period mostly served wealthy clients). This distance allowed Stickley to adopt the critical position of a disinterested reformer; as a nonarchitect he was free to inveigh against Victorian excess, the battle of the styles, the academic-classical versus indigenous-modern debate, and other messy dialectics in American architectural culture. By adopting a social critique of design, and siding with the users of his buildings, Stickley avoided common perceptions of the high-handedness of architects and the cultural elite. Nevertheless, as a designer who offered his services to a wide clientele, he occupied a slippery middle ground. Neither a user nor a builder, and attempting to eschew the position of a professional, he sought to move design, craftsmanship, and building into a unified relationship approximating the one in traditional cultures. Unfortunately, the American building economy was already highly segmented and specialized in 1900. Though seeking to become a mediating force, Stickley became no more than a popular wholesaler of plans. Beginning his program with a paper text, he was left with a file of hundreds of drawings. And the quality of individual Craftsman homes built under varying conditions by owners, Stickley's service, and others suggests that the closer he came to the traditional role of architect or builder, the more "Craftsman-like" the result.

The "one-size-fits-all" model of home design is an attractive but dangerously simplistic notion that also appealed to other pattern-book writers and mail-order manufacturers (fig. 65). Stickley, for his part, saw that in order to provide Americans with a full range of solutions he would need to expand his canon of type forms. The remainder of his house

## Design No. 9080

The arrangement of this House is as follows:

First Floor Plan.

### FIRST FLOOR.

Reception Hall, 18 feet by 14 feet.
Living Room, 12 feet by 12 feet 6 inches.
Dining Room, 12 feet by 6 feet.
Kitchen, 12 feet by 10 feet.
Pantry and Front Porch.

### SECOND FLOOR.

Bedroom, 12 feet by 9 feet 6 inches.
Bedroom, 12 feet by 16 feet 6 inches.
Bedroom, 12 feet by 10 feet.
Bathroom, 7 feet by 13 feet.
5 Closets.

Second Floor Plan.

This Building is 31 feet 6 inches in width; 30 feet in length.

Price of Complete Working Plans and Specifications.................................................. $12.00

The Blue Printed Working Plans for this House consist of basement plan; first and second floor plans; front, right, left and rear elevations; wall sections and all necessary details.

The Typewritten Specifications contain all the necessary information for the proper construction of the House.

52

65. "Design No. 9080," Radford Homes, catalog, p. 52. Courtesy the Winterthur Library, Decorative Arts Photographic Collection.

models are more similar to architect-designed middle-class dwellings and were probably conceived by the New York staff to conform to suburban patterns and middle-class family needs. Larger models such as the "Ten-Room Cement House Suitable for a City Street" of May 1909 suggest the influence of trained architectural designers in the Home Builder's Service and a more sophisticated grasp of house planning and construction than the more vernacular-inspired designs.[18] But if we take Stickley at his word and examine the dwellings he built for himself, it is clear that his preference was for buildings stripped of the kind of design artifice endemic to Architecture with a Capital A—that is, for the primitive and archetypal buildings that we would now place in the realm of the vernacular. Above all, however, Stickley pursued the elusive Holy Grail of simplicity in his architecture. The ideal Craftsman house was a nearly diagrammatic, gable-roofed dwelling that kindled the populist sentiments of farmers, pioneers, and mine workers—the Americans whose children were in 1900 flocking to new streetcar suburbs in record numbers. And though Stickley portrayed his model houses in wide-open country settings more often than city streets, it was the suburban middle landscape that saw the construction of more Craftsman, Aladdin, Sears, and Wilson bungalows than the prairies and forests of rural America.

Indeed, one searches in vain for the rural vernacular sources of Stickley's designs because he did not draw from these types except as sentimental pictures of the ideal house. Cultural geographers have cataloged the common house types found in small towns and agrarian areas of the Northeast, South, and Midwest. The most common early forms are based upon basic wood structural bays—the so-called single-pile, double-pile, and dog-trot houses. In stark contrast to these simple houses, Stickley's "cottage" types are based upon the balloon frame, a Victorian building technology that allowed for multicelled rooms in irregularly massed configurations. Only after 1875 do we find pattern-book houses with these irregular plans, and it is here that Stickley found his real inspiration. Popular authors such as E. C. Gardner, William Comstock, and the Pallisers pioneered the cottage form that Stickley then

"simplified" in his plans and gave a more rustic tenor through construction details. Gardner's 1875 design for "A Planter's House" with its wrapping verandas and square plan provides an apt comparison to Stickley's designs (fig. 66). His houses correspond closely with the "cottage bungalow" and "incised-porch bungalow" types that are found throughout the United States after 1900.[19]

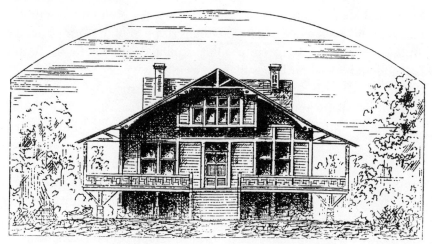

THE PLANTER'S HOUSE.

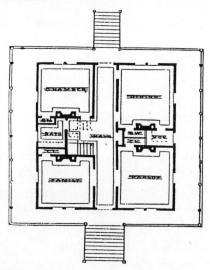

66. E. C. Gardner, "A Planter's House," 1875. Courtesy the Winterthur Library, Decorative Arts Photographic Collection.

As a social critic, Stickley understood that his readers were modern American family members who wanted inexpensive houses that functioned to streamline the tasks of everyday life (fig. 67). Rather than accepting the cramped and outmoded plans of traditional houses, he and his draftsmen adapted Victorian house plans that already had currency among the middle class. Reducing the outline and forms of these plans to basic boxes with a minimum of partitions, and giving his readers the rooms and functions that were minimally required, he found a popular formula for a smaller house type that would gain currency with later

67. "Craftsman Stucco Cottage No. 141," *Craftsman* 22, no. 5 (Aug. 1912). Courtesy the Winterthur Library, Printed Book and Periodical Collection.

mail-order purveyors in the 1920s and '30s. But his most didactic innovations were not in the plans or overall forms of these houses, or even their very modern materials. What he sold to his readers was the image of simplicity—the "back-to-basics" ethic of wholesome good taste, free from clutter and pretense.[20]

Of the nine points in Stickley's ideal program elucidated in the preceding analysis of the Craftsman house, the one mantralike word that not only permeates the hundreds of text descriptions of these dwellings but also dictates the form of Stickley's most cherished designs (such as the Clubhouse at Craftsman Farms) is *simplicity*. In order to more fully understand his core design precepts and illuminate the relationship between architecture and craft in his work, we must penetrate the meaning of this word in the context of Arts and Crafts doctrine and unravel its complex significance for Craftsman architecture and social reform.

## Simplicity

Parody often reveals the keys to significance, no less in texts than in artifacts. In 1911, during the heyday of the Craftsman Home Builder's Service, the editors of *Country Life in America* offered a deliciously satiric morsel to their readers titled "The Daftsman House: A Recipe." From it we can learn much about the treacherous line between simplicity and simplemindedness that Stickley walked with blithe indifference during much of his career.

In five cartoonlike drawings and a few hundred words, author "Fra Thomas" deconstructs the typical Craftsman house as a hilarious melange of epithets, precepts, and slogans (fig. 68). It was "the fad of the hour, and for those who change their houses as often and as easily as their furs, nothing could be better; it is an uncommonly good style to change."[21] Under a plan bearing rather too close a resemblance to its intended victim for comfort is this caption: "Plan of Daftsman House: Any One Can Draw One; Can Be Built for Next to Nothing; And Sold for Even Less." And if these houses are "easy to make," they are even easier to parody (fig. 69).

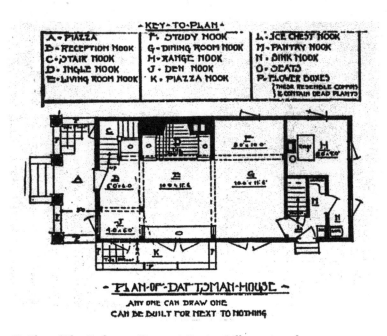

68. Plan. "The Daftsman House: A Recipe," illustrations from
*Country Life in America* 20, no. 2: 36.

69. Elevations, details. "The Daftsman House: A Recipe," illustrations from
*Country Life in America* 20, no. 2: 36.

The message of this article is clear: by "simplifying" the space and form of the house and eschewing common conventions of design, professionalism, drawing, and construction in favor of a naïve pursuit of a "do-it-yourself" ethos, the *Craftsman* ran roughshod over the complex problems of modern domestic architecture.[22] The writer is clearly an architect, and his savage critique of drawing and planning shows it. Describing the multiuse space as "one fair-sized room with a fireplace mysteriously concealed behind clumsy seats," the author points out that "there are seven different apartments in that space: the Reception Nook in which you first set foot; a few steps to the right beyond a low, rough-finished 'made-up' beam; a Den Nook; at the left a Stair Nook; beyond, the Living Nook; at its left, the Ingle-Nook. . . . A few steps farther on . . . you enter the Dining-Nook and the Study Nook." All in all, he points out, "this is a very nooksome style." Contrasting the open ground floor with "the opposite principle" upstairs, the critic notes the constricted space of the bedrooms: "[T]he rooms are so tiny that the doors must swing out into the small, dark hall, and six inches to spare between the foot of the cot bed and the wall is cause for rejoicing; although, as most of the room is down under the eaves, only the family cat can walk about in it anyway." Such, it appears, was the opinion of some members of the architectural profession regarding the quality of Craftsman architecture.

Such satire points directly at some of the most doctrinaire features of the Craftsman house—flexible space, open planning, and informal lifestyle. And there was more to say about Stickley's simple proportions, masses, and cherished roof lines. Describing the classic porch "filled with vast, stumpy columns," there is the matter of scale: "the rule is, 'The Smaller the House, the Larger the Posts.'" Noting the tendency to avoid conventional roof framing on the short dimension of the building (squarish Craftsman plans often made ill-proportioned volumes), Fra Thomas observes that "the plan, which is long and thin, should be roofed the wrong way, straddling across the widest stretch, a gable with wide-spread eaves nearly touching the ground." We see the comical effect in "The Side Elevation of Daftsman House; Any One Can Draw an Elevation."

The Daftsman has struck again. Reducing architecture in Laugieresque terms to the epitome of primitive construction, Stickley sometimes (inadvertently) made cliché when striving for poetry, clumsy forms when seeking the artistic.

To achieve elegance through reduction, "simplicity of form" is the most difficult attainment in design. As Wright wrote, the "single secret of simplicity [is] that we may truly regard nothing at all as simple in itself. . . . To eliminate expressive words in speaking or writing—words that intensify or vivify meaning—is not simplicity. Nor is similar elimination in architecture simplicity. It may be, and usually is, stupidity."[23] Where, indeed, did Stickley's search for ultimate simplification of domestic environment lead? What were the guiding principles that informed his search for the elemental in his art?

There were three areas in which Stickley and other Arts and Crafts advocates sought artistic simplification: everyday life, the practice of design, and the making of the object.[24] Because the moral imperative drove artistic production among these reformers, the "simple life" was the central doctrine, appearing in more literature and theory than any allied philosophy. Derived in part from the Arts and Crafts' loathing for the complexities of Victorian excess and the degradation of work brought about by the industrial revolution, the push for simplification of daily life was also a reflection of nostalgia for past times. Medievalism and rustic naturalism went together in the minds of many advocates of simplification. This movement found fertile ground in America, where since colonial times religious communitarians had sought a return to elemental ways. David Shi has chronicled the consistent thread of "plain living and high thinking" in American culture, noting that Stickley's work connects with the work of early Quakers, Pietists, and other social reformers.[25] But the most direct influence on Americans came (surprisingly) from a French minister: Charles Wagner, the founder of the Union for Moral Action. Wagner was a popular guru for no less than the likes of Teddy Roosevelt, whose cultivation of the "strenuous" outdoor life ignited naturists and populists alike. Wagner's book *The Simple Life* (1901) was a

best-seller in the United States, and he lectured widely in the country during the early years of the century.[26] Stickley published excerpts from Wagner's book in volume 3 of the *Craftsman*, and invited him to speak at the Craftsman Building in Syracuse in 1904. He became, with Edward Carpenter and Prince Kropotkin, one of the philosophical anchors of the Craftsman movement.[27] As Cheryl Robertson has noted, Wagner's philosophy touched numerous Arts and Crafts designers, including the Californians Charles Keeler and Bernard Maybeck, interior decorator Mabel Tuke Priestman, and members of the Prairie School such as William Gray Purcell.[28]

In moral terms, "simplicity" meant piety, joy in everyday labor, altruism, and self-sufficiency. Extending to the realm of the home, it meant a more ascetic and refined sensibility; another popular term borrowed from the English aesthetic movement was *artistic*. Particularly in the design and arrangement of interior spaces, where objects, color, light, and space might enhance the enjoyment of daily life and work, advocates of simplification pressed for a new design ethic. Victorian clutter was a sign of social decadence and a symptom of poor hygiene. Domestic reformers argued for new efficiencies in household management, more enlightened attitudes toward servants, a redesign of the kitchen, greater attention to comfort, and a new emphasis on functional efficacy in both objects and spaces. In her book *Art and Economy in Home Decoration* (1908), Priestman invoked the ideals of Wagner by admonishing women to discover "human beauty" in their daily lives. Suggesting that there was "order, neatness and decorum" to be made in the domestic environment by women, she encouraged her readers to use standards of liveability in their interior decoration: "Let us avoid ostentatious display, and cultivate the beauty of harmony and simplicity."[29]

A similar design ethic was espoused by the California poet-naturalist Charles Keeler (1871–1937). In his 1904 book, *The Simple Home*, he argued persuasively for a completely new attitude toward homemaking and daily life based upon his own family's experience in a Maybeck-designed home in the Berkeley Hills (fig. 70). As founder of the Hillside Club, Keeler created his own utopian experiment in simple living,

70. Charles Keeler house. Bernard Maybeck, Berkeley, Calif., 1895. Courtesy, Robert Winter, *Toward a Simpler Way of Life: The Arts and Crafts Architects of California* (Berkeley: Univ. of California Press, 1990).

extolling the virtues of nature and the garden. Like Stickley, he found most American houses to be "the makeshift of a shoddy age," full of useless ornament and meaningless imitation of past styles. "In the simple home," he wrote, "all is quiet in effect, restrained in tone, yet natural and joyous in its frank use of unadorned material. Harmony of line and balance of proportion is not obscured by meaningless ornamentation; harmony of color is not marred by violent contrasts. Much of the construction shows, and therefore good workmanship is required and the craft of the carpenter is restored to its old-time quality."[30] He spoke eloquently of the vernacular architecture found in primitive societies, pointing to its seemingly natural and unself-conscious usefulness, its perfect balance of function and form, its ultimate beauty.

Keeler's attitude underlines the connection between simplification of daily life and the representation of simplicity in the design and construction of the home. Echoing Stickley's ideas about home building as an expression of art and moral rectitude, Keeler avowed that "the home must suggest the life it is to encompass." Further, he stressed the central position of architecture in bringing the "real, the practical, the utilitarian" concerns of daily life into the realm of art: "[T]he designing of the home brings the artist into closest touch with the life of man." Working with the eccentric California architect Bernard Maybeck, Keeler constructed his own home and studio to embody all of his beliefs: naturalism, the poetry of everyday existence, and the use of indigenous materials in the making of the home. Like Stickley's buildings, the Keeler home in the Hillside colony was constructed of wood and detailed to express the true characteristics of its structure.[31]

Keeler and Maybeck appear to have struck an ideal balance between the creative ideas of the trained designer and the equally creative understanding of the user for the daily requirements and lifestyle preferences of the home environment. An uncommonly intelligent and self-aware client, Keeler nevertheless knew that it required an architect to realize his visions for the ideal house: "[S]uch a man [architect] will sublimate our crude and imperfect conception of the home and make of it a vital expression. Such a home will not merely fit us, but will be like the

clothes of a growing child, loose enough to allow us to expand to its full idea and with seams which can be let out as the experience of years enlarges our ideals."[32] Photos of the library of Keeler's Berkeley house suggest that just such an informal and expansive interior was made with simple skeletal construction, then filled with the bric-a-brac and collections that a wide-ranging intellectual might assemble in the course of his career. Here was a perfect fit between designer and user—two distinct personalities and sensibilities coming together to produce an aesthetic union. It remains to be seen whether, in the absence of an architect or otherwise trained designer, such a balanced and highly expressive aesthetic can be achieved. As Wright suggested, was this a case of "simplicity" born out of a profound understanding of the complexity of design itself?

Both Stickley and Keeler advocated a certain primitiveness in home construction to emphasize the elemental quality of the simple life. Direct involvement with "the useful arts," including all the crafts of homemaking, was a fundamental tenet of the Arts and Crafts movement. If it was possible for men and women to make their own homes—that is, to design them, arrange their furnishings, craft objects to be used daily, or even help in their construction—inevitably their lives would be enriched and made more meaningful. Again, Ruskin's moral imperative was invoked—beauty was to found in the character and the hand of the maker. If the maker and the user were one in the same, so much the better. The aesthetic of simplicity stressed the inherent beauty of useful things, things that acquired even greater value when made and used by the same poet-artisan. "The maker must bend his energies to produce objects uniting in themselves the qualities of utility, of adaptability to place, of comfort, and of artistic effect," Stickley wrote in 1901. "The user must choose with discretion the objects which shall create his home; carefully providing that they express his station in life and his own individuality; furthermore, that they respond to his every-day needs."[33] Extending these precepts from the object to the building, from interior space and decorative arts to architecture, allowed Arts and Crafts advocates to build a complete theoretical edifice. This edifice, which unified

artifacts, space, and construction under the umbrella of "design" and "craftsmanship," became a powerful twentieth-century imperative as the modern movement developed out of the Arts and Crafts movement.[34]

There were two other aspects of simplification that were equally critical to Stickley's architecture: design and construction. By suggesting that Craftsman designs were anonymous and democratic, he promoted the (often false) notion that they might be designed as much by their owners as by his draftsmen. And by encouraging his readers to build their own houses (not necessarily from his designs), he emphasized the unification of life and craft that writers such as Keeler and Wagner encouraged. Yet, there were forces in 1900 that mitigated against that unification: building costs were escalating rapidly, construction practices were changing, new materials and methods were outstripping the vernacular wisdom of traditional builder-craftsmen, and forty-hour-per-week jobs prevented families from devoting time to homemaking. Life and material culture were becoming more complex, not simpler. The representation of simplicity was in many respects a fiction designed to contradict these harsh realities. Achieving "old-time quality" was a quest based more on sentiment than workmanship. And the aesthetic of simplicity was too often an elusive goal for Stickley and his craftsmen and -women when the world pressed in on their vision.

Art, Design, and Technology

A closer look at how design and fabrication were handled in the Craftsman workshops will help to unravel the complex problem of aesthetic quality in Stickley's furniture and how it differs from his buildings. One of the pervasive ideological tenets of modernism in architecture was the belief that art should recognize the new spirit of technology in the machine age—the so-called engineer's aesthetic associated primarily with Le Corbusier. Things that were useful and practical were to be valued, indeed valorized, as aesthetically comparable to the artifacts of high art such as paintings and sculpture for which there was no practical appli-

cation. Another salient principle, associated with the Werkbund and Bauhaus, was that "design" was the highest artistic practice, uniting all of the objects and cultural forms of art, craft, and manufacturing under one rubric.[35] As a didactic designer of many art forms—from metalwork and chairs to buildings—Gustav Stickley embodied these precepts and supported their reification in American culture.

In his study *The Nature and Art of Workmanship*, David Pye exposes many of the fundamental fallacies and truths about craftsmanship in the modern world, taking particular aim at the prejudices introduced by Arts and Crafts theorists. One of his first lessons is about the dissociation between handiwork and machine work, a distinction that he considers meaningless despite the protestations of Ruskin. Machines, in Stickley's day as in ours, were ubiquitous and necessary—no less necessary to craftsmanship than tools in a traditional society. The machine and the hand are equal partners; machines degrade work only when the human element, "workmanship," is subsumed by the apparatus or by division of labor. Pye distinguishes two kinds of workmanship: the workmanship of risk (requiring judgment, skill, and mastery of a medium) and the workmanship of certainty (requiring none—something any machine can do better than any human). A master craftsperson acquires the skill and judgment to control workmanship in his or her discipline through years of exposure to processes, tools, and materials. Judgment comes as a result of intimate familiarity with a craft. Machine production renders this judgment unnecessary by reducing decisions to a minimum through mechanized, repetitive processes. This distinction will be important as we look more closely at Stickley's art. "In one sense, detailing was born when craftsmanship died," observes architect Edward R. Ford, underlining this point. A second lesson of Pye's study concerns the nature of design itself. As he notes, "Design is what, for practical purposes, can be conveyed in words and by drawing: workmanship is what, for practical purposes, can not."[36]

Gustav Stickley was a quintessential twentieth-century designer. He shared a kind of genius with American innovators such as Thomas

Edison, Henry Ford, Frank Lloyd Wright, Louis Comfort Tiffany, and Raymond Loewy: the capacity to envision and realize objects holistically—that is, a command of both concepts and processes. One of the reasons that Stickley succeeded in marketing, manufacturing, and selling so much furniture, when other talented Arts and Crafts designers did not, was this capacity to recognize and exploit the entire process of fabricating his products and bringing them to market. As we have seen, he was not only a master of woodcraft but also a master of public relations and an excellent judge of taste in the popular arena. More important, he understood how to use people, technology, and capital to produce high-quality furniture.

Recent scholarship by David Cathers, Paul Davidoff, and others has shown how Stickley's ambition and ability to synthesize ideas came together in 1900 and 1901 to launch his "new furniture" line from a series of potentially disastrous business ventures (fig. 71). Like Edison and Ford, he brought together a group of ideas, capital sources, and interested parties to form a successful company. With the help of Irene Sargent as intellectual and writer, Pratt-educated Lamont Warner as designer-draftsman, anonymous shop workers, art director and former Roycrofter Jerome Connor, the initial marketing and capital of Chicago's Tobey Furniture Company, and the sales savvy of his brother Leopold, Stickley assembled the components of a successful cooperative enterprise. Using ideas gained from his European trips (almost yearly after 1898), he pressed toward a new kind of furniture that was based "on simple lines and so solidly made as to be almost indestructible." Knowing well that the market would be crowded with others working on similar pieces (Elbert Hubbard was launching his Roycroft line; Rose Valley was in production), he drew and filed patents for many of his new designs. An example of an early Craftsman side chair shows the results of these first efforts. David Cathers points to its plain qualities balanced by "beautifully worked out proportions and revealed structure." Stickley had hit upon a notion that he later called the "structural idea," by which he meant the representation of strength and firmness in structural lines and

71. Trestle table No. 637 from 1910 Stickley catalog. Courtesy the Winterthur Library, Decorative Arts Photographic Collection.

the clear demonstration of the techniques of joinery. Large oak members, fumed and oiled, are joined either by revealed pins through mortises and tenons or by tenons in the legs and stretchers.[37] (Line perspectives and shop drawings of these pieces were published in volume 5 of the *Craftsman* in 1904.) Stickley's mature Craftsman pieces, like the classic furniture of the Shakers, stressed "simple lines" and the most transparent expression of joinery. Early designs begin to suggest these qualities, whereas later pieces (1904 and after) distill and perfect the expression sought.

If design is something that "can be conveyed by words and by drawing," then design is what Stickley set out to represent in his first published advertisements, catalogs, and articles on his furniture. There is great significance in the way he chose to show and explain his work. In

the first volumes of the *Craftsman* magazine, his early publication titled *Chips from the Workshops of Gustave Stickley*, and in other published documents, pieces are shown in precise but evocative line drawings rather than photographs. These illustrations are often accompanied by (to modern readers) wordy miniessays, full of idealistic poetic and gospel-like descriptions. Notwithstanding the start-up required to bring his products to market, these "pictures" of his work suggest several things about Stickley's attitude toward his art and how to present it to the public. First, they are the ideas of a man experimenting with concepts, not the tediously worked-out products of a craftsman (such as we find in the highly original pieces of Charles Rohlfs, for instance). Second, they are vivid, didactic, even messianic in their impact on an audience: "[M]en can not be civilized and bound together in brotherhood, unless they are given a share in art, which is no mere accident, but rather an essential and a positive necessity of life. . . . If we advance still another step, we can state with emphasis that one office of art is to give people pleasure in the things that they must perforce use; that a second office is to give people pleasure in the things that they must perforce make."[38] This message accompanies the first furniture catalog published by Stickley's young company. It reads like a Ruskinian or Emersonian diatribe. Stickley's intent was not to toil behind a bench making his art, only to find he had no buyers. Rather, he wanted to make certain—by designing and marketing his work—that his readers and buyers became part of the flock he would lead forward, toward his new aesthetic. By invoking "necessity" and "art" in his words, and "simplicity" and "solidity" in his drawings, he demonstrated to his potential followers that they must go with him in his quest. Like Morris, he created a design for a new little world and invited his customers to enter it.

In concert with his first publications, Stickley set to work on the design of a manufacturing process for his new line of furniture. Here, he employed the basic technology of the furniture industry to good advantage, using machines to reduce the labor required to prepare the basic wood pieces for joinery. Although no machines are shown in publicity photo-

graphs of the Eastwood shops, business records show that the company used a wide range of common woodworking, metalsmithing, and sewing machines in its production. The very latest planing, sawing, milling, and turning machines were employed in making Craftsman furniture.[39] Stickley rationalized this decision by suggesting that the worker would know "the joy and enthusiasm of carrying out an idea that is his own, or with which he is in such perfect sympathy that the work becomes a delight." Combining workmanship of certainty (mass production of parts by machine) with the workmanship of risk (joinery, assembly, and finishing by hand) gave Craftsman products the aura of originality and handwork without undue expenditure of labor. Nonetheless, his pieces were expensive by the standards of the day and remained so even after production and sales increased.[40]

A few examples of his furniture show how these aspects were controlled and how the designed objects in the Craftsman factory emphasized both structural lines and the look of solid craftsmanship. As Stickley put it in his introduction to the 1910 catalog, "Being designed upon the most natural lines and made in the most natural way, there is little room for change in the style, and that the style itself has made good its appeal to the American people is best proven by the fact that, during the twelve years it has been upon the market, it has remained unchanged, except for such modifications and improvements as evidence a healthy growth along normal lines of development."[41] Pieces were designed to look "styleless" and to give customers a strong sense of permanence, durability, and overall value. Early pieces, such as the medieval-inspired trestle table No. 637 from the 1910 catalog that maintained its popularity over the years (see fig. 71), were likely to be as durable as the later English-inspired trestle table No. 623 from the same catalog (fig. 72). The former was constructed with simpler joinery and smaller stock oak pieces, but does not look as solid and heavy as the latter, made with Stickley's trademark pegged mortise and tenon joints at the lower leg and stretcher connection. Moreover, the square legs of No. 623 were likely constructed using a clever conceit to maintain the

72. Classic Craftsman trestle table No. 623 from 1910 Stickley catalog. Courtesy the Winterthur Library, Decorative Arts Photographic Collection.

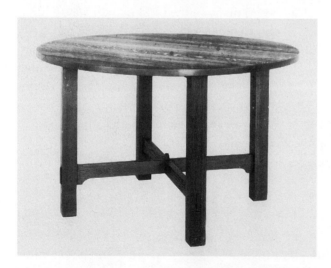

73. Round table No. 669 from 1910 catalog. Courtesy the Winterthur Library, Decorative Arts Photographic Collection.

quartersawn grain on all four faces—miter joints concealed the fact that each leg was not one massive piece of oak, but actually four smaller face pieces. To achieve the look of simplicity, Stickley's factory resorted to some quite complex manufacturing processes. The classically simplified and beautifully proportioned round table, No. 669 from 1910, achieved the kind of structural balance that Stickley sought in all his furniture (fig. 73).

Stickley's unique finishing methods, made possible through mass-production fuming processes and significant hand labor, gave his furniture an even more distinctive and "natural" appearance. Here he went to great pains to emphasize the way in which each individual piece of wood might achieve its maximum potential beauty via the painstaking process of drying, fuming in a 26 percent solution of ammonia water,

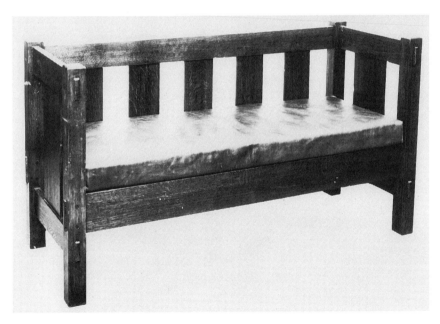

74. Craftsman settle No. 205 from 1910 catalog. Courtesy the Winterthur Library, Decorative Arts Photographic Collection.

and applying a secret two-step finish of oil stain and Craftsman "Wood Luster," touted as "not a varnish or a polish."[42] When he spoke of the three natural colors imparted to oak through his invented process, Stickley underscored the essentially modern and artistic prejudices that guided his search for form and patina. One can see, even in monochrome photos, the superb luster that these methods provided in such pieces as the leather-seated rocker (No. 317), settle (No. 205), and armchair (No. 318) (figs. 74, 75). When combined in an interior with muted earth tones of leather and fabric, the Craftsman "look" was achieved. Handcraftsmanship in these kinds of artifacts was obtained not entirely through a "workmanship of risk" but via a self-consciously designed

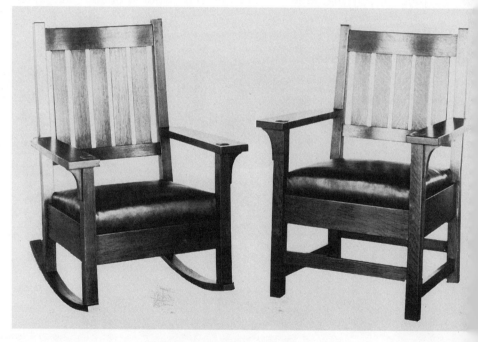

75. Armchair and rocker Nos. 318 and 317 from 1910 catalog. Courtesy the Winterthur Library, Decorative Arts Photographic Collection.

methodology intended to impart the most "natural" possible end product. Indeed, the two largest cohorts in the Eastwood factory were the "cabinetmakers" and the "finishers," both paid relatively high wages. The multiple steps in this process could be tightly controlled by managing a linear manufacturing "assembly line," precisely the kind of industry spawned by nineteenth-century organizations pioneered in the United States.

Like William Morris, Stickley understood the essential components and processes required to "craft" or produce the objects he designed in his workshops. With this understanding he used words and drawings to convey to both his workers and his public a sense of the aesthetic qualities he wished to bring to his creations. By controlling the process of manufacture no less than the messages broadcast to his market, he created a popular art form out of an essentially commercial mechanism (design-production-consumption). This process differs considerably from the idealized guild system sought by proponents of the Arts and Crafts movement and even more markedly from the endeavors of an individual artist. The ultimate artist-craftsman in Stickley's system is the designer, aided by his associates. Ultimate responsibility for quality is shared among these artists and the workers who produce each artifact.[43] There is some "workmanship of risk" in the final production tasks, but most of the artistic quality in the artifact is the result of "design," not "craftsmanship" in the medieval sense. Design is accomplished largely through a process of invention, cognition, drawing, and communication (verbal, visual, and so on). It requires a synthetic appreciation of how the object will be produced, but not a true craftsman's judgment; a craftsman "knows" his or her materials and methods so intimately as to be able to circumvent many details in the process, details that will be judged and produced unself-consciously. But the designer, in order to impart judgment and aesthetic sensibility, must "draw" or otherwise control all aspects of the process of making the object. Because he could supervise and direct production in his Eastwood shops, Stickley guaranteed a modicum of quality and workmanship in all of his Craftsman products—except, that is, his buildings.

Whereas Stickley was intimately familiar with virtually all the proce-
dures, materials, and design requirements associated with furniture pro-
duction, he knew very little about the design and technology associated
with modern buildings. Nor was he trained in the skills of the drafting
room, where the "design" in architecture occurs. This deficiency in un-
derstanding did not prevent him from inventing and adapting house de-
signs, or from advancing provocative and original notions about the
domestic environment. Indeed, many of America's most influential envi-
ronmental designers were initially untrained in their chosen profes-
sions—both Andrew Jackson Downing and Frederick Law Olmsted
began with only marginal professional skills. But because Stickley did not
"test" his germinal notions about architecture in the arena of production,
that is, by building houses in the contemporary economy, he was left with
a significant gap in both understanding and aesthetic quality, a gap that
did not occur in his furniture products. Craftsman Farms occupies a cen-
tral place in his oeuvre because it attempts to fill that void.

Crafting Versus Building

The average building constructed with modern materials and methods
contains more than one hundred thousand individual components. The
average piece of manufactured furniture consists of less than fifty. Stan-
dard specifications in the building industry, created around the time that
Stickley was operating his home building service, are organized into ap-
proximately a dozen trades, each broken down into subassemblies and
materials. The complexity of the building process and the multifaceted
nature of architectural design make the discipline required of an archi-
tect one of the most time consuming and intensive to learn of all forms
of professional knowledge.

When Craftsman Farms was constructed, the U.S. building industry
was entering a period of enormous technological upheaval, perhaps the
most fertile experimental period in history. More new materials, engi-
neering advances, and architectural theories were entering the field than

at any time prior to World War II.[44] The pace and technical scope of these changes were such that many professional architects were hard-pressed to keep up with required knowledge. Moreover, the economics of the building industry were also changing rapidly—prices for wood, steel, concrete, brick, and other necessities fluctuated greatly between 1900 and 1930. And though manufactured homes sold by Sears and other mail-order companies flooded the market during this period, the do-it-yourself builder had trouble keeping up with the ever expanding construction industry, reorganizing itself to be able to keep pace with growing demand for architecture, infrastructure, and transportation systems in the United States. Traditional wood and masonry construction, controlled by small builder-tradesmen, was being rapidly supplanted by a new specialized system of labor and materials delivery akin to modern industrial production.

Stickley's justification for entering the building field was to finally unite his social, artistic, and philosophical ideals under the umbrella of domestic architecture, where he might make the most direct contribution to the lives of everyday citizens. He looked toward architectural design as the culmination of his lifelong effort to integrate craftsmanship and design; buildings offered the greatest challenge to his highly developed sense of the "structural idea" and expression of the material essence in constructed objects. Like Marc-Antoine Laugier, the eighteenth-century French theorist, Stickley sought to prove that there was a primitive, essential quality in good buildings that could be learned and practiced by anyone with the moral fiber and artistic integrity to recognize the fundamentals of building as *craft*. In this context it is worth noting that the word that Stickley canonized in his magazine and furniture comes from an Old English root, *craeft*, which also exists in Germanic languages.[45] The main meanings of this term relate to skill in handwork, "power, strength, or virtue," and mental cunning or wiles, all attributes cultivated by this quintessential artist-businessman. By invoking the ideal of artful workmanship by hand in a field increasingly dominated by intellectual activity and resisting the forces of new technology, Stickley was reaching

backward for the archetypal connection between human beings and the fabrication of their own dwellings. He hoped that the course taken by architects and builders in the post-Enlightenment period—toward design as an abstract and technically aloof discipline—might be reversed by a popular movement embracing vernacular, do-it-yourself construction.

Stickley was one of many architectural designers working around 1900 to follow this line of reasoning. Combating what they saw as the industrialization of architecture, his architectural mentors and contemporaries were making similar pronouncements and staking their careers on a return to handicrafts in building. Some English designers, such as Ernest Gimson, Detmar Blow, and (at times) Philip Webb, were religiously zealous about vernacular building traditions and the role of the local tradesman in achieving handwrought work.[46] But Stickley was almost unique among English and American Arts and Crafts exponents in his blunt insistence on a kind of amateur spirit in building design—tendencies nowadays consigned to house-kit purchasers and prefabricated log cabin manufacturers. Because his houses, and particularly those structures built at Craftsman Farms, embody a peculiar primitive building ethos, it is worth exploring the difference between this concept of craftsmanship in building and the one followed by leading architects of the period.

The architects who followed Ruskin's and Morris's ideas about honesty in building and a return to the integrity of crafts understood keenly the limitations of the hand-built approach. Buildings are assembled with numerous disparate materials and components, many of which do not react equally to climate—solar radiation, moisture, even abrasion by windblown dust can alter the behavior of various materials. As Edward Ford has pointed out in his study of modern architectural detailing, virtually all nineteenth- and twentieth-century construction is a sandwich or veneer of interior finishes, structural framing, and exterior cladding. By using the "skin and skeleton" system, modern architects came to terms with numerous exigencies of construction technology and climate control.[47] Rather than a building object, designers began to conceive of a

"building envelope" in the modern sense, consisting of layers of construction assemblies, each controlled by different trades. Unfortunately, all such systems were suspect from the critical eye of Arts and Crafts theorists because they did not transparently present "structural facts" or honest craftsmanship. Some components, invariably, had to remain hidden, others exposed. Monolithic construction—one material utilized for load-bearing walls, exposed both inside and out—was considered more "truthful" because the structural characteristics of the material could be appreciated. Generally, Gustav Stickley subscribed to the notion that monolithic expression was to be preferred in building. But like other architects he was compelled to deal with the necessity of incorporating new materials and technology into buildings and with making concessions to an expanding industry incorporating building trades.

Thus, as Stickley constructed his experiment at Craftsman Farms he faced two paradoxes that have continued to bedevil the modern architect: the question of how to maintain craft ("the workmanship of risk") in a discipline increasingly controlled by designers and industrial manufacturers and the problem of expressing the essential characteristics of structure and materials in buildings that tend to conceal their load-bearing elements behind veneers and are designed to maintain a controlled, tempered interior environment. Let us consider first how leading Arts and Crafts architects handled these problems before looking at Stickley's solutions.

Charles and Henry Greene are generally lionized as America's ultimate craft-oriented architects. Their brief creative breakthrough corresponds almost exactly with the ten-year period of Stickley's architectural career, and the two California architects were clearly influenced by their East Coast contemporary. Both brothers were educated in an industrial arts curriculum in St. Louis and were thus nearly as familiar with the practice of woodworking as Stickley.[48] Their seminal works—the Gamble, Blacker, Pratt, and Thorsen houses designed from 1907 to 1909— embody Craftsman ideals as succinctly as any architecture of the turn of the century.

Prior to the construction of the cottages and Clubhouse at Craftsman Farms, Gustav Stickley visited Pasadena and toured a half-dozen examples of the Greenes' work. He was clearly inspired by their approach to form as well as to craftsmanship. Publication of this California architecture in the *Craftsman* hastened the brothers' renown nationally, but also seemed to spur Stickley to attempt similar experiments on his own (fig. 76). In July 1907 the *Craftsman* published its first article on the Greenes' work, commenting on the "subtle" Japanese influence on Charles's own house in Pasadena.[49] Views of the Henry M. Robinson house (1904), F. W. Hawkes house (1906), Robert Pitcairn Jr. house (1907), and R. R. Blacker house (1909) appeared in August 1912 with detailed analysis of the interiors and exteriors of these works (fig. 77).[50] Other articles treated emerging trends in California architecture.

The Greenes achieved their extraordinary forms, details, and finishes through a highly controlled design and production process that is only now coming to be fully understood. They employed a staff of draftsmen in a traditional architectural office to produce extensive working drawings and full-scale sketches of each individual element in a typical house commission. As architects they were also fully in control of the structural-, material-, and site-planning issues that are essential to realizing a complex design. Moreover, the Greenes employed a group of master woodworkers led by Peter and John Hall and a glass artisan, Emile Lange, as a team that could execute their designs under strict supervision and artistic control. This group was more akin to a medieval cathedral workshop than to most architect-contracting associations—all the key personnel were highly trained in their disciplines and worked together to achieve a superb integration of conception, design, and finished product. Moreover, the time and expense required to achieve this level of art was well beyond the means of ordinary clients—most of the Greenes' post-1905 houses were built for the ultrawealthy.

Charles and Henry Greene understood the complexity and uncertainties of the building process, entrusting nothing to chance in the execution of their commissions. As Edward Ford has pointed out, their wood

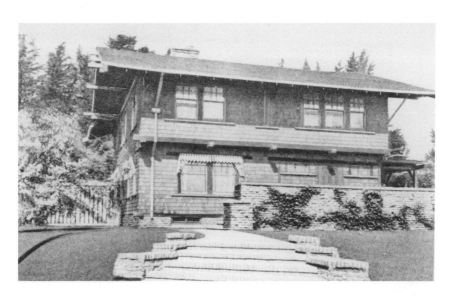

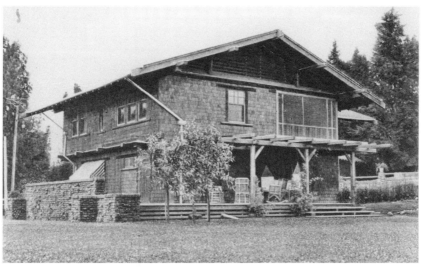

76. Charles and Henry Greene, the Mary Ranney house, Pasadena, Calif. *Craftsman* 22, no. 5 (Aug. 1912): 541. Courtesy the Winterthur Library, Printed Book and Periodical Collection.

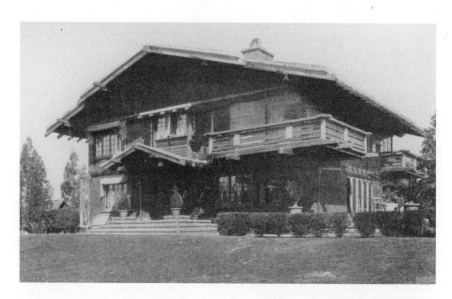

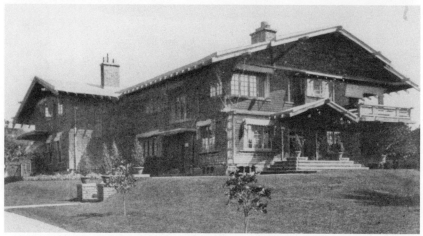

77. Charles and Henry Greene, the Robert Pitcairn house, Pasadena, Calif., 1907. *Craftsman* 22, no. 5 (Aug. 1912): 538. Courtesy the Winterthur Library, Printed Book and Periodical Collection.

houses are built with a complex system of different "analogous" and "real" components, each designed to fulfill a role in either expressing (that is, dramatizing or emphasizing) spatial, tectonic, or decorative concepts or performing a traditional structural or constructional function. Seldom are their buildings made with monolithic, traditional means. Indeed, the style invoked is more akin to the interlocking system of the Japanese wooden temple or teahouse combined with an American balloon-frame system (fig. 78). Ford's illustration of the wall section of the Gamble house demonstrates the essentials of this method. Members

78. Charles and Henry Greene, "A detail view of one corner of the Pitcairn residence . . ." *Craftsman* 22, no. 5 (Aug. 1912): 539. Courtesy the Winterthur Library, Printed Book and Periodical Collection.

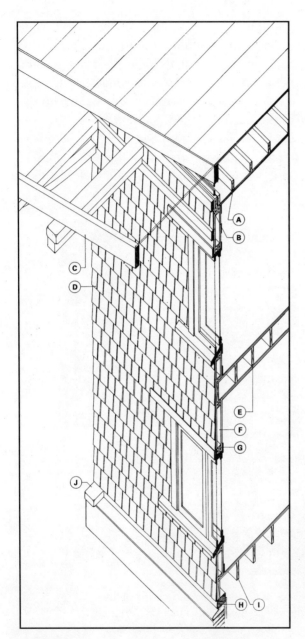

79. Cutaway axonometric of corner by Edward R. Ford. Charles and Henry Greene, the David R. Gamble house, Pasadena, Calif., 1907. Courtesy, Edward R. Ford, *Details of Modern Architecture*, vol. 1 (Cambridge: MIT Press, 1990).

that show on the exterior or interior of the house are often designed as redundant pieces, using special woods that in finish or resistance to weather can "stand in" for the actual structural members behind— pieces that function best when covered over or are less costly than analogous members (fig. 79). Combining several different woods, the brothers and their craftsmen fashioned a composite building that showed its structural characteristics brilliantly with some essentially ornamental members. Ford describes the system employed at the Gamble house:

> Including the interior, there are three general types of wood used in the Gamble house, and there are three different levels of craftsmanship in finish and joinery that correspond to them. The Oregon pine platform frame is completely concealed. Its boards are left unfinished as they came from the mill, and its joints are made with nails. Most of the exposed exterior structure is also of Oregon pine timbers, planed to produce round ends and edges and sanded to remove most of the mill marks. The pieces are joined with oak wedges and pegs, although they often cover screws and nails. The finish wood of the interior (teak, mahogany, white cedar, etc.) is shaped and joined with a high degree of finish, and it is polished much more than the exposed exterior timbers. Like the beams themselves, the joint materials—wedges, pegs or screws—are usually used to cover the real fasteners and sometimes are purely ornamental.[51]

Thus, the role played by each individual component in either showing or functioning as structure was carefully calculated; then the appropriate material and finish were decided. Ford then asks the important questions, "[M]ust the analogous system replicate what is covered, or can it be altered to emphasize or clarify architectural readings?" concluding that "the Greenes [sic] works give no clear answer."[52] Indeed, their architecture is a complex amalgam of building and craft that suggests mainly the necessity for highly controlled design and production as the only guarantee of true aesthetic quality in architectural work (fig. 80). Doctrine did not produce these great works, but rather the judgment and talent of individual creative artists. Both craft skill and design acumen were required.

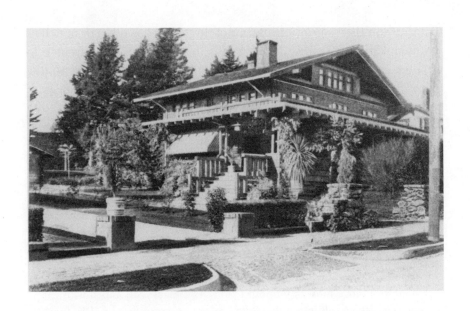

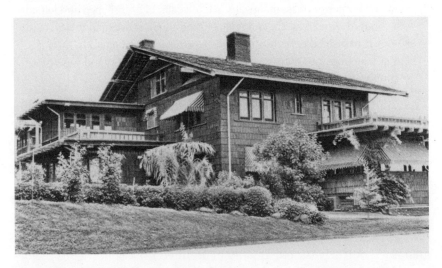

80. Charles and Henry Greene, the F. W. Hawkes house. *Craftsman* 22, no. 5 (Aug. 1912): 540. Courtesy the Winterthur Library, Printed Book and Periodical Collection.

The Greenes were acutely aware of the need to overarticulate joints, edges, and transitions in their buildings to make architectural concepts more legible. Notice the widely overhanging eaves on their Hawkes, Ranney, and Pitcairn houses, and the numerous carved rafter ends projecting beyond the roof edge (fig. 81; see figs. 76, 77, 80). Here one perceives the essential strengths of wood construction—high tensile strength, lightness, and simple carpenter joinery. Stickley made similarly bold overstatements in his furniture, but was uncharacteristically tongue-tied in the architecture he designed at Craftsman Farms. The cottages and Clubhouse do not move beyond the vernacular prototype to become poetic statements about wood construction as do the works of the Greenes (fig. 82). They remain in the realm of naïvely vernacular design and construction. The best Arts and Crafts architecture celebrates the tectonic elements of buildings, bringing together design and craftsmanship in the artful detail as well as overall proportion and massing.

Stickley's buildings at Craftsman Farms, from the barns to the elaborate Clubhouse, were intended to show that such self-conscious design was not necessary to achieve good building, from either a moral or an aesthetic point of view. Each of the structures constructed at the Farms was made with some indigenous materials and some purportedly vernacular construction methods to demonstrate the applicability of a do-it-yourself ethos (fig. 83). The cottages and Clubhouse are suitably rustic, relatively inexpensive by the standards of the day, and reasonably handsome, but they hardly achieve the aesthetic quality of more carefully designed and more expensive Arts and Crafts buildings of the period. Even the best California bungalows of Henry Wilson and the more modest efforts of Wilson Eyre and William L. Price around Philadelphia achieve a greater aesthetic resonance within the "craft" ethos (fig. 84). Why, finally, did Stickley's architecture often result in oddly inarticulate buildings with a mixed message? What distinguishes his architecture from his contemporaries'?

The answer lies perhaps in the ambiguous realm between design and building, between vernacular craft judgment and emerging building

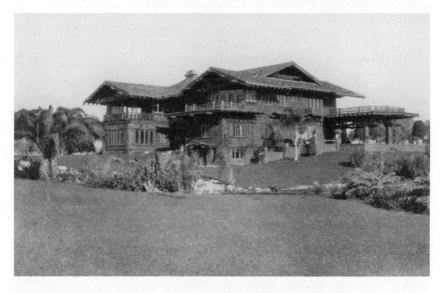

81. Charles and Henry Greene, the R. R. Blacker house. *Craftsman* 22, no. 5 (Aug. 1912): 537. Courtesy the Winterthur Library, Printed Book and Periodical Collection.

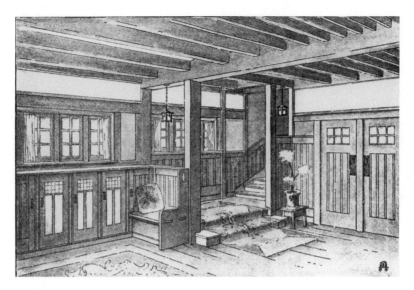

82. "Home of Gustav Stickley, a corner of the living room . . ." *Craftsman* 15, no. 5 (Oct. 1908): 83. Courtesy the Winterthur Library, Printed Book and Periodical Collection.

83. Elevation of Clubhouse at Craftsman Farms, Dec. 1908. Courtesy Avery Architectural and Fine Arts Library, Columbia University in the City of New York.

84. Clubhouse at Craftsman Farms, during Farny ownership, 1926. Courtesy Curtis Collection, no. 3030, Free Library of Morristown and Morris Township, Morristown, N.J.

technologies of the early twentieth century. Stickley's buildings are "mixed" constructions that flirt with the conventional types and constructional techniques of the rural vernacular—the cabin, the farmhouse, the bungalow—but do not adopt their forms or tectonics unquestioningly. Some early-twentieth-century architects found great inspiration for their art in the most humble vernacular structures in their regions—John Byers learned from the adobes of California and Mexico, John Gaw Meem from New Mexico's Spanish and Native American heritage, Wilson Eyre from the Pennsylvania farmstead, Richard Koch from the French and Creole architecture of Louisiana. But these architects

designed their buildings to carefully replicate formal and structural aspects of the type, controlling each facet of building and craft by controlling the production process. Stickley *romanticized* the vernacular without fully embracing it; his architecture was also tied firmly to emerging building technologies such as synthetic roofing, new jointing solutions, and hybrid systems. The wall construction in his own "Craftsman's" house demonstrates a tendency to experiment, to tinker with time-honored solutions. His 1907 series of log cabins also utilized unusual plans but maintained the conventional saddle-joint construction of traditional American log buildings. In both, the metaphors were jumbled.

Because Stickley was a modern designer, his methodology necessarily circumvented the folkloric knowledge and judgment of the vernacular craftsman or builder. Yet, he insisted upon the moral standard in traditional craftsmanship—ownership of one's work and one's judgment, and knowledge of materials and building solutions. In so doing, he created a kind of contradiction resident in all of his buildings—the "mixed" metaphor that appears in the Clubhouse and in much of his work. The Craftsman house was, on the one hand, a product of the individual builder (who might purchase plans from the CHBC); on the other, it was an invention of the magazine and empire that Stickley created. It was simultaneously a *designed* object and one *crafted* by the judgment of an individual artisan, but one who did not necessarily possess the skills to carry out all processes and trades. Its construction was intended to replicate vernacular building methods, but also to improve upon their technology and offer less expensive alternatives to labor-intensive practices and scarce materials. Unlike the products of medieval guilds—highly secretive and almost cabalistic societies in which knowledge was imparted by long training and intense practice—Stickley's buildings were produced in an amorphous, pluralistic culture of shifting knowledge and experimental solutions. Although the *Craftsman* could reasonably offer "home training in cabinetwork," it could not offer home training in the construction trades.

In the buildings at Craftsman Farms, Stickley attempted to maintain craft—that workmanship of risk or judgment—through intention and design rather than through employment of skilled artisans. He explained and rationalized the log joint and the wood construction in his magazine, but did not bring skilled artisans into the process to interject their own aesthetic into the work. Whereas the Greenes and other architects created designs that conveyed the essential formal and material qualities of the finished work and entrusted the execution to superb craftspeople in their workshops, Stickley insisted that this knowledge was available to any homeowner and designed his buildings to the level of skill that he believed his readers possessed. His products varied considerably in quality—from highly articulate houses constructed at considerable expense to relatively modest ones. Even the messages sent in his publications for the Craftsman Home Builders' Club were ambivalent: at certain times plans were advertised for sale and architectural services provided to clients; at others, the designs were published to be copied or to serve "as inspiration" to readers.

As demonstrations of the "structural idea," Stickley's buildings were likewise constrained by his moral imperative: that the ethic of building take precedence over the final result. Thus, his wall construction and detailing maintained a kind of purity that architects such as the Greenes renounced in order to create more evocative and articulate statements about the nature of construction, craft, and materials. Stickley's buildings contain little that is "analogous" or metaphorical—there are no stand-ins for load-bearing construction as in the Gamble house, no elaborately contrived demonstrations of woodcraft or joinery. The simplicity that Stickley proclaimed in all of his writings would be compromised by such artifice. However, as the riddle of the lap joint in the Clubhouse shows, Stickley stubbornly clung to the belief that if structural facts were imparted in the making of the joint or component, they would also be conveyed to the observer. Unfortunately, the hybrid, layered building technology that increasingly dominated twentieth-century construction militated against this concept. The Craftsman ethos was in many ways a

cry muffled by the din of technological progress. The buildings at Craftsman Farms signaled the end, not the beginning, of a movement.

Perhaps the final lesson in the complex parable of Craftsman Farms can be found in this schism between large-scale building and individual handicraft. In 1900 America and the industrial world were at the cusp of a further technological and social transformation that would dwarf the changes of the early industrial revolution so threatening to Marx, Carlyle, Ruskin, and Morris. Artistic production at the level of building and furniture manufacture had already been wrested from the hands of the guilds and trades. Even the era of Ibsen's master builder or "architect as hero and genius" (in the words of Andrew Saint) was fast approaching its end at the middle of the twentieth century.[53] If the designer had replaced the guild master as ultimate creative arbiter of aesthetics in the everyday world, where would the individual find aesthetic quality and worth? With the end of the twentieth century, it became apparent that technological processes would continue to reduce the role of the individual tradesperson in the execution of all kinds of industrial process—from porcelain manufacture and metalwork to building trades such as masonry, concrete, and steel—eventually making production a largely intellectual and social activity controlled by the capacity of individuals and groups to communicate their ideas to each other and to machines. Individual craftsmanship will no longer play a role in large-scale industries—buildings will be assembled from components outside the ken of individuals. The artisan, the craftsman, will produce only luxuries, not necessities. When Stickley created his buildings and his furniture, the telltale signs of this transformation were already apparent, leading perhaps to the intense, almost militant movements that he and his Arts and Crafts brethren promulgated.

   Stickley's heroic and ultimately failed attempt to create a utopia that would bring together the useful crafts and building trades in the domestic realm would be a sharp lesson to capitalist society and to the America

that would become its beacon. By proclaiming that architecture and all the useful arts were imperiled by the demoralizing disjunction between individual creativity and daily work, between design and craftsmanship, between production and consumption of everyday goods, his utopia offered a lesson in physical form so poignantly critical that it cannot be ignored. Here, indeed, is a parable about production and consumption in the modern world that, if read with knowledge of its context and intentions, can continue to stimulate the debate about the necessity for creative work at the level of "craeft" so vital to Gustav Stickley and his followers.

"The underlying principles that make a chair good are the same as those that make architecture significant and good," wrote William Price in the *Artsman* in 1905. As Stickley, Price, Hubbard, and Ashbee among many others attempted to demonstrate, the aesthetic qualities of design and craftsmanship in the artifacts of the past—proportion, fitness of use, economy, sincerity, fine workmanship—remain as lessons for those people who seek the core principles of all architecture and decorative arts. Craftsman Farms, like other utopias, offered practical and moral lessons in the truth of this dictum. And though Stickley saw his dream for a Craftsman's camp meeting and artistic colony dashed by economic and personal contradictions, he maintained his central beliefs as a prophet in a bewildering, pluralistic frontier at the cusp of a new century. Craftsman Farms is a critical piece of his legacy. As Price might have written in his epitaph:

> [T]here is nothing made for use so humble that it may not be epochal, and there is nothing done for beauty or glory that may not drag us backwards into decadence and death. Art is not the flower of progress but the root. The desires of the body are the seed. The chair and the building are alike produced at the instance of our human wants. With the proper fulfilment of this impulse art is born. Thus do chairs and chairmakers become the prophets of better things.[54]

Notes

Bibliography

Index

# Notes

## 1. Prologue and Method

1. For the best general source, see Wendy Kaplan, ed., *The Art That Is Life: The Arts and Crafts Movement in America, 1875–1920.*

2. See Richard Hofstadter, *The Age of Reform: From Bryan to FDR,* on the "Progressive Impulse" (124–74). On the intellectual aspects of the era, see Henry Steele Commager, *The American Mind,* esp. 227–46.

3. On the origins of the movement and a chronology, see Robert Judson Clark, *The Arts and Crafts Movement in America, 1876–1916,* 9–13. On California, see Kenneth R. Trapp, ed., *The Arts and Crafts Movement in California: Living the Good Life,* 9–14.

4. Richard Guy Wilson, "'Divine Excellence': The Arts and Crafts Life in California," 233–46.

5. See Robert Edwards, "The Art of Work," 223–36.

6. On resorts and colonies, see Richard Guy Wilson, "American Arts and Crafts Architecture: Radical Though Dedicated to the Cause Conservative," 117–26; and Cheryl Robertson, "The Resort to the Rustic: Simple Living and the California Bungalow." On the naturist philosophy, see Peter T. Schmitt, *Back to Nature: The Arcadian Myth in Urban America, 1900–1930,* and Mark Alan Hewitt, *The Architect and the American Country House, 1890–1940,* 153–93.

7. On Lewis, see Karen J. Weitz, "Midwest to California: The Planned Arts and Crafts Community."

8. Edwards, "The Art of Work," 223.

9. See Martin Eidelberg, "Art Pottery"; Ellen Snyder-Grenier, "Cornelius Kelley of Deerfield, Massachusetts: The Impact of Change on a Rural Blacksmith";

and Richard Stamm, "The Bradley and Hubbard Manufacturing Company and the Merchandising of the Arts and Crafts Movement in America."

10. Richard Ohmann, *Selling Culture: Magazines, Markets, and Class at the Turn of the Century*, 11–30.

11. For an analysis of the place of the *Craftsman* among other publications, see Marilyn B. Fish, *The New Craftsman Index*, 9–22.

12. Stickley's house and several other buildings on the Craftsman Farms properties in Parsippany were purchased by the township in 1989 and are now run as a municipal park and house museum under the auspices of the Craftsman Farms Foundation, a not-for-profit organization. See A. Patricia Bartinique, "Parsippany Claims Craftsman Farms." The house was opened to the public on April 28, 1990. Restoration of the Clubhouse is part of a long-range preservation plan for the structures, funded in part by bond-act funds from the New Jersey Historic Trust. I wish to thank the key individuals who have worked to document and preserve the site, including Vivian Zoe, Nancy Strathearn, Ray Stubblebine, Robert Guter, Janet W. Foster, Constance Greiff, and Phil Holt for their help in preparing this chapter. In addition, I am grateful to the students in the 1992 Craftsman Farms preservation studio at the New Jersey Institute of Technology for their efforts in the documentation of the Clubhouse, in particular to Lori Jean Ryder.

13. Mary Ann Smith, *Gustav Stickley: The Craftsman*, 156–57; Barry Sanders, *A Complex Fate: Gustav Stickley and the Craftsman Movement*, 157–62; Internal Revenue Service to Judge S. D. Amen, Aug. 12, 1919, Joseph Downs Manuscript Collection, Stickley Business Papers, Winterthur Museum. The inspector states: "A superficial examination of the books for the period from June 1, 1914 to March 31, 1915 show that heavy losses had been incurred through the operation of the New York store and the loss is apparently so large that in my opinion, I don't believe that enough additional tax could be found to off-set this loss" (2).

14. See Jules David Prown, "Mind in Matter: An Introduction to Material-Culture Theory and Method," 7–10.

15. Clifford Geertz, *The Interpretation of Cultures*, 14.

2. Persona

1. [Irene Sargent], "Chips from the *Craftsman* Workshops." The first mention of Hans Sachs occurs here, later followed by other invocations of the hero's life and philosophy of work.

2. Arthur G. Wirth, *John Dewey as Educator: His Design for Work in Education*, 7.

3. T. J. Jackson Lears, *No Place of Grace: Antimodernism and the Transformation of American Culture, 1876–1914*; Michael Kammen, *Mystic Chords of Mem-*

*ory: The Transformation of Tradition in American Culture*; Hewitt, *Architect and American Country House.*

4. Charlotte Brancaforte, ed., *The German Forty-Eighters in the United States*; Marilyn B. Fish, *Gustav Stickley: Heritage and Early Years*, 1–3; U.S. Census, 1870. Records courtesy of the State Historical Society of Wisconsin, Madison. Inhabitants of Osceola Town, Polk County, State of Wisconsin, enumerated June 10, 1870: "House number 140, Family number 149: Leabold [*sic*] Stickley, age 49, farmer, place of birth Baden, Germany; Barbara Stickley, his wife, age 42, place of birth: Baden, Germany." Seven children are also listed: Mary, age nineteen, the eldest daughter; Gustavus, age twelve, the eldest son; and Charles, Albert, Anna, Christina, and Leapold Jr. (70).

5. La Vern J. Ripley, *The German Americans*. There were 1,186,000 Germans who came to the United States between 1820 and 1860; the Forty-Eighters made up a small percentage, four in ten thousand (51).

6. Richard H. Zeitlin, *Germans in Wisconsin*, 16–17. Titled "Handbuch zum Nuken und Besten der Einwanderer: Bevolkerung, Bodenbeschaffenheit und Klima in Norden Wisconsin's [*sic*]," the handbooks were distributed through the state's Commission on Immigration, established in 1852 (7). There were 939,149 men, women, and children who emigrated from the southwestern German states during this period (4).

7. Larry Gara, *A Short History of Wisconsin*. On German American Forty-Eighters, see pp. 89–91.

8. See Terry G. Jordan, *Texas Log Buildings: A Folk Architecture*, 21–25. "The Pennsylvania Germans gave us the log cabin, along with other vital pioneer paraphernalia, such as the long rifle and Conestoga wagon" (24).

9. Margaret Walsh, *The Manufacturing Frontier: Pioneer Industry in Antebellum Wisconsin, 1830–1860*, 37–38. See also pp. 1–36 on early development of lumber, craft, and agriculture in the state.

10. Zeitlin, *Germans in Wisconsin*, 16–17.

11. Theodore S. Hamerow, "The Two Worlds of the Forty-Eighters."

12. James F. Harris, "The Arrival of the Europamude: Germans in America after 1848."

13. Bettina Goldberg, "The Forty-Eighters and the School System in America," 207.

14. WPA American Guide Series, *Wisconsin: A Guide to the Badger State*, 433. *Asi-yahole* literally means "black drink halloer."

15. Fish, *Gustav Stickley*, 11.

16. There are discrepancies among the published sources as to Stickley's birth date: March 9, 1857, or March 9, 1858.

17. Fish, *Gustav Stickley*, 12. These dates come from the comprehensive treatment of the Stickley brothers' often complex business relationships in Donald A. Davidoff and Stephen Gray, eds., *Innovation and Derivation: The Contribution of L. and J. G. Stickley to the Arts and Crafts Movement*, 21.

18. On the impact of the farm economy on the nation, see Richard A. Bartlett, *The New Country: A Social History of the American Frontier, 1776–1890.* "By the 1840s the myth that the prairie could not produce crops had been destroyed" (191–92). New farm technology, including the Deere steel plow (1838), McCormick reaper (1839–41), and thresher (1850s), was transforming production in the years around the Civil War.

19. Frank William Nowlin, *The Bark-Covered House; or, Back in the Woods Again*, 31.

20. Gustav Stickley, "Als Ik Kan: A School for Citizenship," 119.

21. Gustav Stickley, "A Second Visit to Craftsman Farms: The Country and Long Life." Fish has shown that this separation was simply the first of several between Leopold and Barbara Stickley, based upon a published record in the *Polk County Press* (*Gustav Stickley*, 16, 17).

22. The standard accounts of this period are found in John Crosby Freeman, *Forgotten Rebel: Gustav Stickley and His Craftsman Mission Furniture*, 11–14; John Crosby Freeman, "Forgotten Rebel: Gustav Stickley," 7–12; M. A. Smith, *Gustav Stickley: The Craftsman*, 1–5; Joseph Bavaro and William Mossman, *The Furniture of Gustav Stickley*, 17–20; and Davidoff and Gray, *Innovation and Derivation*, 24–27. New research has finally set the record straight on the relationship between Jacob Schlager and Henry William Brandt—business partners in tanneries since 1845—and on the Stickley family's tenure in Brandt, Pa. (Fish, *Gustav Stickley*, 20–29).

23. Fish, *Gustav Stickley*, 28. Again, this research has dispelled many rumors concerning the courtship of Gus and Eda.

24. Gustav Stickley, *Chips from the Craftsman Workshops*, quoted in Freeman, "Forgotten Rebel: Gustav Stickley," 12.

25. Freeman, "Forgotten Rebel: Gustav Stickley," 15–18; Bavaro and Mossman, *Furniture of Gustav Stickley*, 18; Davidoff and Gray, *Innovation and Derivation*, 24–25.

26. David M. Cathers, *Furniture of the American Arts and Crafts Movement*, 16.

27. Cathers, interview with Barbara Stickley Wiles, in *Furniture of the Arts and Crafts Movement*, 241–42.

28. For a general overview, see Wayne Rassmussen, "Wood on the Farm."

29. Cecil D. Elliott, "Wood," 12–13.

30. Stickley patented a wood-bending jig in around 1896, according to David Cathers, and was up-to-date with the latest in machine tools (interview by author, 1999).

31. See Michael J. Ettema, "Technological Innovation and Design Economics in Furniture Manufacture."

32. Ibid., 206; Stickley, *Chips from the Craftsman Workshops*, 25–28.

33. Cathers, *Furniture of the Arts and Crafts Movement*, 17.

34. Frank Ransom, *The City Built on Wood: A History of the Furniture Industry in Grand Rapids, Michigan, 1850–1950*, 19–37.

35. Stickley, *Chips from the Craftsman Workshops*, 3.

36. Ibid., 16.

37. Stickley, *Chips from the Workshops of Gustave Stickley* (Syracuse: n.d.), 19. Courtesy of the Winterthur Library. David Cathers dates this publication to 1901 (interview by author, 1999).

38. On the design of these chairs, see Cathers, *Furniture of the Arts and Crafts Movement*, 57–61; and A. Patricia Bartinique, ed., *Gustav Stickley: His Craft*, 56–72.

39. Cleota Reed, "'Near the Yates': Craft, Machine, and Ideology in Arts and Crafts Syracuse, 1900–1910."

40. M. A. Smith, *Gustav Stickley: The Craftsman*, 9–21, 27–37; Fish, *The New Craftsman Index*, 10–15.

41. Cleota Reed, "Irene Sargent: Rediscovering a Lost Legend" and "Irene Sargent: A Comprehensive Bibliography of Her Published Writings."

42. See Fish, *The New Craftsman Index*, 15–21.

43. On the exhibition in the context of other Arts and Crafts shows, see Coy L. Ludwig, *The Arts and Crafts Movement in New York State, 1890s–1920s*, 55–58.

44. Irene Sargent, "William Morris: Some Thoughts upon His Life: Work and Influence."

45. Irene Sargent, "William Morris," in Sanders, *The "Craftsman": An Anthology*, 3–4.

46. Marilyn Fish has maintained in recent publications that Stickley was dependent upon editors and other writers for virtually all of his output. This assertion would explain the relative sophistication of his prose, despite a very limited education (*The New Craftsman Index*, 9–25).

47. Erving Goffman, *The Presentation of Self in Everyday Life*, 17–76, 107–40.

## 3. Utopias

1. Robert S. Fogerty, *Dictionary of American Communal and Utopian History* (Westport, Conn.: Greenwood Press, 1980), lists more than 250 such experiments in U.S. history.

2. The classic and archetypal study of these efforts is William Alfred Hinds, *American Communities* (1878; reprint, New York: Corinth Books, 1961).

3. Dolores Hayden, *Seven American Utopias: The Architecture of Communitarian Socialism, 1790–1975,* 9; see Eileen Boris, "The Communal Impulse: Back to the Land with the Arts and Crafts," in *Art and Labor: John Ruskin, William Morris, and the Craftsman Ideal in America, 1876–1915.*

4. Robert Judson Clark and Wendy Kaplan, "Arts and Crafts: Matters of Style," in *The Art That Is Life,* edited by Kaplan, 78–100.

5. These novels by William Dean Howells were *A Traveler from Altruria: A Romance* (1894), *Through the Eye of a Needle* (1907), and *Letters of an Altrurian Traveller* (1896; facsimile, 1961).

6. William Morris, "News from Nowhere," 272–96.

7. See John L. Thomas, introduction to Edward Bellamy, *Looking Backward, 2000–1887,* 1–88.

8. For an extended analysis of Howells's views on capitalism and money, see Jan W. Dietrichson, *The Image of Money in the American Novel of the Gilded Age,* 238–325. Above quote from *Letters of an Altrurian Traveller* on p. 292.

9. Howells, *Traveler from Altruria* (New York: Hill and Wang, 1957), 55–57.

10. *Utopia* derives etymologically from a Greek root meaning "nowhere," a fact undoubtedly known to Morris.

11. David Cathers's research has documented trips in 1896 and 1900 as well as Stickley's attendance at the 1903 London show of the Arts and Crafts Exhibition Society (interview by author, 1999). M. A. Smith, *Gustav Stickley: The Craftsman,* 9–21; Bavaro and Mossman, *Furniture of Gustav Stickley,* 19. Freeman states that Stickley and Ashbee met while in England (*Forgotten Rebel,* 44, 53); Alan Crawford suggests that "no supporting evidence is given" that the two met in England in 1898 (*C. R. Ashbee: Architect, Designer, and Romantic Socialist,* 409, 461 n. 33).

12. Crawford, *C. R. Ashbee,* 66–69, 94–100. The first trip, of six weeks, took Ashbee mainly to the East Coast, where he lectured at universities about the British educational system; the second, sponsored by the British National Trust, was to concentrate on conservation but brought Ashbee into contact with numerous architects, including Wright and Wilson Eyre. In 1900 he and his wife, Janet, met Elbert Hubbard in East Aurora and spent time in Syracuse (98).

13. Ibid., 74–149.

14. Fiona MacCarthy, *The Simple Life: C. R. Ashbee in the Cotswolds*, 37–62.

15. For some of his major views, see William Morris, "The Lesser Arts," "Feudal England," and "Useful Art Versus Useless Toil," in *Hopes and Fears for Art and Signs of Change*, by Morris, 3–27, 39–59, 98–121. These compilations of seminal lectures of the 1870s and 1880s were originally published in 1882 and 1888. They were read and reprinted in America as well as England.

16. Oscar Lovell Triggs, *Chapters in the History of the Arts and Crafts Movement*, 142–43. Ashbee's principles were postulated in his earliest published work, *A Few Chapters in Workshop Re-Construction* (London, 1894). See Crawford, *C. R. Ashbee*, 53–54.

17. See, for instance, C. R. Ashbee, ed., *The Manual of the Guild and School of Handicraft* (1892; reprint, New York: Garland, 1978).

18. Ernest A. Batchelder, "Why the Handicraft Guild at Chipping Campden Has Not Been a Business Success," 175. As will be noted below, this issue is one in which Stickley published designs and descriptions of the Craftsman Farms experiment. He was undoubtedly intimately familiar with Ashbee's endeavors.

19. Crawford, *C. R. Ashbee*, 143–45; MacCarthy, *Simple Life*, 158–78.

20. Eileen Boris, "Dreams of Brotherhood and Beauty: The Social Ideals of the Arts and Crafts Movement."

21. Karal Ann Marling, introduction to *Woodstock: An American Art Colony, 1902–1977*, 1; Boris, *Art and Labor*.

22. Lears, *No Place of Grace*, 96.

23. The most comprehensive treatment of this experiment is William Smallwood Ayres, "A Poor Sort of Heaven, a Good Sort of Earth: The Rose Valley Arts and Crafts Experiment, 1901–1910." For a contemporary account, see Mabel Tuke Priestman, "Rose Valley: A Community of Disciples of Ruskin and Morris," and George E. Thomas, *William L. Price: Arts and Crafts to Modern Design*, 75–113.

24. George E. Thomas, "William L. Price (1861–1916): Builder of Men and Buildings," is the definitive treatment of Price's life and work. See also George E. Thomas, "William L. Price, Architect: 'Prophet without Honor'" and "Rose Valley Architecture," in William S. Ayres, *A Poor Sort of Heaven, a Good Sort of Earth: The Rose Valley Arts and Crafts Experiment*, 23–36; and G. E. Thomas, *William L. Price*.

25. William S. Ayres, prologue in *Poor Sort of Heaven*, 12; William L. Price, "Man Must Work to Be Man," quoted in Boris, *Art and Labor*, 356. "The art that is life" was the motto of the Rose Valley community, appearing on the cover of each issue of the *Artsman*.

26. Priestman, "Rose Valley," 161; Ayres, "Poor Sort of Heaven," 7–10.

27. William L. Price, "Is Rose Valley Worthwhile?" 9.

28. Jeannine Falino, "The Monastic Ideal in Rural Massachusetts: Edward Pearson Pressey and New Clairvaux," in *The Substance of Style: Perspectives on the American Arts and Crafts Movement*, edited by Bert Denker, 375.

29. Ralph Radcliffe Whitehead, *Grass of the Desert* (London, Chiswick Press: 1892). See Lisa L. Lock, "The Byrdcliffe Colony and the Politics of Arts and Crafts," 1–6.

30. Marling, "The Byrdcliffe Colony of Arts and Crafts," in her *Woodstock*, 9–12.

31. Lock, "Byrdcliffe Colony," 13–18. See also Ludwig, *Arts and Crafts in New York State*, 45–46.

32. Lock, "Byrdcliffe Colony," 18–20.

33. Ayres, *Poor Sort of Heaven*, 20.

34. This point is conclusively demonstrated by Jack Quinan, "Elbert Hubbard's Roycroft."

35. Ludwig, *Arts and Crafts in New York State*, 35.

36. Cleota Reed, *Henry Chapman Mercer and the Moravian Pottery and Tile Works*, 49–122.

37. On the efficacy of these efforts, see Quinan, "Elbert Hubbard's Roycroft," 15–16. "The legacy of Roycroft is twofold. Hubbard did raise the intellectual consciousness of Americans a notch, especially in the areas of literature and fine printing. But his principal legacy, in this writer's opinion, is the *idea* of the Roycroft" (16). Reed, *Mercer and the Tile Works*, 72–74. She contends that "one of Mercer's remarkable achievements was that he consistently made a profit producing Arts and Crafts tiles" (72). Reed points out that Mercer's reception among Arts and Crafts critics was uneven. His most successful showing occurred at the 1904 St. Louis World's Fair, where he won a grand prize (76–78). For another view of the discrepancies between design and workmanship in Mercer's work, see David B. Driscoll, "Henry Chapman Mercer: Technology, Aesthetics, and Arts and Crafts Ideals," in *Substance of Style*, edited by Denker, 243–62.

38. John Dewey, *The School and Society*, rev. ed. (Chicago: Univ. of Chicago Press, 1923); John Dewey, *Democracy and Education* (New York: Macmillan, 1916).

39. John Dewey, "Plan of Organization of the University Primary School," app. E, in *John Dewey as Educator*, by Wirth, 302.

40. On the relationship between manual trades, Arts and Crafts education, and the Dewey system, see Boris, *Art and Labor*, 182–89.

41. The connection between Addams, Dewey, Triggs, and the University of Chicago reform program is discussed in Boris, "Dreams of Brotherhood and Beauty," 215; and Wirth, *John Dewey as Educator*, 44–46.

42. Oscar Lovell Triggs, "The Workshop and School," 21; Boris, *Art and Labor*, 169–84.

43. On the manual trades movement, see Melvin L. Barlow, *History of Industrial Education in the United States* (Peoria, Ill.: Bennet, 1967); and Lewis F. Anderson, *History of Manual and Industrial School Education* (New York: Appleton, 1926).

44. Triggs, *Chapters*, 172; Boris, *Art and Labor*, 87.

45. Triggs, *Chapters*, 161.

46. Oscar Lovell Triggs, "A School of Industrial Art," 220, 221.

47. Ibid., 221.

48. This point is substantiated in Boris, "Dreams of Brotherhood and Beauty," 218.

49. Gustav Stickley, "The Public School and the Home: The Part Each Should Bear in the Education of Our Children," 288; Gustav Stickley, "Manual Training and the Public Schools," 120. In addition to these two articles, the *Craftsman* series included: "Manual Training and Citizenship"; "Education," 12, no. 6 (1907): 704–7; "Practical Education Gained on the Farm and Workshop"; "Danger of Too Much System in Education as Opposed to the Real Training That Comes from Direct Experience," 15, no. 4 (Jan. 1909): 493–94; and "Teaching Boys and Girls How to Work: What We Need Is Not More Schools but Common Sense," 18, no. 4 (July 1910): 428–31. Stickley initiated his reform series with an announcement at the end of vol. 12, suggesting a multifaceted program of articles and manufacturing efforts to "bring forward prominently the ethical value of systematic training in handicrafts" (no. 6, p. ix).

50. *Craftsman* 12 (1907): ix and ff.

51. Boris, "Dreams of Brotherhood and Beauty," 216–18 n. 50. By 1905 the *Craftsman* had a circulation of around twenty-five thousand, considered large for such a specialized periodical (figures from Ayer and Sons, *American News Annual*, 1895–1915).

52. "A Novel Scheme: A 'Craftsman Village' for the Education of Boys Planned," *Jerseyman* (June 5, 1908): 1. "Mr. Stickley does not announce the exact location of the property, but inquiry shows that he has been negotiating for thirty acres of Homer Davenport's estate, the Garrigus place of ten acres adjoining and nearly all the Harrison place at Morris Plains. In July the purchases were reported" ("The *Craftsman's* Village," *Jerseyman* [July 3, 1908]: 5). The article suggested that the farm-school would open its doors three days later, on July 6.

53. In chronological order, they are:

Gustav Stickley, "The Craftsman's House: A Practical Application of All the

Theories of Home Building Advocated in This Magazine." Craftsman Farms, buildings, design drawings for Gustav Stickley's own house, not built.

Gustav Stickley, "Three Craftsman Bungalows That May Prove Useful for Summer or Weekend Cottages." Craftsman Farms, buildings. One of the prototypes is constructed in modified form.

Gustav Stickley, "The Club House at Craftsman Farms: A Log House Planned Especially for the Entertainment of Guests." Craftsman Farms, buildings, drawings and illustrations of the Clubhouse, including the first plan.

"A Visit to Craftsman Farms: The Study of an Educational Ideal." Craftsman Farms, school, first version.

"A Country Home for the Business Man: A Second Visit to Craftsman Farms." Craftsman Farms, buildings.

"The Value of a Country Education for Every Boy: A Talk with the Host of Craftsman Farms." Discussion of school and brief description of cutting logs.

"Another Talk with the Host of Craftsman Farms." Craftsman Farms, buildings, progress.

Gustav Stickley, "Als Ik Kan: School." Craftsman Farms, school in second version.

Raymond Riordan, "A Visit to Craftsman Farms: The Impression It Made and the Result: The Gustav Stickley School for Citizenship." Craftsman Farms, school, excellent photos, the first published of the log house, interiors and exteriors, plans.

"Craftsman Farms: Its Development and Future." Craftsman Farms, buildings, excellent photos.

54. This comparison has been made by M. A. Smith, Greiff, and Fish. For a detailed scholarly treatment of Ashbee's experiment and its relation to Morris, see MacCarthy, *Simple Life.*

55. Gustav Stickley, "Catalogue of Furniture Made by Gustav Stickley at the Craftsman Workshops, Eastwood, New York," Winterthur Library, n. 127.

56. For a contemporary account and views of these country estates, see Charles Edward Surdam and W. G. Osgoodby, *Beautiful Homes of Morris County and Northern New Jersey* (Morristown, N.J.: Pierson and Surdam, 1910).

57. Marilyn B. Fish, "Craftsman Farms School: Theory, Location, and Curriculum," 5.

58. See chronological list in note 54, nos. 1–3.

59. Constance M. Greiff, *The Log House at Craftsman Farms: Historic Structures Report,* 12–14; "A Novel Scheme." This parcel is illustrated in Mueller, *Atlas of Morris County* (Philadelphia: A. H. Mueller, 1910), as belonging to "Eda Stickley" (pl. 19).

60. Stickley, "The Craftsman's House," 339. Stickley's aesthetic theories derive, at least in part, from his familiarity with the ideas of William Morris. On the notion of "transcendent practicality" or "mystical common sense" in Morris and Lethaby, see Peter Stansky, *Redesigning the World: William Morris, the 1880s, and the Arts and Crafts,* 135–37. On Morris's life, see Fiona MacCarthy, *William Morris: A Life for Our Time.*

61. For an exploration of American-European crosscurrents in Arts and Crafts design, see Clark and Kaplan, "Arts and Crafts," in *The Art That Is Life,* edited by Kaplan, 78–100. The authors note that Harvey Ellis, and perhaps Stickley as well, was conversant with art nouveau, secessionist, Jugendstil, and other Continental trends in interior design just after 1900.

62. Ruskin's famous indictment of various "architectural deceits" is best illustrated in "The Lamp of Truth," in *The Seven Lamps of Architecture* (New York: John Wiley and Sons, 1890), 52–102. Each room was to be finished in a different wood, ranging from white oak to cypress, Georgia pine, ash, hazel, maple, birch, beech, and California redwood. Joinery and finish were carefully considered, and Stickley went so far as to mention his admiration for Japanese woodworking while discussing these aspects. Stickley, "The Craftsman's House," 92.

63. Stickley, "Club House," 344; see Harvey H. Kaiser, *Great Camps of the Adirondacks.* In 1907 the Stickleys had visited a camp colony in California planned on similar lines. In 1909 the MacDowell colony was published in the *Craftsman;* Mary Means, "The Work and Home of Edward MacDowell, Musician," *Craftsman* 16, no. 4 (July 1909): 416–27. The cabins and studios are remarkably similar to the ones proposed at Craftsman Farms.

64. Stickley, "Club House," 343, 344.

65. Two of the three houses are documented in drawings in the Stickley Collection at the Avery Architectural Archives, Columbia Univ. The stone bungalow, Avery 1908-2, was not constructed; however, the clapboard bungalow, Avery 1908-1, is similar to the two cottages that currently exist on the site. Stickley, "Three Craftsman Bungalows"; two designs are reprinted in Gustav Stickley, *Craftsman Homes* (1909; reprint, New York: Dover, 1979), 81. The *Craftsman* was a pioneering publication in the dissemination of Native American folklore and history. See, for instance, Irene Sargent, "Indian Basketry: Its Structure and Decoration," *Craftsman* 7, no. 3: 265–74.

66. "Sale of 157 acres, Hanover Township from Sisters of Charity of St. Elizabeth," *Jerseyman* (Apr. 16, 1909): 6. "Stickley, Gustav of New York purchased 500 acres in Hanover Township from Helen F. and Harold J. Genung" (*Jerseyman* [Apr. 1, 1910]: 1). This parcel is listed as number 14 on an inventory of twenty-four properties filed as loan collateral by Stickley in October 1914, prior to his bank-

ruptcy. "Real Estate Owned by Gustav Stickley in Morris County, New Jersey," legal document, Stickley Business Papers, Winterthur Library, Collection 60, Box 18, "State of New Jersey" file. Payment for this land is recorded in the Gustav Stickley Company "Cash Receipts and Disbursements" ledger for July 1909–July 1910, vol. 76x101.4578, p. 75, as: "July 3, 1910: $7000.00 payment, interest $58.34 to H.F. Genung" (Stickley Business Papers, Collection 60, Winterthur Library).

67. Stickley's wife, Eda, made several documented trips to Craftsman Farms prior to moving the family from Syracuse. Train and trolley tickets as well as other expenses for travel are noted in the company ledger on Mar. 1, May 19, and June 30, 1911. A large freight expense appears on the "Farm" account on June 1, 1911 (Ledger (1910–11), vol. 76x101. 4579, 85–101. Stickley Business Papers, Collection 60, Winterthur Library).

68. That Stickley was well aware of the Guild of Handicraft is proved by an article published in 1908 by his colleague and friend, the California educator Ernest Batchelder ("Handicraft Guild at Chipping Campden"). Was this article, in the same issue as his designs for Craftsman Farms, an influence on his decision to eschew the Ashbee model? On the structure, philosophy, and operation of the Guild of Handicrafts, see Crawford, *C. R. Ashbee*, 74–149.

69. "A Novel Scheme," 1.

70. For a discussion of each, see Fish, "Craftsman Farms School," 6–7.

71. Riordan, "Visit to Craftsman Farms," 152.

72. Ibid., 154, 163.

73. Stickley, "Als Ik Kan: School," 119.

74. Stickley, "Practical Education," 117–18.

75. The major exposition of his program is contained in Gustav Stickley, "Small Farming and Profitable Handicrafts: A General Outline of the Practical Features of the Plan; by the Editor," *Craftsman* 14, no. 1 (1907): 52–64.

## 4. Artifact and Place

1. Marwyn S. Samuels, "The Biography of Landscape," in *The Interpretation of Ordinary Landscapes*, edited by D. W. Meinig, 53.

2. See F. A. Canfield, "Sketch of the Geology and Physical Geography of Morris County," in *History of Morris County, New Jersey* (New York: Munsell, 1882), 102–8.

3. Robert S. Grumet, *Indians of North America: The Lenapes*, 13–41.

4. E. T. Halsey, "History of Morris County," in *History of Morris County*, 15–20.

5. Cam Cavanaugh, *In Lights and Shadows: Morristown in Three Centuries*, 86–87.

6. Munsell, *History of Morris County*, 165.

7. On Davenport's life, see Mickey Hickman, *Homer: The Country Boy* (Silverton, Oreg.: by the author, 1986), and Leland Huot, *Homer Davenport of Silverton: Life of a Great Cartoonist* (Bingen, Wash.: West Shore Press, 1973). Marion Flaccus, interview, Local History Collection, Free Library of Morristown and Morris Township, Elaine Narramore Ellis with Myriam Flaccus, Apr. 12, 1982, 3; Virginia Vogt, "The Powerful Pictures of Homer C. Davenport of Morris Plains," 8.

8. Cavanaugh, *In Lights and Shadows*, 158.

9. Downs Collection, Winterthur, "Real Estate Owned by Gustav Stickley in Morris County, New Jersey," dated Oct. 30, 1914, in connection with bankruptcy papers, Box 19.

10. Stickley Business Papers, Winterthur, Ledgers 60:76x101.54E and E2; "Sale of 40 Acres from Homer Davenport Estate and 10 Acres Garrigus; Practically All of Old May Tuttle Farm, $6,000," *Jerseyman* (July 3, 1908). "Sale of 157 Acres Hanover Township from Sisters of Charity of St. Elizabeth. Consideration $1," *Jerseyman* (Apr. 16, 1909): 6.

11. Stickley Business Papers, Winterthur, Ledger 76x101.17, 1907–9, sheets 3–21.

12. Thomas J. Schlereth, *Victorian America: Transformations in Everyday Life*, 78.

13. Downs Collection, Winterthur, Ledgerbooks 76x101.23 showing sales figures. Page 32 lists "Circulation" of the *Craftsman* from 1904 through 1912, peaking at $42,148.31 in revenues that final year. Page 5 lists Eastwood sales, page 6 the sales of the Washington and Boston stores. For analysis of the financial aspects of Stickley's empire, see Sanders, *Complex Fate*, 157–62; M. A. Smith, *Gustav Stickley: The Craftsman*, 149–58.

14. Cyril Farny, interview by Elaine Narramore Ellis, Mar. 1, 1982. Typescript in the collection of the Free Library of Morristown and Morris Township, page MIA-12.

15. Winterthur, Downs Collection, Ledger 76x101.16, p. 33. Paint, roofing, lumber, coal, fireplaces, and plumbing expenses are listed starting on Aug. 17, 1909.

16. Gustav Stickley, "The Colorado Desert and California," *Craftsman* 6, no. 3 (June 1904): 235–59.

17. See Fred Kniffen and Henry Glassie, "Building in Wood in the Eastern United States: A Time-Place Perspective," *Geographical Review* 56, no. 1 (Jan. 1966): 40–66. In this classic study, the authors trace the diffusion of log and other timber building techniques from the eastern seaboard westward, mapping the occurrence of various cornering types. Their analysis suggests that in Wisconsin, Stickley's birthplace, saddle notching, false-corner timbering, and square notching were the preferred joints. In Pennsylvania, closer to the original heart of wood building folkways, V-notching, full dovetails, and saddle notches were preferred.

18. On log cabins and the presidential campaigns of the nineteenth century, see C. A. Welsager, *The Log Cabin in America from Pioneer Days to the Present*, 261–315.

19. Gustav Stickley, "Three Craftsman Log Houses: Series of 1907: Number III," *Craftsman* 11, no. 6 (Mar. 1907): 742. One of these designs is quite similar to the design of the Clubhouse, though its construction differs markedly, as shown below.

20. Harold R. Shurtleff, *The Log Cabin Myth: A Study of the Early Dwellings of the English Colonists in North America*, 6. "The reasons for this emotional basis for the Log Cabin Myth are not far to seek," contends Shurtleff. "In the nineteenth century Americans began to marvel at their own progress, and to make a virtue of their early struggles with the wilderness. The log cabin as a symbol of democracy was dramatized in two famous presidential campaigns, those of 1840 and 1860. In the literature the popular 'Log Cabin to the White House' series firmly fixed the log cabin as the proper scenario for the birth of a great American; . . . Thus the log cabin came to be identified with 'Old Hickory,' 'Tippencanoe' and Abraham Lincoln, with democracy and the frontier spirit, with the common man and his dream of the good life, and with those persons, types, and forces of which Americans are justly proud" (5–6). Stickley's use of the log cabin as a nationalistic symbol has been cited by historian William Rhoads in his study of the colonial revival ("The Colonial Revival and American Nationalism," esp. 245–46). Catherine D. Groth, "Peer Gynt's Cabin and Other Log Houses Associated with the History and Romance of Norway," *Craftsman* 22, no. 6 (Sept. 1912): 582–96. The article featured the folk buildings reassembled at Mihaugen in the Gulbrandsdal by Dr. Sandvig for study purposes, and noted that log construction was now too expensive for the common person, even in Norway (Fish, *The New Craftsman Index*, 129, index no. 2425).

21. Scholarship on the dispersion of log cornering types, following the work of Kniffen and Glassie above ("Building in Wood"), includes the following studies: Donald A. Hutslar, *Log Construction in the Ohio Country, 1750–1850* (Athens: Ohio University Press, 1992); Terry G. Jordan, "Log Corner Timbering in Texas," *Pioneer America* 8, no. 1 (Jan. 1976): 8–18; Henry Chapman Mercer, "The Origin of Log Houses in the United States," parts 1–2, *Old-Time New England* 18, no. 1 (July 1927): 2–20; no. 2 (Oct. 1927): 51–63; Welsager, *Log Cabin in America*; and Peter O. Wacker and Roger T. Trindell, "The Log House in New Jersey: Origins and Diffusion," *Keystone Folklore Quarterly* 13 (1968): 248–68. On the principles of log building structure, see Jordan, *Texas Log Buildings*, 35. On southern traditions, see Catherine Bishir, *North Carolina Architecture* (Chapel Hill: Univ. of

North Carolina Press, 1990), 142–48. All of the authors cited point out that considerable variation in jointing and hewing techniques are visible in various regions and cultural catchments. On Stickley's methods of joinery, see Mark Taylor, "Commentary: Joinery and Construction," in *Gustav Stickley: His Craft*, edited by Bartinique, 84–85.

· 22. Edward R. Ford, *The Details of Modern Architecture*, 123–61. Ford mistakenly interprets the 1908 Stickley house design for Craftsman Farms as a completed structure, but provides many telling points of analysis on its relationship to other modern buildings. "Gustav Stickley—in some ways the primary American exponent of the American Arts and Crafts movement—reached a similar intellectual position to his European contemporaries [Voysey, Webb, Gimson] by a different route. . . . His primary interests were the design and construction of furniture . . . in which he echoed the English ideas of truth to material, response to site, structural fitness, and absence of conscious style" (133). Natalie Curtis, "The New Log House at Craftsman Farms: An Architectural Development of the Log Cabin."

23. The following chronology can be suggested. According to entries in the Stickley Company "Cash Disbursements" ledgers, expenditures for the "Farm" account in 1910–11 suggest an intense period of work from Apr. 30, 1910, until the end of Aug. 1911. Invoices for labor from a workman called only "S. B." in the record and miscellaneous expenses indicate that some $1,700 out of a total of more than $5,000 went into the construction. Stickley Business Papers, Winterthur Library, Col. 60, Ledger 75x101.54 (Apr. 1910–Jan. 1912). Decorating and finishing went on through the end of the year.

24. The Gustav Stickley Collection of Drawings for Craftsman Houses contains 134 sets of pattern drawings by the *Craftsman* architects and miscellaneous drawings of houses commissioned by specific clients. The Clubhouse and two cottages are represented in the collection. A catalog was compiled by Virginia Durshan, Sept. 1980. Drawers 76–77, Avery Architectural and Fine Arts Library, Columbia University. The author wishes to thank Janet Parks and her staff for their assistance with this research.

25. Stickley began publishing designs for Craftsman houses in 1902, and in 1903 employed two trained architects, Harvey Ellis (1852–1904) and Ernest W. Dietrich (1857–1924), as associates. They shared credit for designs published during 1903–4. It is likely that Stickley also employed a staff of draftsmen, but their names are not known at present. The only clues are a series of initials in the drawings preserved at the Avery Architectural Archives. See M. A. Smith, *Gustav Stickley: The Craftsman*, 59–75. The draftman's initials are "F. E. M."

26. Curtis, "The New Log House," 203.

27. Ibid., 196.

28. Illustrations of typical saddle cornering appear on the working drawings for one of these designs, labeled "Bungalow, log house, magazine house no. 3," on sheet no. 1, "Ground Floor Plan, Detail of Corners and Crossings." Stickley Collection, Avery No. 1907-4, Drawing 76-77.

29. "The leaders of all divisions of men are now earnestly seeking to recognize, display and emphasize the structural idea," Stickley wrote in his famous 1903 essay, "the idea that reveals, explains, and justifies the reason for the existence of any being, organism or object." See Gustav Stickley, "The Structural Style in Cabinet-Making," *House Beautiful* 15, no. 1 (Dec. 1903): 20–25.

30. Curtis, "The New Log House," 203.

31. H. Eisinger, a finisher from the Syracuse shop, was paid to travel to New Jersey and spend the months from February to May 1911 working on the Farm. Ledger 76x101.4579, Stickley Business Papers, Winterthur Library.

32. Gustav Stickley, "The Value of Permanent Architecture as a Truthful Expression of National Character," *Craftsman* 16, no. 1 (Apr. 1909): 80–91; on Gill's work, see Irving Gill, "The Home of the Future: The New Architecture of the West," *Craftsman* 30, no. 2 (May 1916): 140–51.

33. For a comparison of English and American architects, see Peter Davey, *Arts and Crafts Architecture*, 193–205. Davey notes the awkwardness and derivative quality of Stickley's house exteriors.

34. *Jerseyman* (July 28, 1911): 5.

35. "Stickley Craftsman Furniture Catalogues" (1910; reprint, New York: Dover, 1979), 104.

36. Flaccus interview, 6.

37. "The New Brick House at Craftsman Farms and a Small Bungalow," *Craftsman* 24, no. 2 (May 1913): 221–23. The house, numbered no. 159, was to be for the Wiles family, but was not constructed on the property. Flaccus interview, 8.

38. Flaccus interview, 3, 4. The 1915 Census listed the following residents at Craftsman Farms: Stickley family—Gustav, age fifty-four; Eda, age fifty-two; Mildred, age twenty-five; Hazel, age twenty-three; Marion, age twenty-two; Gustav Jr., age twenty; and Ruth, age seventeen. Others listed were Joseph Lader, farmer; Berg Engman, useful man; Samuel Louis, farmer; and Daniel Brogan, farmer. See Greiff, *Log House*, 21.

39. M. A. Smith, *Gustav Stickley: The Craftsman*, 157; see also Sanders, *Complex Fate*, 157–62.

40. See Greiff, *Log House*, 22, 23.

41. "Major G. S. Weinberg, U.S.A., Buys a Quaint 'Craftsman Farm' Place, Formerly Mr. Stickley's," *Jerseyman* (Aug. 31, 1917): 2.

42. Farny interview, MIA-2.

## 5. Architecture and Craft

1. Gustav Stickley, *Craftsman Homes* (New York: Craftsman Publishing, 1909); Gustav Stickley, *More Craftsman Homes* (New York: Craftsman Publishing, 1912); Gustav Stickley, *Craftsman Houses: A Book for Home Makers* (New York: Craftsman Publishing, 1913). Stickley notes that the first book sold twenty thousand copies in short order, thus becoming one of the most popular architecture books of its time. There are 134 plan sets contained in the Gustav Stickley–Craftsman Houses collection at the Avery Architectural Archives in New York City. Catalog compiled by Virginia Kurshan, Sept. 1980. Collection DR 76–77. The earliest drawings are labeled "1904-1" from January 1904, published in vol. 5 of the *Craftsman* on p. 399. The latest drawings are dated Oct. 1914, published in vol. 27 on p. 81. Ray Stubblebine counts 421 Craftsman House designs from his assessment of published sources. Following Stickley's bankruptcy the plan service was discontinued (in June 1915) and then restarted by George Fowler, a Stickley employee in 1916 for a few months. See Stubblebine, *Old House Journal*, 31–32.

2. Gustav Stickley, "The *Craftsman* Ideal in Home Building," *Craftsman* 15, no. 1 (Oct. 1908): 78–93, quoted in Freeman, *Forgotten Rebel*, 103. This point is clear from the final pages of his popular first book, *Craftsman Homes*, which proclaims that Craftsman Farms is to be "the most complete exposition of *The Craftsman* idea as a whole" (204).

3. Freeman, *Forgotten Rebel*, 103.

4. M. A. Smith, *Gustav Stickley: The Craftsman*, 54–56, 77–82.

5. David Cathers and Ray Stubblebine have discussed Stickley's debt to other designers, but no definitive list of them has yet come to light. See, for instance, Cathers, "The *Craftsman* Designs of LaMont A. Warner," *Style 1900* 9, no. 3 (summer/fall 1996): 38–41; and Stubblebine, "Gustav Stickley's Craftsman Home," *Style 1900* 9, no. 2 (spring/summer 1996): 22–25.

6. Robert Guter and Janet W. Foster note that Stickley's houses were published during a spate of mail-order and pattern-book business in the United States (*Building by the Book: Pattern-Book Architecture in New Jersey*, esp. their comparison on p. 210 and the treatment on pp. 196–215). See also Ray Stubblebine, "In Search of Craftsman Homes," *Old House Journal* (July–Aug. 1996): 27–33.

7. See Carolyn Kinsler, "Craftsman Architecture: The Search for a Vernacular Style," *Arts and Crafts Quarterly* 5 (1993): 26–30. She maintains that the Craftsman house was "the first time a popular style started with small middle class houses and moved to larger buildings," and that it was also "the first popular style promoting design based on materials, constructive details, simplicity and function rather than on achieving a pre-established criteria for 'style'" (26).

8. See J. L. Garvin, "Mail Order House Plans and American Victorian Architecture," *Winterthur Portfolio* 17, no. 4 (1981): 309–34. On the spread of mail-order houses, beginning in the 1840s, see Alan Gowans, *The Comfortable House: North American Suburban Architecture, 1890–1930,* 41–59.

9. There are two major articles on the subject published in the *Craftsman,* and subsequently incorporated into the three books Stickley published: "The *Craftsman* Idea in Home Building," 15, no. 1 (Oct. 1908): 78–93; and "Home Building from an Individual, Practical Standpoint," 23, no. 2 (Nov. 1912): 183–87. See also "A Word about Craftsman Architecture," in his *More Craftsman Homes,* 1–4; "The *Craftsman* Idea of the Kind of Home Environment That Would Result from More Natural Standards of Life and Work," in *Craftsman Homes,* 194–205.

10. "Distinguishing Features of the Craftsman House," *Craftsman* 23, no. 6 (Mar. 1913): 727–29.

THE RULING PRINCIPLE OF THE CRAFTSMAN HOUSE IS SIMPLICITY.

- simplicity spells economy.
- the simple lines of the craftsman house give it a beauty and a dignity which react most favorably upon the life and character of the family.
- a craftsman house answers the question—"what are the needs of the family?"
- a craftsman house represents not only economy in cost but economy in floor space.
- built-in features are often incorporated to meet special needs.
- a distinctive note of the true craftsman interior is the fireplace.
- decoration is accomplished by proper use of structural features.
- craftsman dining rooms are arranged to simplify household machinery.
- the craftsman kitchen is designed to provide for the housewife every kind of convenience and comfort.
- craftsman bedrooms are simply furnished as individual retreats.
- craftsman interior decoration is brought about by the proper use of woods and harmonious color schemes.

- craftsman exterior construction is such as to effect a complete harmony between the house and its surroundings.
- the craftsman house always commands a market price far in excess of the ordinary dwelling.

11. Wright's famous core precepts for "organic architecture" included: simplicity, plasticity, continuity (the horizontal), use of glass, materials "for their own sake," integral ornament ("at last"), and power. See Frank Lloyd Wright, *The Natural House* (New York: Horizon, 1954), 13–79. See Hayden, *The Grand Domestic Revolution;* Wright, *A Social History of American Housing;* and Clark, *The American Family Home.*

12. See, for instance, H. Allen Brooks, "Chicago Architecture: Its Debts to the Arts and Crafts," 312–17; and Thomas, *William L. Price.*

13. On the bungalow form, see Robert Winter, *The California Bungalow* (Los Angeles: Hennesey and Ingalls, 1980). See Clay Lancaster, *The American Bungalow* (New York: Abbeville, 1985).

14. Wright on "simplicity": "Crude furniture of the Roycroft-Stickley-Mission style, which came along later [than Wright's 'organic' designs] was offensively plain, plain as a barn door—but was never simple in the true sense" (*The Natural House,* 42).

15. Gustav Stickley, "A Roomy, Homelike Farmhouse for Lovers of Plain and Wholesome Country Life," in *Craftsman Homes,* 67.

16. Chilson D. Aldrich, *The Real Log House* (New York: Macmillan, 1928): 106–17.

17. Aladdin, of Bay City, Michigan, was founded in 1904; Sears and Roebuck began their mail-order business prior to 1910 and quickly became the industry leader. The first complete mail-order houses were sold by the Gordon Van Tine Company in 1900; William A. Radford's Chicago company began issuing its plans in the same decade. See Guter and Foster, *Building by the Book,* 208–11.

18. "Cement House, Compact yet Spacious, Suitable for a City Street," in *More Craftsman Homes,* 34–35.

19. On the diffusion and location of these types, see John A. Jakle, Robert W. Bastian, and Douglas K. Meyer, *Common Houses in America's Small Towns: The Atlantic Seaboard to the Mississippi Valley* (Athens: Univ. of Georgia Press, 1989), 171–81 and app. See also Robert Finley and E. M. Scott, "A Great Lakes–to-Gulf Profile of Dispersed Dwelling Types," *Geographical Review* 30: 412–19; and Richard Mattson, "The Bungalow Spirit," *Journal of Cultural Geography* 1: 75–92.

20. Guter and Foster, *Building by the Book*, 197.

21. "The Daftsman House: A Recipe," *Country Life in America* 20, no. 2 (May 15, 1911): 36. Subsequent quotes from the same page.

22. For Stickley's views on the relationship between architects and home builder–owners, see "Home Building from an Individual Standpoint," 182–83. Here he suggests that it is the owner's responsibility to design and build the house, not "to rely on other people's [an architect's] experience to solve one of the most important and intimate problems of their lives."

23. Wright, *The Natural House*, 42.

24. Kaplan, *The Art That Is Life*, is organized according to reform in aesthetics, reform in craftsmanship, and reform in the home. See essays by Kaplan, Boris, and Robertson.

25. David Shi, *The Simple Life: Plain Living and High Thinking in American Culture*.

26. Charles Wagner, *The Simple Life*, translated by Mary L. Hendee (New York: McClure Phillips, 1902).

27. Sanders, *Complex Fate*, 72–78.

28. Cheryl Robertson, "House and Home in the Arts and Crafts Era: Reforms for Simpler Living," in *The Art That Is Life*, edited by Kaplan, 336–38.

29. Mabel Tuke Priestman, *Art and Economy in Home Decoration* (New York: John Lane, 1908), 18.

30. Charles Keeler, *The Simple Home*, 4–5.

31. Ibid., xlv, 1. For analysis of the house, see Jeffery W. Limerick, "Bernard Maybeck," in *Toward a Simpler Way of Life: The Arts and Crafts Architects of California*, edited by Robert W. Winter, 52–54.

32. Keeler, *The Simple Home*, 18.

33. Stickley, *Chips from the Workshops of Gustave Stickley*, 3.

34. See, for instance, Nicholas Pevsner's seminal work *Pioneers of Modern Design* (Harmondsworth, England: Penguin, 1964).

35. See ibid.

36. Ford, *Details of Modern Architecture*, 7; David Pye, *The Nature and Art of Workmanship*, 1.

37. Cathers, *Furniture of the Arts and Crafts Movement*, 48–49. Stickley launched his new company following an aborted attempt to form a "chair trust" with other manufacturers in the Midwest. He briefly (for a year or less) signed a contract with the Tobey Company of Chicago to produce a complete line of Arts and Crafts–influenced pieces, directly invoking the new European styles—Glasgow school, Morris, art nouveau, Belgium, and so on (45–47).

38. See Michael L. James, "Charles Rohlfs and the 'Dignity of Labor,'" in *Substance of Style*, edited by Denker, 229–41. James points out that Rohlfs (1853–1936) has suffered from being seen as a "fringe" figure in the Arts and Crafts movement because he did not write or proselytize, but merely "crafted." A self-conscious artist who in many respects embodied the purest tenets of the Arts and Crafts ethos, Rohlfs has paradoxically remained obscure, whereas Stickley's fame has increased. Stickley, *Chips from the Workshops of Gustave Stickley*, 39.

39. Winterthur Library, Downs collection, No. 60, Stickley business papers, 76x101.67. "List of structures" for insurance records contained in the three Eastwood shops buildings. The mill department contained twenty-two machines, ranging from buzz planers, lathes, four-sided moulders, pedestal grinders, swing cut-off saws, two-spindle shapers, and single surfacers; the machine department contained thirty-three machines, including various sanders, band saws, scroll saws, dovetailing machines, back-tenoning machines, bit-mortising machines, boring machines, drill presses, and the like. The second-floor cabinet department had a smaller variety, only twelve machines. The metal shop, fabric department, finishing rooms, and other departments also used the latest technology.

40. Stickley, "Als Ik Kan," *Craftsman* 8, no. 6 (Sept. 1905): 835; Sanders, *Complex Fate*, 135. "In 1902, one of Stickley's settles with leather cushions sold for $78; a sideboard for $84; a dining room table for $60; a bookcase for $108; and a dining chair for $7.25." In 1909, at the height of production, his prices were reduced: a bookcase sold for $28, and a settle for $42. In contrast, the Widdicomb Company of Grand Rapids offered a five-drawing oak sewing cabinet for a mere $7.00 in 1901 (see Ransom, *City Built on Wood*, 56).

41. "Stickley Craftsman Furniture Catalogues," 5.

42. Ibid., 5–6.

43. Stickley's 1909 Syracuse payroll lists some 203 workers in the following departments: mill workers, yard men, glazing and veneering, rush seating, heat and power, metalwork, shipping room, machine department, driving men, cabinetmakers (19), general labor, upholstery, packing room, finishing room, sanding, leather department, fabric department, and office (Winterthur Library, 76x101.28, "Payroll: Sept. 30, 1909 to May 5, 1910").

44. On material technology, see, for instance, Thomas C. Jester, ed., *Twentieth-Century Building Materials* (New York: McGraw-Hill, 1995).

45. According to the Oxford English Dictionary, 2d ed., the original meaning of the word found in Old English, Old High German, Icelandic, and the Norse languages is "strength, power, virtue, and intellectual prowess."

46. On these architects, see Davey, *Arts and Crafts Architecture*, 155–65.

47. Ford, *Details of Modern Architecture*, 1–13.

48. See *Macmillan Dictionary of Architects*, s.v. Greene, Charles Sumner, and Greene, Henry Mather.

49. Henrietta Keith, "The Trail of Japanese Influence in Our Modern Domestic Architecture," *Craftsman* 12, no. 4 (July 1907): 446–51. See also Fish, *The New Craftsman Index*, entry 1106.

50. "California's Contribution to a National Architecture in Significance and Beauty as Shown in the Works of Greene and Greene, Architects," *Craftsman* 22, no. 5 (Aug. 1912): 532–47.

51. Ford, *Details of Modern Architecture*, 147.

52. Ibid.

53. Andrew Saint, *The Image of the Architect*, (New Haven: Yale Univ. Press, 1987).

54. William L. Price, "Architecture and the Chair," *Artsman* 2, no. 5 (Feb. 1905): 161–63.

# Bibliography

Unpublished Sources

Ayres, William S. "A Poor Sort of Heaven, a Good Sort of Earth: The Rose Valley Arts and Crafts Experiment, 1901–1910." Master's thesis, Winterthur Museum and Univ. of Delaware, 1982.

"Craftsman Farms Historic Landscape Report." Prepared by the Department of Landscape Architecture, Temple Univ., fall 1994, Philip W. Larsen, ASLA, instructor.

Craftsman Farms National Historic Site, Craftsman Farms Foundation, Parsippany, N.J. Farny Papers and Photographic Archives.

Downs, Joseph. Manuscript Collection. Winterthur Museum and Library, Winterthur, Del. Stickley Business Records and Papers.

Early, Marcia Andrea. "The *Craftsman* (1901–1916) as the Principal Spokesman for the Craftsman Movement in America, with a Short Study of the Craftsman House Projects." Master's thesis, Institute of Fine Arts, New York Univ., 1963.

Freeman, John Crosby. "Forgotten Rebel: Gustav Stickley." Master's thesis, Univ. of Delaware, 1964.

Kinsey, Sally J. "Gustav Stickley and the Early Years of the *Craftsman*." Master's thesis, Syracuse Univ., 1972.

Local History Collections, Joint Free Public Library of Morristown and Morris Township, N.J. Curtis Photographic Collection and various smaller collections.

Lock, Lisa L. "The Byrdcliffe Colony and the Politics of Arts and Crafts." Master's thesis, Winterthur Museum and Univ. of Delaware, 1992.

Photographic Collections, Winterthur Museum and Library, Winterthur, Del. Stickley Glass Plate Negatives.

Rare Book and Manuscript Room, Winterthur Museum and Library, Winterthur, Del. Craftsman magazines, Craftsman books and pamphlets.

Stickley Drawings Collection (Craftsman Home Builders' Club), Avery Architectural Archives, Avery Architectural and Fine Arts Library, Columbia Univ., New York City.

Thomas, George E. "William L. Price (1861–1916): Builder of Men and Buildings." Ph.D. diss., Univ. of Pennsylvania, 1975.

## Books and Articles

Aldrich, Chilson D. *The Real Log Cabin.* New York: Macmillan, 1928.

"Another Talk with the Host of Craftsman Farms." *Craftsman* 19, no. 5 (Feb. 1911): 485–88.

Ashbee, C. R. "The Experiment of the Guild and School of Handicraft." In *Manual of the Guild and School of Handicraft,* edited by C. R. Ashbee, 16–20. 1892. Reprint. New York: Garland, 1978.

Ayres, William S. *A Poor Sort of Heaven, a Good Sort of Earth: The Rose Valley Arts and Crafts Experiment.* Chadds Ford, Pa.: Brandywine River Museum, 1983.

Bartinique, A. Patricia. "Parsippany Claims Craftsman Farms." *Arts and Crafts Quarterly* 3, no. 3 (1991): 32–35.

———, ed. *Gustav Stickley: His Craft.* Parsippany, N.J.: Craftsman Farms Foundation, 1992.

Bartlett, Richard A. *The New Country: A Social History of the American Frontier, 1776–1890.* New York: Oxford Univ. Press, 1974.

Batchelder, Ernest A. "Why the Handicraft Guild at Chipping Campden Has Not Been a Business Success." *Craftsman* 15, no. 2 (Nov. 1908): 173–75.

Bavaro, Joseph, and William Mossman. *The Furniture of Gustav Stickley.* New York: Van Nostrand, 1984.

Bellamy, Edward. *Looking Backward, 2000–1887.* Cambridge: Harvard University Press, Belknap Press, 1987.

Binns, Charles F. "The Arts and Crafts Movement in America: Prize Essay." *Craftsman* 14 (June 1908): 275–79.

Bohdan, Carol L., and Todd M. Volpe. "The Furniture of Gustav Stickley." *Antiques* (May 1977): 989–98.

Boris, Eileen. *Art and Labor: John Ruskin, William Morris, and the Craftsman Ideal in America, 1876–1915.* Philadelphia: Temple Univ. Press, 1986.

———. "Dreams of Brotherhood and Beauty: The Social Ideals of the Arts and Crafts Movement." In *The Art That Is Life: The Arts and Crafts Movement in America, 1875–1920,* edited by Wendy Kaplan, 208–22. Boston: Museum of Fine Arts, 1987.

Brancaforte, Charlotte, ed. *The German Forty-Eighters in the United States.* Madison: State Historical Society of Wisconsin, 1989.

Brooks, H. Allen. "Chicago Architecture: Its Debts to the Arts and Crafts." *Journal of the Society of Architectural Historians* 30 (Dec. 1971): 312–17.

Cathers, David M. "The Craftsman Designs of M. Lamont Warner." *Style 1900* 9, no. 3 (summer–fall 1996): 38–41.

———. *Furniture of the American Arts and Crafts Movement.* Rev. ed. Philmont, N.Y.: Turn of the Century Editions, 1996.

———. *Stickley Style: Arts and Crafts Homes in the Craftsman Tradition.* Photographs by Alexander Vertikoff. New York: Simon and Schuster, 1999.

———, ed. *Gustav Stickley's Craftsman Farms: A Pictorial History.* Parsippany, N.J.: Craftsman Farms Foundation and Century Editions, 1999.

Cavanaugh, Cam. *In Lights and Shadows: Morristown in Three Centuries.* Morristown, N.J.: Joint Free Public Library of Morristown and Morris Township, 1986.

Clark, Robert Judson, ed. *The Arts and Crafts Movement in America, 1876–1916.* Princeton: Princeton Univ. Press, 1972.

Commager, Henry Steele. *The American Mind.* New Haven: Yale Univ. Press, 1950.

"A Country Home for the Business Man: A Second Visit to Craftsman Farms." *Craftsman* 19, no. 1 (Oct. 1909): 55–62.

"Craftsman Farms: Its Development and Future." *Craftsman* 25, no. 1 (Oct. 1913): 8–14.

Cram, Ralph Adams. "The Craftsman and the Architect." In *The Ministry of Art,* by Ralph Adams Cram, 143–46, 164–65. Boston: Houghton Mifflin, 1914.

Crawford, Alan. *C. R. Ashbee: Architect, Designer, and Romantic Socialist.* New Haven: Yale Univ. Press, 1985.

Cumming, Elizabeth, and Wendy Kaplan. *The Arts and Crafts Movement.* New York and London: Thames and Hudson, 1991.

Curtis, Natalie. "The New Log House at Craftsman Farms: An Architectural Development of the Log Cabin." *Craftsman* 21, no. 2 (Nov. 1911): 196–203.

Davey, Peter. *The Architecture of the Arts and Crafts Movement*. London: Architectural Press, 1980.

———. *Arts and Crafts Architecture*. 2d rev. ed. London: Phaidon, 1996.

Davidoff, Donald A. "Maturity of Design and Commercial Success: A Critical Reassessment of the Work of L. and J. G. Stickley and Peter Hansen." In *The Substance of Style: Perspectives on the American Arts and Crafts Movement*, edited by Bert Denker, 161–83. Winterthur, Del.: Winterthur Museum; Hanover: Univ. Press of New England, 1996.

———. "Sophisticated Design: The Mature Work of Gustav Stickley." *Antiques and Fine Art* 7, no. 1 (Dec. 1989): 84–91.

Davidoff, Donald A., and Stephen Gray, eds. *Innovation and Derivation: The Contribution of L. & J. G. Stickley to the Arts and Crafts Movement*. Parsippany, N.J.: Craftsman Farms Foundation, 1995.

Denker, Bert, ed. *The Substance of Style: Perspectives on the American Arts and Crafts Movement*. Winterthur, Del.: Winterthur Museum; Hanover: Univ. Press of New England, 1996.

Dewey, John. "Waste in Education." In *The School and Society*, by John Dewey, 59–84. New York: Macmillan, 1900.

Dietrichson, Jan W. *The Image of Money in the American Novel of the Gilded Age*. Oslo and New York: Universitetsforlaget and Humanities Press, 1969.

Edwards, Robert. "The Art of Work." In *The Art That Is Life: The Arts and Crafts Movement in America, 1875–1920*, edited by Wendy Kaplan, 223–36. Boston: Museum of Fine Arts, 1987.

———. "The Roycrofters: Their Furniture and Crafts." *Art and Antiques* 4, no. 6 (Nov.–Dec. 1981): 80–87.

Eidelberg, Martin. "Art Pottery." In *The Arts and Crafts Movement in America, 1876–1916*, edited by Robert Judson Clark, 119–86. Princeton: Princeton Univ. Press, 1972.

Elliott, Cecil D. "Wood." In his *Technics and Architecture: The Development of Materials and Systems for Buildings*, by Cecil D. Elliott, 5–22. Cambridge: MIT Press, 1992.

Ettema, Michael J. "Technological Innovation and Design Economics in Furniture Manufacture." *Winterthur Portfolio* 17, no. 2–3 (1991): 197–223.

Fish, Marilyn B. "Craftsman Farms: Landscape and Building Programs." *Arts and Crafts Quarterly* 4, no. 1 (1992): 34–39.

———. "Craftsman Farms School: Theory, Location, and Curriculum." *Arts and Crafts Quarterly* 3, no. 4 (1991): 4–7.

———. *Gustav Stickley: Heritage and Early Years.* North Caldwell, N.J.: Little Pond Press, 1997.

———. *The New Craftsman Index.* Lambertville, N.J.: Arts and Crafts Quarterly Press, 1997.

Ford, Edward R. *The Details of Modern Architecture.* Vol. 1. Cambridge: MIT Press, 1990.

Foy, Jessica, and Karal Ann Marling, eds. *The Arts and the American Home, 1890–1930.* Knoxville: Univ. of Tennessee Press, 1994.

Freeman, John Crosby. *Forgotten Rebel: Gustav Stickley and His Craftsman Mission Furniture.* Watkins Glen, N.Y.: Century House, 1966.

Gara, Larry. *A Short History of Wisconsin.* Madison: State Historical Society of Wisconsin, 1962.

Garvin, James L. "Mail Order House Plans and American Victorian Architecture." *Winterthur Portfolio* 17, no. 4 (1981): 309–34.

Geertz, Clifford. *The Interpretation of Cultures.* New York: Basic Books, 1973.

Glassie, Henry. *Folk Housing In Middle Virginia.* Knoxville: Univ. of Tennessee Press, 1975.

Goffman, Erving. *The Presentation of Self in Everyday Life.* New York: Anchor Books, 1959.

Goldberg, Bettina. "The Forty-Eighters and the School System in America." In *The German Forty-Eighters in the United States,* edited by Charlotte Brancaforte, 202–18. Madison: State Historical Society of Wisconsin, 1989.

Gowans, Alan. *The Comfortable House: North American Suburban Architecture, 1890–1930.* Cambridge: MIT Press, 1986.

Gray, Stephen. *The Early Work of Gustav Stickley.* Philmont, N.Y.: Turn of the Century Editions, 1996.

Greiff, Constance M. *The Log House at Craftsman Farms: Historic Structures Report.* Parsippany, N.J.: Holt Morgan Russell, Architects, and Craftsman Farms Foundation, 1993.

Grumet, Robert S. *Indians of North America: The Lenapes.* New York: Chelsea House, 1989.

Guter, Robert, and Janet W. Foster. *Building by the Book: Pattern-Book Architecture in New Jersey.* New Brunswick: Rutgers Univ. Press, 1992.

Hamerow, Theodore S. "The Two Worlds of the Forty-Eighters." In *The German Forty-Eighters in the United States,* edited by Charlotte Brancaforte, 19–35. Madison: State Historical Society of Wisconsin, 1989.

Hardin, Evamaria. *Syracuse Landmarks: An AIA Guide to Downtown and Historic Neighborhoods.* Syracuse: Syracuse Univ. Press, 1993.

Harris, James F. "The Arrival of the Europamude: Germans in America after 1848." In *The German Forty-Eighters in the United States,* edited by Charlotte Brancaforte. Madison: State Historical Society of Wisconsin, 1989.

Harris, Neil. *Building Lives: Constructing Rites and Passages.* New Haven: Yale Univ. Press, 1999.

Hayden, Dolores. *Seven American Utopias: The Architecture of Communitarian Socialism, 1790–1975.* Cambridge: MIT Press, 1976.

Hewitt, Mark Alan. *The Architect and the American Country House, 1890–1940.* New Haven: Yale Univ. Press, 1990.

———. "Words, Deeds, and Artifice: Gustav Stickley's Club House at Craftsman Farms." *Winterthur Portfolio* 31, no. 1 (1996): 23–51.

Hofstadter, Richard. *The Age of Reform: From Bryan to FDR.* New York: Vintage Books, 1955.

Howe, Samuel. "A Visit to the Workshops of the United Crafts." *Craftsman* 3 (Oct. 1902): 59–64.

Howells, William Dean. *A Traveler from Altruria: A Romance.* New York: Harper and Brothers, 1894.

Hubbard, Elbert. *The Roycroft Shop: Being a History.* East Aurora, N.Y.: Roycroft Press, 1908.

Hubka, Thomas C. *Big House, Little House, Back House, Barn: The Connected Farm Buildings of New England.* Hanover: Univ. Press of New England, 1984.

Jakle, John A., Robert W. Bastian, and Douglas K. Meyer. *Common Houses in America's Small Towns: The Atlantic Seaboard to the Mississippi Valley.* Athens: Univ. of Georgia Press, 1989.

Jordan, Terry. *Texas Log Buildings: A Folk Architecture.* Austin: Univ. of Texas Press, 1978.

Kaiser, Harvey H. *Great Camps of the Adirondacks.* Boston: David R. Godine, 1982.

Kammen, Michael. *Mystic Chords of Memory: The Transformation of Tradition in American Culture.* New York: Alfred A. Knopf, 1991.

Kaplan, Wendy, ed. *The Art That Is Life: The Arts and Crafts Movement in America, 1875–1920.* Boston: Museum of Fine Arts, 1987.

Kaufmann, Edgar, Jr. "The Arts and Crafts: Reactionary or Progressive." *Journal of the Art Museum, Princeton University* 34, no. 2 (1975): 6–12.

Keeler, Charles. *The Simple Home.* 1904. Reprint, Salt Lake City: Peregrine Smith, 1979.

Kinsler, Carol. "Craftsman Architecture: The Search for a Vernacular Style." *Arts and Crafts Quarterly* 5 (1993): 26–30.

Koch, Robert. "Elbert Hubbard's Roycrofters as Artist Craftsmen." *Winterthur Portfolio* 3 (1967): 67–82.

Kornwolf, James D. *M. H. Baillie Scott and the Arts and Crafts Movement: Pioneers of Modern Design.* Baltimore: Johns Hopkins Univ. Press, 1972.

Lancaster, Clay. *The American Bungalow.* New York: Abbeville Press, 1985.

Lears, T. J. Jackson. *No Place of Grace: Antimodernism and the Transformation of American Culture, 1876–1914.* New York: Pantheon, 1981.

Ludwig, Coy L. *The Arts and Crafts Movement in New York State, 1890s–1920s.* Hamilton, N.Y.: Gallery Association of New York State, 1983.

MacCarthy, Fiona. *The Simple Life: C. R. Ashbee in the Cotswolds.* London: Lund Humphries, 1981.

———. *William Morris: A Life for Our Time.* New York: Alfred A. Knopf, 1995.

Makinson, Randall L. *Greene and Greene: Architecture and Fine Art.* Salt Lake City: Peregrine Smith, 1972.

Marling, Karal Ann. *Woodstock: An American Art Colony, 1902–1977.* Vassar College Art Museum, 1977.

Meinig, D. W., ed. *The Interpretation of Ordinary Landscapes.* New York: Oxford Univ. Press, 1979.

Morris, William. *Hopes and Fears for Art and Signs of Change.* Vol. 3. 1882. Reprint, Bristol, England: Thoemmes Press, William Morris Library, 1994.

———. "News from Nowhere." In *News from Nowhere and Selected Writings and Designs,* edited by Asa Briggs, 183–301. Harmondsworth, England: Penguin English Library, 1984.

Mumford, Lewis. "Stickley on Simplicity and Domestic Life." In *The Roots of Contemporary American Architecture,* by Lewis Mumford, 299–305. New York: Reinhold, 1952.

Naylor, Gilian. *The Arts and Crafts Movement.* London: Studio Vista, 1971.

"The New Brick House at Craftsman Farms and a Small Bungalow." *Craftsman* 24, no. 2 (May 1913): 221–23.

Nowlin, Frank William. *The Bark-Covered House; or, Back in the Woods Again.* 1876. Reprint, Detroit: Great Americana Series, Readex Microprint, 1966.

Ohmann, Richard. *Selling Culture: Magazines, Markets, and Class at the Turn of the Century.* London and New York: Verso, 1996.

Otto, Celia Jackson. *American Furniture of the Nineteenth Century.* New York: Viking Press, 1965.

Price, William L. "Architecture and the Chair." *Artsman* 2, no. 5 (Feb. 1905): 161–63.

———. "Is Rose Valley Worthwhile?" *Artsman* 1, no. 1 (Oct. 1903): 9.

Priestman, Mabel Tuke. "Rose Valley: A Community of Disciples of Ruskin and Morris." *House and Garden* 10, no. 4 (Oct. 1906): 159–65.

Prown, Jules David. "Mind in Matter: An Introduction to Material-Culture Theory and Method." *Winterthur Portfolio* 14, no. 1 (spring 1982): 1–19.

Pye, David. *The Nature and Art of Workmanship.* Cambridge: Cambridge Univ. Press, 1968.

Quinan, Jack. "Elbert Hubbard's Roycroft." In *Head, Heart, and Hand: Elbert Hubbard and the Roycrofters,* edited by Marie Via and Margorie Searl, 1–19. Rochester: Univ. of Rochester Press, 1994.

Ransom, Frank. *The City Built on Wood: A History of the Furniture Industry in Grand Rapids, Michigan, 1850–1950.* Ann Arbor: Edwards Brothers, 1955.

Rassmussen, Wayne. "Wood on the Farm." In *Material Culture of the Wooden Age,* edited by Brooke Hindle, 15–34. Tarrytown, N.Y.: Sleepy Hollow Press, 1981.

Reed, Cleota. *Henry Chapman Mercer and the Moravian Pottery and Tile Works.* Philadelphia, Univ. of Pennsylvania Press, 1980).

———. "Irene Sargent: A Comprehensive Bibliography of Her Published Writings." *Courier* 18 (spring 1981): 9–25.

———. "Irene Sargent: Rediscovering a Lost Legend." *Courier* 16 (summer 1979): 3–13.

———. "'Near the Yates': Craft, Machine, and Ideology in Arts and Crafts Syracuse, 1900–1910." In *The Substance of Style: Perspectives on the American Arts and Crafts Movement,* edited by Bert Denker, 359–74. Winterthur, Del.: Winterthur Museum; Hanover: Univ. Press of New England, 1996.

Rhoads, William. "The Colonial Revival and American Nationalism." *Journal of the Society of Architectural Historians* 35, no. 4 (Dec. 1976): 239–54.

Riordan, Raymond. "A Visit to Craftsman Farms: The Impression It Made and the Result: The Gustav Stickley School for Citizenship." *Craftsman* 23, no. 2 (Nov. 1912): 151–64.

Ripley, La Vern J. *The German Americans.* Boston: Twayne, 1976.

Roberts, Mary Fanton. "One Man's Story." *Craftsman* 30 (May 1916): 188–200.

Robertson, Cheryl. "House and Home in the Arts and Crafts Era: Reforms for Simpler Living." In *The Art That Is Life: The Arts and Crafts Movement in America, 1875–1920,* edited by Wendy Kaplan, 336–57. Boston: Museum of Fine Arts, 1987.

———. "The Resort to the Rustic: Simple Living and the California Bungalow." In *The Arts and Crafts Movement in California: Living the Good Life*, edited by Kenneth Trapp, 89–103. New York: Abbeville Press, 1993.

Rosenberg, Nathan. "America's Rise to Woodworking Leadership." In *America's Wooden Age: Aspects of Its Early Technology*, edited by Brooke Hindle, 37–62. Tarrytown, N.Y.: Sleepy Hollow Press, 1975.

Ruskin, John. "The Two Paths, Being Lectures on Art and Its Application to Decoration and Manufacture." In vol. 10 of *Works of John Ruskin*, 22–23. 1859. Reprint, Kent: George Allen, 1884.

Sanders, Barry. *A Complex Fate: Gustav Stickley and the Craftsman Movement*. Washington, D.C.: Preservation Press, 1996.

———. *The "Craftsman": An Anthology*. Santa Barbara: Peregrine Smith Press, 1978.

———. "Gustav Stickley: A Craftsman's Furniture." *Art and Antiques* 2, no. 4 (1979): 46–53.

[Sargent, Irene]. "Chips from the *Craftsman* Workshops." *Craftsman* 5, no. 1 (Oct. 1903): 100–101.

———. "A Recent Arts and Crafts Exhibition." *Craftsman* 4 (May 1903): 69–83.

———. "William Morris: Some Thoughts upon His Life: Work and Influence." *Craftsman* 1, no. 1 (Oct. 1901): 1–14.

Saylor, Henry H. *Bungalows*. New York: McBride, Winston, 1911.

Schlereth, Thomas J. *Victorian America: Transformations in Everyday Life*. New York: HarperCollins, 1991.

Schmitt, Peter T. *Back to Nature: The Arcadian Myth in Urban America, 1900–1930*. New York: Oxford Univ. Press, 1969.

Shi, David E. *The Simple Life: Plain Living and High Thinking in American Culture*. New York: Oxford Univ. Press, 1985.

Shurtleff, Harold R. *The Log Cabin Myth: A Study of the Early Dwellings of the English Colonists in North America*. Cambridge: Harvard Univ. Press, 1939.

Smith, Bruce. *Greene and Greene Masterworks*. Photographs by Alexander Vertikoff. San Francisco: Chronicle Books, 1998.

Smith, Mary Ann. *Gustav Stickley: The Craftsman*. Syracuse: Syracuse Univ. Press, 1983.

Snyder-Grenier, Ellen. "Cornelius Kelley of Deerfield, Massachusetts: The Impact of Change on a Rural Blacksmith." In *The Substance of Style: Perspectives on the American Arts and Crafts Movement*, edited by Bert Denker, 263–79. Winterthur, Del.: Winterthur Museum; Hanover: Univ. Press of New England, 1996.

Stamm, Richard. "The Bradley and Hubbard Manufacturing Company and the Merchandising of the Arts and Crafts Movement in America." In *The Substance of Style: Perspectives on the American Arts and Crafts Movement*, edited by Bert Denker, 183–97. Winterthur, Del.: Winterthur Museum; Hanover: Univ. Press of New England, 1996.

Stansky, Peter. *Redesigning the World: William Morris, the 1880s, and the Arts and Crafts*. Princeton: Princeton Univ. Press, 1985.

Stein, Roger B. *John Ruskin and Aesthetic Thought in America*. Cambridge: Harvard Univ. Press, 1967.

Stickley, Gustav. "Als Ik Kan: A School for Citizenship." *Craftsman* 23 (Oct. 1912): 119–21.

———. "Als Ik Kan: Cooperation of Employer and Employed as a Solution to the Labor Problem." *Craftsman* 15, no. 5 (Feb. 1909): 620–21.

———. *Chips from the Craftsman Workshops*. New York: Kalhoff, 1906.

———. "The Club House at Craftsman Farms: A Log House Planned Especially for the Entertainment of Guests." *Craftsman* 15, no. 3 (Dec. 1908): 339–44.

———. "Craftsman Furniture." In *Catalogue of Craftsman Furniture*. Edited by David M. Cathers. 1910. Reprint, New York: Dover, 1979.

———. "The Craftsman's House: A Practical Application of All the Theories of Home Building Advocated in This Magazine." *Craftsman* 15, no. 1 (Oct. 1908): 78–93.

[———]. "Manual Training and Citizenship." *Craftsman* 5, no. 4 (Jan. 1904): 406–12.

———. "Manual Training and the Public Schools." *Craftsman* 16, no. 1 (Apr. 1909): 119–28.

———. "The Modern Home and the Domestic Problem." *Craftsman* 11, no. 4 (Jan. 1907): 452–57.

———. "A Plain Little Cabin That Would Make a Good Summer Home in the Woods." *Craftsman* 15, no. 2 (Nov. 1908): 81.

———. "Practical Education Gained on the Farm and Workshop." *Craftsman* 14, no. 1 (1908): 115–18.

———. "The Public School and the Home: The Part Each Should Bear in the Education of Our Children." *Craftsman* 16, no. 3 (June 1909): 284–90.

———. "A Second Visit to Craftsman Farms: The Country and Long Life." *Craftsman* 19, no. 5 (Feb. 1911): 487.

———. "The Structural Style in Cabinet Making." *House Beautiful* 15 (Dec. 1903): 19–23.

———. "Thoughts Occasioned by an Anniversary: A Plea for Democratic Art." *Craftsman* 7, no. 1 (Oct. 1904): 43–64.

———. "Three Craftsman Bungalows That May Prove Useful for Summer or Weekend Cottages." *Craftsman* 15, no. 2 (Nov. 1908): 215–21.

———. "The Use and Abuse of Machinery, and Its Relation to the Arts and Crafts." *Craftsman* 11, no. 2 (Nov. 1906): 202–7.

———. *What Is Wrought in the Craftsman Workshops.* 1904. Reprint, Philmont, N.Y.: Turn of the Century Editions, 1997.

"Structure and Ornament in the *Craftsman* Workshops." *Craftsman* 5, no. 4 (Jan. 1904): 391–96.

Stubblebine, Ray. "Gustav Stickley's Craftsman Home." *Style 1900* 9, no. 2 (spring–summer 1996): 22–25.

———. "In Search of Craftsman Homes." *Old House Journal* (July–Aug. 1996): 27–33.

Surdham, Charles, and William Osgoodby. *Beautiful Homes of Morristown and Morris County, New Jersey.* Morristown, N.J.: privately printed, 1910.

Thomas, Fra. "The Daftsman House: A Recipe." *Country Life in America* 20, no. 2 (May 15, 1911): 36.

Thomas, George E. *William L. Price: Arts and Crafts to Modern Design.* New York: Princeton Architectural Press, 2000.

Tinniswood, Adrian. *The Arts and Crafts House.* New York: Watson-Guptill Publications, 1999.

Trapp, Kenneth R., ed. *The Arts and Crafts Movement in California: Living the Good Life.* Oakland: Oakland Museum and Abbeville Press, 1993.

Triggs, Oscar Lovell. *Chapters in the History of the Arts and Crafts Movement.* Chicago: Bohemia Guild of the Industrial Art League, 1902.

———. "The New Industrialism." *Craftsman* 3, no. 2 (Nov. 1902): 93–106.

———. "A School of Industrial Art." *Craftsman* 3, no. 4 (Jan. 1903): 215–23.

———. "The Workshop and School." *Craftsman* 3, no. 1 (Oct. 1902): 20–32.

"The Value of a Country Education for Every Boy: A Talk with the Host of Craftsman Farms." *Craftsman* 19, no. 4 (Jan. 1911): 388–94.

"A Visit to Craftsman Farms: The Study of an Educational Ideal." *Craftsman* 18, no. 6 (Sept. 1910): 638–45.

Vogt, Virginia. "The Powerful Pictures of Homer C. Davenport of Morris Plains." Morris Plains, N.J.: Morris Plains Museum, 1995.

Wagner, Charles. *The Simple Life.* Translated by Mary L. Hendee. New York: McClure Phillips, 1902.

Walsh, Margaret. *The Manufacturing Frontier: Pioneer Industry in Antebellum Wisconsin, 1830–1860.* Madison: State Historical Society of Wisconsin, 1972.

Weitz, Karen. "Midwest to California: The Planned Arts and Crafts Community." In *The Substance of Style: Perspectives on the American Arts and Crafts*

*Movement*, edited by Bert Denker, 447–69. Winterthur, Del.: Winterthur Museum; Hanover: Univ. Press of New England, 1996.

Welsager, C. A. *The Log Cabin in America from Pioneer Days to the Present*. New Brunswick: Rutgers Univ. Press, 1969.

Wilson, Richard Guy. "American Arts and Crafts Architecture: Radical Though Dedicated to the Cause Conservative." In *The Art That Is Life: The Arts and Crafts Movement in America, 1875–1920*, edited by Wendy Kaplan, 101–31. Boston: Museum of Fine Arts, 1987.

———. "'Divine Excellence': The Arts and Crafts Life in California." In *The Arts and Crafts Movement in California: Living the Good Life*, edited by Kenneth Trapp, 233–46. New York: Abbeville Press, 1993.

Winter, Robert W. "The Arts and Crafts as a Social Movement." *Record of the Art Museum, Princeton University* 34, no. 2 (1975): 36–40.

———. *The California Bungalow*. Los Angeles: Hennessey and Ingalls, 1980.

———, ed. *Toward a Simpler Way of Life: The Arts and Crafts Architects of California*. Berkeley and Los Angeles: Univ. of California Press, 1997.

Wirth, Arthur G. *John Dewey as Educator: His Design for Work in Education*. New York: John Wiley and Sons, 1966.

WPA American Guide Series. *Wisconsin: A Guide to the Badger State*. New York: Duell, Sloan, and Pearce, 1941.

Zeitlin, Richard H. *Germans in Wisconsin*. Madison: State Historical Society of Wisconsin, 1977.

# Index

Page numbers in italics denote figures.

Chestnut Hill (Philadelphia), 4
Chicago Society of Arts and Crafts, 74
*Chips from the Craftsman Workshops*
  (Stickley), 42, 176
citizenship, school for, 81, 93–95
Claflin, John, 109
Clubhouse: as archetype, 150–51; conception of, 86–88, 96, 97, 117, 119, 121, 130; construction of, 9, 121–22, 198; critique of, 134–35, 147; design of, 88–90, 122–30; exterior views of, *10, 11, 121, 195, 196*; horizontal lines in, 154; interior views of, *131, 132, 133, 137, 138*; as log dwelling, 124, 126–30; preservation of, 7, 12; simplicity demonstrated in, 131–34; site for, 90, 114–15; social activities at, 135–44. *See also color insert*
Cody, Buffalo Bill, 107
Columbia Teachers' College, 3
Columbus Avenue house, 139
Comstock, William, 161–62
Connor, Jerome, 174
consumerism: accommodation to, 59, 70, 175–76; demands of, 57; machine-produced furniture and, 36–37; rejection of, 50–52; rise of, 34, 35. *See also* mass culture
Cooper Union, 77
cottages. *See* cabins and cottages
country life: British movement for, 55–56; idealization of, 26–28, 146; model of, 80–81; value of, 2, 4
*Country Life in America* (magazine), 164–67
*Country Time and Tide* (magazine), 63
craft, definition of, 183, 223n. 45
craft production: building vs., 182–99; designer and maker merged in, 15; in industrial era, 199–200; market for, 70; media and ideology linked to, 6–7. *See also* craftsmanship
Craftsman architecture: description of

typical, 149–52, 220–21n. 10; eclectic design approach to, 152–58, 219n. 5, 220n. 7; furniture compared to, 172–82; ideals underlying, 148–49, 158–64, 172, 216n. 20, 220n. 9; metaphors mixed in, 196–97; parody of, 164–67; simplicity's meaning for, 164, 166–72; Wright's critique of, 154, 221n. 14. *See also* buildings (Craftsman Farms)
Craftsman Building (Crouse Stables, Syracuse), 42, 168
Craftsman Building (N.Y.): financial difficulties and, 10, 143, 204n. 13; restaurant in, 96, 111, 115
Craftsman Farms (Morris County, N.J.): approach to, 13–16; context of, 3–7, 49, 100; critique of, 147, 193, 196–99; goals of, 9, 80–81, 96–98; influences on, 59, 70, 76–77, 87–88, 97–98; as laboratory, 148–49, 219n. 2; meaning of, 144–47; paper construction of, 80–98; as parable, 199–200; paradoxes faced in, 185; preservation of, 7, 11–12; primary ideal of, 71–80; properties purchased for, 7, 8, 9, 80, 82, 83, 110–13, 211n. 52, 213–14n. 66; as representative, 1–2, 47, 150–51; 1915 residents at, 218n. 38; water supply for, 115; workshops and, 92. *See also* agriculture and agrarianism; buildings (Craftsman Farms); finances (Stickley's); landscape
Craftsman Farms Foundation, 12, 204n. 12
Craftsman Home Builders' Club (CHBC), 149, 198
Craftsman Home Builder's Service: architects for, 149, 217n. 25; Clubhouse design and, 122; design process of, 82, 149–50, 217n. 25; publishing designs of, 79, 219n. 1, 219n. 6; Stickley's role in, 148–49, 159, 161
*Craftsman Homes* (Stickley), 219nn. 1–2
*Craftsman Houses* (Stickley), 152, 153

McCormick, Stanley, 76

McLanahan, M. Hawley, 59, 62, 66

McLaughlin, M. Louise, 3

media: Hubbard's use of, 67–68, 70; ideology's link to, 6–7; Rose Valley's use of, 62–63; Stickley's use of, 32, 45, 81, 139–40, 150–51. *See also Craftsman* magazine

Meem, John Gaw, 196

Mercer, Henry Chapman: legacy of, 210n. 37; mentioned, 3; as model, 97; success of, 67; tiles of, 67, 68, 70–71

Merchant, Daniel M., 109, 111, 141

Merton Abbey workshops, 49, 54, 80

metalwork production, 5

Miller, Frank, 4

Miller, Joaquin, 4

Milwaukee (Wisc.), immigrants in, 21

Mission Inn (Calif.), 4

Moravian Pottery and Tileworks, 3, 67, 68, 70–71

*More Craftsman Homes* (Stickley), 156–57

Morris, William: focus of, 33; influence by, 1, 6, 44–45, 59, 76, 184, 213n. 60; legacy of, 53, 56; utopianism of, 14, 49–52

Morris and Essex Railroad, 103

Morris Canal, 103

Morris Plains (N.J.): description of, 109–11; diverse institutions in, 103–6; geology of, 101–3; as ideal location, 76–77, 96; luminaries in, 81–82, 85, 106–9; maps of, 8, 83, 100, 114; as place, 14–15, 99, 144–47; properties purchased in, 7, 8, 9, 80, 82, 83, 110–13, 211n. 52, 213–14n. 66. *See also* Craftsman Farms (Morris County, N.J.)

Morse, Samuel F. B., 103

mottos: Rose Valley's, 209n. 25; Stickley's, 17, 45

Mount Tabor (N.J.), church camp in, 104–6

National Historic Landmark, 12

National Trust (England), 55–56, 208n. 12

Native Americans: influence by, 27, 90, 213n. 65; landscape of, 101–2

nature: Stickley on, 27–28; woodcraft linked to, 33. *See also* wood and woodcraft

Newark and Mount Pleasant Turnpike Company, 102–3

New Clairvaux (Montague, Mass.), 59, 63, 66

"New Industrialism," concept of, 75–80

New Jersey, geology of, 101–3, 145–47. *See also* Morris Plains (N.J.)

New Jersey Historic Trust, 204n. 12

New Jersey Institute of Technology, 204n. 12

*News from Nowhere* (Morris), 49–50

New York City, city planning in, 4. *See also* Craftsman Building (N.Y.)

New York State Penitentiary, 31

*New York Times,* on Stickley's bankruptcy, 143

Norton, Charles Eliot, 3, 41, 57

Nowlin, Frank, 26–27

Ohmann, Richard, 6

Olmstead, Frederick Law, Jr., 4, 182

Osceola (Wisc.), settlement of, 25

Osgoodby, William, 109

outdoor life: facilitated in floor plan, 84, 85; simplicity and, 167–68

Pallisers (company), 161–62

Palmer, Potter, 76

Parker, Daniel, 141

Park Rail Road Company, 31

Parsippany (N.J.): properties in, 204n. 12; rediscovery of, 12

pastureland, 140

patents, 207n. 30

Pennsylvania: fantasy house in, 70; immigrants in, 205n. 8; log dwellings in,

Wilder, Laura Ingalls, 26

Wiles, Barbara Stickley (daughter): assistance from, 11; childhood of, 31, 116; home of, 141–42; marriage of, 139; on Stickley's woodcraft, 32–33, 38

Wiles, Ben, 10, 11

Wilson, Henry, 152, 161, 193

Wilson, Woodrow, 19, 74

Wisconsin: immigrants in, 20–24; log dwellings in, 21, 23, 215n. 17

women, domestic reform and, 149, 168, 170

wood and woodcraft: centrality of, 117; diversity in Stickley's plan, 85, 213n. 62; Greenes' use of, 191; identification with, 32–33, 36–37, 40; properties of, 39; technology in, 34–35; use of chestnut, 86, 124, 126, 146; use of oak, 37, 38, 179–80. *See also* furniture and furniture design; log dwellings

Woodstock art colony. *See* Byrdcliffe Arts and Crafts colony (Woodstock, N.Y.)

Woodward, George, 4

work: apprenticeships in, 28–29, 36–37, 75; art linked to, 58, 60, 62, 71–75; class divisions and, 57–58; education and agriculture linked to, 95–96; industrial revolution's impact on, 167; labor vs. machine in, 34–35; model of, 80–81; redeeming power of, 24; social experiments in, 5–6; utopian writing on, 50–52. *See also* guild ideal; manual trades movement

workmanship, types of, 173, 177, 181. *See also* craftsmanship

World's Fair (1904, St. Louis), 210n. 37

Wright, Frank Lloyd: architecture of, 18–19, 135; Ashbee's association with, 208n. 12; character of, 47; on Craftsman architecture, 154, 221n. 14; as designer, 174; friends of, 53; in Industrial Art League, 76; on natural house, 151, 221n. 11; residence-farm-studio of, 97; rhetoric of, 152; on simplicity, 167, 171, 221n. 14

Wurlitzer, Sylvia, 143. *See also* Farny family

Yates Hotel (Syracuse), 32, 41

Yellin, Samuel, 5

Yelping Hill (Conn.), 4

*Yeoman* magazine, 113

Yosemite Valley tent colonies, 4